in memory of John Winter

Making Beauty

THE GINORI PORCELAIN MANUFACTORY AND ITS PROGENY OF STATUES

Florence, Museo Nazionale del Bargello, 18 May–1 October 2017

RESTORATIONS AND RADIOGRAPHIC ANALYSIS
Roberto Bonaiuti
Antonella Lauricella
Marcello Miccio
Francesca Rossi
Stefano Sarri
Laura Speranza
Filippo Tattini

INSTALLATION
Installation design
Luigi Cupellini
with the collaboration of
Carlo Pellegrini
Maria Cristina Valenti Quintana

Exhibition installation
Opera Laboratori Fiorentini-Civita

Graphics
Paola Vannucchi
with the collaboration of
Matteo Bertelli

Technical department
Vincenzo De Magistris
Michele Martino
Nicola Voria

Conservation and restoration of some of the works in the exhibition
Francesca Rossi

Translations of the didactics
Lucian Komoy/Language Consulting Congressi, Milan

Security systems
E.RI.SIST, Sesto Fiorentino

Packing company
Arteria

Insurance
Willis Towers Watson

LENDERS
We are grateful to:
Liechtenstein. The Princely Collections, Vaduz-Vienna
Lionardo Lorenzo Ginori Lisci, Florence
Livia Sanminiatelli Branca, Florence
Los Angeles County Museum of Art, Los Angeles
Lucrezia Corsini Miari Fulcis, Florence
Museo dell'Accademia Etrusca e della Città di Cortona (MAEC), Cortona
Museo Richard Ginori della manifattura di Doccia, Sesto Fiorentino
Seattle Art Museum, Seattle
and the collectors who wish to remain anonymous.

CATALOGUE
Essays
Cristiano Giometti
Cristina Gnoni Mavarelli
Alvar González-Palacios
Marino Marini
Cristina Maritano
Tomaso Montanari
Dimitrios Zikos

Catalogue entries
Daniele Lauri
Maria Persona
Dimitrios Zikos

Photographic campaign
Arrigo Coppitz

Editor
Marco Salucci
Maria Cecilia Del Freo

Art director
Paola Vannucchi

Translations
Lucian Komoy/Language Consulting Congressi, Milan
Oliva Rucellai
Anaka Allen

Pre-print
Puntoeacapo, Florence

Print and binding
Varigrafica, Rome

Acknowledgements
Andrea Bacchi, Nadia Bacic, Rita Balleri, Alessandra Bandini, Ilaria Bartocci, Maria Eletta Benedetti, Sara Bernardini, Alessandro Biancalana, Monica Bietti, Anna Bisceglia, Roberto Bonaiuti, Paolo Bruschetti, Eleonora Butteri, Fausta Calderai, Donatella Carmi, Tullia Carratù, Jennifer Celani, Benedetta Chiesi, Alan Chong, Marco Ciatti, Ilaria Ciseri, Augusto Clot, Valentina Conticelli, Lucrezia Corsini Miari Fulcis, Alessandro Cosma, Luigi Dei, Anna Di Bene, Jane Donnini, Nicholas Dorman, Brian K. Duffey, Girolamo and Roberta Etro, Francesca Franciolini, Sara Gaggio, Riccardo Galli, Lorenzo Mariano Gallo, Bruno Gialluca, Davide Gambino, Giancarlo Gentilini, Nicola Giagnoni, Giovanni Giunchedi, Lionardo Lorenzo and Alessandra Ginori Lisci, Cristina Gnoni Mavarelli, Gabriele Gori, Orsola Gori, Paola Grifoni, Ferdinando and Anna Maria Guicciardini, Alexandra Hanzl, Mario Iozzo, Chiyo Ishikawa, Laurence Kanter, Kislak Center for Special Collections, Rare Books and Manuscripts, University of Pennsylvania; Johann Kräftner, Antonella Lauricella, Gilberto Lazzeri, Patrice Marandel, Alessandra Marino, Maurizio Mazzoneschi, Piero Marchi, Sascha Mehringer, Eri Mizukane, Jennifer Montagu, Anna Moore Valeri, Giovanni Morganti, Giuliano Moscatelli, Peta Motture, Ludovica Nicolai, Carlo Orsi, Chiara Padelletti, Davide Arno Panten Pagnotta, Simona Pasquinucci, Peter Pritchard, Andrea Pessina, Giovanni Pratesi, Valentina Puggelli, Sandro Quagliotti, Maddalena Ragni, Paola Refice, Patrizia Rocchini, Rita Romanelli, Kimerly Rorschach, Francesca Rossi, Oliva Rucellai, Fioranna Salvadori, Livia Sanminiatelli Branca, Eike Schmidt, Michael Schweller, Daniela Smalzi, Lucià Simonato, Laura Speranza, Maddalena Taglioli, Sandra Tarchiani, Filippo Tattini, Maurizio Toccafondi, Riccardo Todesco, Umberto Tombari, Alexandra Toscano, Veronica Vestri, Sophie Wistawel, Katherine Zock.
We are also grateful to Trinity Fine Arts Ltd. for having provided the shipment from Los Angeles County Museum of Art, Los Angeles.

Mandragora s.r.l.
piazza del Duomo 9, 50122 Firenze
www.mandragora.it

Printed in Italy

isbn 978-88-7461-349-6

Making Beauty

THE GINORI PORCELAIN MANUFACTORY
AND ITS PROGENY OF STATUES

edited by

TOMASO MONTANARI and DIMITRIOS ZIKOS

with the collaboration of

CRISTIANO GIOMETTI and MARINO MARINI

Mandragora

Founded in 1737 by Marquis Carlo Ginori at Doccia, near Florence, the porcelain manufactory of Sesto Fiorentino is the oldest in Italy.

From the time of its foundation, Marquis Ginori systematically collected the moulds belonging to sculptors working from the late Renaissance to the Baroque periods still available in Florentine workshops, making use of them to create his large-scale porcelain sculptures. At the same time, he bought models from sculptors of the time, or commissioned smaller-scale versions from them of the most celebrated statues of antiquity. Thanks to a refined and sophisticated expertise, the Doccia kilns produced a series of monumental porcelain figures that are quite extraordinary in terms of technical prowess and size.

The collection of models was subsequently expanded by Carlo's heirs, and today is divided between the Manifattura Richard Ginori – which became such in 1896 – and the Museum adjacent to the factory, unfortunately closed since May 2014.

The nucleus, comprising the collection of models and porcelain works, represents a unique group of fundamental importance for the history of sculpture.

It is in order to focus attention on this exceptional heritage, known, appreciated and valued abroad more than it has been so far in Italy, that this exhibition was conceived, and the ideal place for it could only be the Museo Nazionale del Bargello, the *locus* par excellence of Italian sculpture.

"Making Beauty. The Ginori Porcelain Manufactory and its Progeny of Statues" has been curated by Tomaso Montanari and Dimitrios Zikos, with the collaboration of Cristiano Giometti and Marino Marini, and has been organised in a partnership with the Associazione Amici di Doccia, and in particular with Livia Frescobaldi Malenchini and Oliva Rucellai. More than a year of art-historical research and passionate academic and cultural discussions have led to a wide-ranging exhibition and catalogue.

In the Bargello exhibition, the most important sculptures produced in the first period of the manufactory are presented in fresh relationships with the terracotta or bronze works that served as total or partial models for the porcelain.

Divided into six thematic sections, the exhibition traces the story of the transformation of a sculptural *inventio* into a porcelain work.

Through new research focusing on individual case studies, the porcelain works create a dialogue with those in the Bargello and with other selected sculptures borrowed from national and foreign institutions and private individuals, some exhibited in Italy for the first time.

I would like to thank HSH Prince Hans-Adam II von und zu Liechtenstein who has generously granted his patronage to the exhibition as well as the loan of his bronze *Venus* by Massimiliano Soldani Benzi, which returns to Italy after more than three hundred years.

The Museo Ginori has kindly loaned the two most important works of the whole collection: the *Venus de' Medici*, which reproduces the famous statue in the Tribuna, and the monumental *Fireplace*, crowned by the smaller-scale copies of *Dawn* and *Dusk* by Michelangelo for the Medici tombs, restored for this exhibition.

Thanks to the collaboration with the Accademia Etrusca di Cortona, the extraordinary *Tempietto to the glory of Tuscany* donated by Carlo Ginori to the Accademia itself is on show and was also restored for the exhibition. The *Tempietto* summarises and concentrates not only the artistic, but also the political ambitions of the manufactory's founder.

My most sincere gratitude goes to the Italian and foreign collectors who have agreed to lend their rare works.

The Soprintendenza Archeologia, Belle Arti Paesaggio for the city of Florence and the provinces of Pistoia and Prato, and the Università degli Studi di Firenze have also contributed to the exhibition.

Thanks to an agreement for the internship with the SAGAS Department of the University, two students, Daniele Lauri and Maria Persona, have participated at various stages of the project and prepared the catalogue entries.

The exhibition has been organised thanks to funding from the Fondazione Cassa di Risparmio di Firenze, to sponsorship from Richard Ginori, and to the collaboration of Firenze Musei. In addition, Opera Laboratori Fiorentini and Arteria have contributed, respectively for the layout and for the transport.

I would like to thank Mario Curia and the staff of Mandragora for the professionalism and care shown in preparing the catalogue and for the graphic design of the exhibition.

The curators and authors of the essays worked without charge to reduce the cost of the exhibition and support the Museo Ginori, of which two of the displayed works were restored and re-catalogued. I would like to express my deepest gratitude to them for the dedication and intellectual passion shown in the organisation of this exhibition.

Many of the players and protagonists of this enterprise – from the institutions that have generously financed it, to the curators, and Amici di Doccia – will be at the forefront in outlining the future administration of the Museo Ginori following the happy announcement of its purchase by the state made by the Minister of Cultural Affairs, Dario Franceschini.

It is hoped that this exhibition will represent an initial model for collaboration between the public and private sectors, and that it will contribute to the revival of the Museum and relaunch of the Doccia manufactory.

Paola D'Agostino
Director, Museo Nazionale del Bargello

A story of stories. This is the Museo di Doccia that represents the best of the conjunction between art and manufacturing activities, but which also has a long and complicated history: the separation of the museum from the production (of which it had originally been an integral part) provoked a crisis, but the recent announcement by the Minister for Cultural Affairs the museum will be acquired by the state resolves this problem. As ever, the Fondazione Cassa di Risparmio di Firenze has been close to this unique institution, and we are still delighted to offer our support.

This is a matter of history, culture, art, but also of an important reality that produced what was known as 'white gold' due to its precious nature. The exhibition "Making Beauty. The Ginori Porcelain Manufactory and its Progeny of Statues" marks an innovative collaboration between the Museo Nazionale del Bargello – the most important sculpture museum in the world, home to some of the finest masterpieces by leading artists – and the Museo Richard Ginori of the Doccia manufactory which holds works that were once defined as 'minor arts' and are now better known as 'applied arts'.

This dialogue had already been anticipated by the founder, the farsighted Leopoldo Carlo Ginori Lisci, a man endowed with extraordinary entrepreneurial spirit, who, around the first half of the 18th century, founded the manufactory, establishing a profound link between his production and the great history of Florentine and Italian art. Porcelain, which through its process connects the whole world, linking the ancient Chinese tradition, its German version and French taste, found a refined expression in Florence that succeeding in using this new material to render the greatest artistic expressions of Florentine art and the legacy of Antiquity in the splendid white it offered.

The time of the founding of the factory was difficult for Tuscany, with the passage of power between the Medici dynasty and the House of Lorraine, and with the fear of the sale of the masterpieces of the ruling family. While the Lorraine rulers closed the Grand Ducal workshops which for centuries had assured the production of refined *pietra dura* works replicating the quality of the major works in a small format, Carlo Ginori opened the porcelain manufactory at Doccia. And with the great figures, the "progeny of statues" to borrow the evocative title of the exhibition, which reproduce the masterpieces of Italian art, he assured both the continuity of a long cultural tradition through an act that safeguarded the national heritage, and also a fundamental production activity for the 'metropolitan city' as we call it today, looking also to an audience that was then starting to emerge: travellers who, when unable to buy originals, bought souvenirs, casts, bronzes replicating the works admired during their journey.

And with the 'models gallery' – which he wished should house the drawings, wax, plaster sculptures and terracotta works used in the manufactory – Ginori created the oldest business museum in the world; one that recounts, archives and preserves the secrets of a product, but also celebrates the entrepreneurial skills carried forward through the centuries by the history of a brand that has also formed the history of taste. A unique institution, firmly bound to its territory that the Fondazione Cassa di Risparmio di Firenze has contributed in preserving and making known more widely to the general public including through exhibitions like the present one.

Umberto Tombari
President, Fondazione Cassa di Risparmio di Firenze

The Amici di Doccia is a non-profit cultural association inspired by the desire of various enthusiasts, scholars, academics and collectors to create a centre for research on the ceramics produced by the manufactory at Doccia, to deepen its study and disseminate knowledge of it in Italy and abroad. For fourteen years, the Amici di Doccia have promoted research, ranging from the eighteenth and nineteenth centuries to the first half of the twentieth century, and thanks to the intense exhibition activity, an ever-wider and varied audience has been reached. The "Making Beauty" exhibition happily accords with the route we set out on in 2003 when, for the Biennale Internazionale dell'Antiquariato in Florence, an exhibition was organised on the basis of an idea by John Winter with Fabrizio Guidi Bruscoli with Giovanni Pratesi, entitled "The Statues of the Marchese Ginori", which awakened the interest of scholars and collectors with regard to the white porcelain of Doccia: an extraordinary production unequalled by any other manufactory in the world. Only two years later, forty porcelain sculptures from Doccia formed an entire section of the magnificent "Baroque Luxury Porcelain" exhibition organised at the Liechtenstein Museum in Vienna, consolidating the interest for Doccia at an international level.

Some years later, we are happy that thanks to the support of Tomaso Montanari, the Museo Nazionale del Bargello welcomes an exhibition designed to celebrate the excellence and importance of these extraordinary sculptural works in porcelain. We wish to thank Paola D'Agostino, director of the Museum, Marino Marini, curator of ceramics, the curators of the exhibition and Cristiano Giometti for the commitment they have generously devoted to this project.

Today, Doccia is experiencing an epochal change: after more than 250 years the collection and the Museo di Doccia building are about to be acquired by the state, whose fundamental intervention is part of a broader project that will see the creation of a public-private foundation given the the task of managing and promoting the collections so that they become an essential resource for the education and cultural enrichment of present and future citizens. While awaiting the moment the museum opens its doors to the public, this exhibition offers an opportunity to reflect on its identity, which developed in parallel with the manufactory over a period of nearly three centuries of continuity. We hope and must commit ourselves to ensuring that this should only be, even though the museum and the factory are now in separate hands, in the interest of promoting both realities, the factory and the museum; two distinct but synergic entities that only through constant dialogue will once again be able to express the excellence and creativity that the whole world admires and that have always constituted Doccia's unique feature.

Lionardo Lorenzo Ginori Lisci
Honorary president, Amici di Doccia

Livia Frescobaldi Malenchini
President, Amici di Doccia

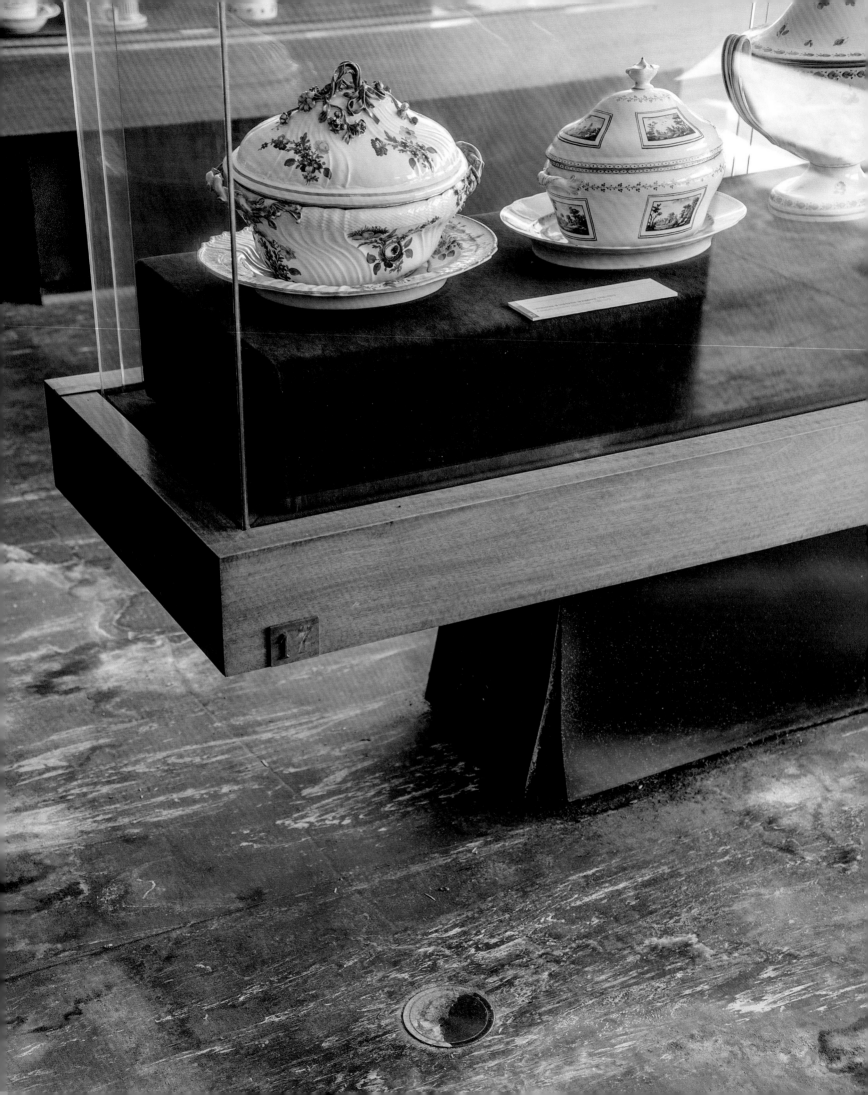

An exhibition for a museum: saving the Museo Ginori

TOMASO MONTANARI

This exhibition is a different exhibition.

It is a political exhibition in the highest sense of the word. An exhibition that has been conceived, desired, organised to help save a piece of *polis*, or city.

I allude to the Museo Ginori, an extraordinarily important piece of the cultural heritage of the Florence region. But I allude also to the life of those currently employed in the Ginori factory. And finally, to something more intangible, but no less significant: the cultural, moral and social fabric that must continue to hold together features that today contrast with each other: Florence and Sesto Fiorentino, the Museo del Bargello and the Museo Ginori, the great history of art and industrial work, beauty and endeavour.

In 1837, the Doccia manufactory celebrated its first century of activity. That same year saw the death of Leopoldo Carlo Ginori Lisci, grandson of the founder, Carlo Ginori; in the beautiful eulogy published by Raffaello Lambruschini in that same year, we can read that

> the Marquis Carlo… imagined and built a circular furnace 37 *braccia* high on four levels, which made it much more powerful in terms of heating capacity, and much cheaper to operate given the smaller amount of fuel consumed. This furnace has been deemed so worthy of attention by art people that Alessandro Brongniart published a description and drawings of it. The same Marquis Carlo expressly built a large space in Doccia in which to place a collection put together by him of the most prized antique models and modern sculptures. And in every possible way, he promoted the study of drawing and painting, so that in its finery, the porcelain of Doccia should show itself to be of Italian workmanship. And the products of his factory increased and varied to such an extent that the increased sales provided a living for two hundred people in the lovely hills surrounding the factory. A happy population that Ginori wanted to prosper not only through work, also to be well-educated, honest and cheerful, graced by the fine arts that open the soul to pure delight, and cultivate the faculties of the spirit and train those of the body. At Doccia, he opened a primary school for the workers, as well as schools of the arts of design, as I mentioned above, and an academy of music. Moreover, with the first foundation in Florence of a savings bank, he deposited a substantial sum on behalf of the workers themselves, gathered by him into mutual aid societies: so that if a man was prevented from working through illness, he would receive a daily help from this common fund, destined to succour misfortune and formed from the savings of the industrious, with sums established in Doccia for certain deficiencies, and in notable part by the generosity of the Marquis Ginori.[1]

It is only with a good measure of paternalism that we can believe today in the "happiness" of the "population" tied, at that time, to the manufactory. But – as Piero Bevilacqua has recalled in his recent book[2] – the striving for the building of a public happiness, a civic happiness, is an important thread in the history of what we now call the Italian cultural heritage. And, on the other hand, the solidarity of Lambruschini illustrates well the range of meanings that the history of the manufactory, despite everything, held together. The history of the art of the past and the creation of the present; cultural training and mutual aid; the profit of the owner and – to adopt

1–3. Views of the current tragic condition of the Museo Ginori (April 2017)

13

the words that would be included in the Constitution of the Italian Republic more than a century later – "the full development of the human person". And, at the centre of all this, the "large space" of the museum.

Recent history has witnessed the progressive crumbling of this network of values, interests, relationships, with the extreme results we see today. In 2004, the Ginori firm sold the land on which both the factory and the museum stand to a real estate company (Ginori Real Estate, which had as its members a number of property developers since involved in various legal investigations). In 2010, Ginori Real Estate was placed in liquidation, and in 2013 the same happened to Ginori itself, which went bankrupt (this was followed by a trial for fraudulent bankruptcy). After long struggles on the part of the workers, the factory itself was 'saved' by Gucci, which took it over. But the purchase of the factory by a multinational and foreign-based holding company in the luxury sector (Gucci belongs to Kering, itself owned by François Pinault) cut the last thread connecting the current Ginori production with the history of the Ginori manufactory: and first consequence was the loss of interest for the museum, which in fact was not purchased by the holding company, and remained in a situation of bankruptcy without the necessary means to continue its activity. Thus, while the museum's death sentence was signed by Florentine speculators, failure to save it is instead the responsibility of the new foreign owners.

The result is an inconceivable split, given that even today a large part of the museum's holdings are stored at the plant, and a significant portion of the daily tasks carried out by the factory's modellers and decorators are rooted in the life of the moulds from the museum.

The physical disintegration of the museum – damaged by water seepage and attacked by mould which (as I write, in April 2017) obliges us to enter only with a protective mask – can be read as an eloquent symbol of the consequences of financial globalisation, mediated by banks, on the industrial, cultural and social fabric. Everything that was dear to Leopoldo Carlo Ginori Lisci – the links between his production and Florentine art history and with the happiness of his workers – is precisely what is not of the least interest today, and that is why the struggle to save the museum is intertwined with that of saving jobs at Ginori.

And it is for this reason too that we wanted the title of the exhibition to include the word "popolo", because the centrality of the human figure that is so present in the Florentine tradition does not concern only the 'progeny' of statues emerging from Ginori's furnaces, but also the 'population' of workers who, then as now, work at those furnaces.

But how can an exhibition help in a situation like this? It can help if it succeeds in re-forging some broken links, and in awakening a concern, in nourishing an awareness, in fostering a love.

Showing works from the Bargello alongside other ones languishing in the Museo Ginori means affirming and highlighting the strength of the artistic and historical ties that bind the museum at Doccia to the very heart of Florentine culture: it is like broadcasting that what happens in Sesto concerns Florence and all the Florentines. The history of the Museo Ginori is not a provincial, secondary story, another story: it is one that is central, fundamental, the same story.

And extending this dialogue to other works, from museums in Europe and America, is to demonstrate that this unity is recognised at a worldwide level. We want to contrast the lack of awareness typical of financial globalisation, focused on the short term, on immediate economic returns, with a global culture that knows, respects and loves the history of Italian culture. And which is anxious to protect a museum that conserves and retains a very significant part of that history.

The hope that, in September 2015, convinced me to propose the idea of this exhibition to Director Paola D'Agostino – to whom I am very grateful – is that a Florentine, Italian and international audience will leave the rooms of the Bargello sufficiently aware and motivated to make its voice heard, thereby stimulating the political sector to play its part.

On 30 March 2017, during the final stages of preparation for the exhibition, the Minister for Cultural Heritage Dario Franceschini announced that the state would acquire the Museo Ginori. This is in some ways a paradoxical outcome. It is remarkable that neither the industrialists, nor the great families or the banks of a Florence-Disneyland dominated by the rhetoric of beauty

sought to buy a private asset: to save and relaunch it into the future. Faced with the paralysis of an entire ruling class, the state has been forced to intervene, eliminating at a stroke the propaganda that views the private sector as the only hope when it comes to supporting cultural heritage. But it is evidently the only possible outcome and one that is of course welcome.

However, the current management of cultural heritage favours the major museums (the so-called "big tourist attractors") at the expense of the lesser, which are undergoing a period of neglect. Objectively, this casts doubt on the possibility of reviving the Museo Ginori and effectively ensuring the study and management of its collections.

For this reason, writing in "Repubblica" on 4 May 2016, I proposed a participatory Foundation put together by the Municipality of Sesto Fiorentino, the Tuscany Region, the Ministry for Cultural Heritage, the holding company that owns the factory and an association of Ginori employees. I think this path may still be possible, and the Municipality of Sesto is ready to follow it. Others that could do so – and it would be a good sign – are Confindustria (which will provide funds to finance the initial operation of the museum), the Fondazione Cassa di Risparmio, which will support the restoration, and the Amici di Doccia, who have invested so much effort into saving the museum.

Those who will certainly do so are the ordinary citizens, who are presently establishing an association that will begin to raise money in order to be a social member of the future foundation. This will, I believe, be the world's first example of a community buying a slice of a museum. It is doing so because it sees its own identity in that of the museum, and wishes to have a say in its management and its projects. This is where the spirit of Doccia's founder, Carlo Ginori, comes to the fore once more. Ginori was someone who courageously built the future, thanks to his love of history and culture.

This exhibition – to which all the authors have worked for free, as a form of personal contribution to the saving of the Museo Ginori – aims to hasten a similar resurrection, and also to lift art-historical research out of that stifling and egoistic self-referentiality that has been plaguing it for some time.

Our hope is that in not too many years, this catalogue will appear on the shelves of a newly revived Museo Ginori busily involved in scientific and teaching activities (and therefore not with just a director, but with a real community of resident researchers), deeply embedded in the daily life of the region of Sesto and a wider Florence, in continuous contact with a Ginori factory full of workers, still active, tied to its land and its history.

In short, the project's aim is still that of building a "happy population … not only to prosper through work, but to be well-educated, honest and cheerful, graced by the fine arts that open the soul".

1 [Lambruschini] 1837, pp. 8–9.
2 Bevilacqua 2017.

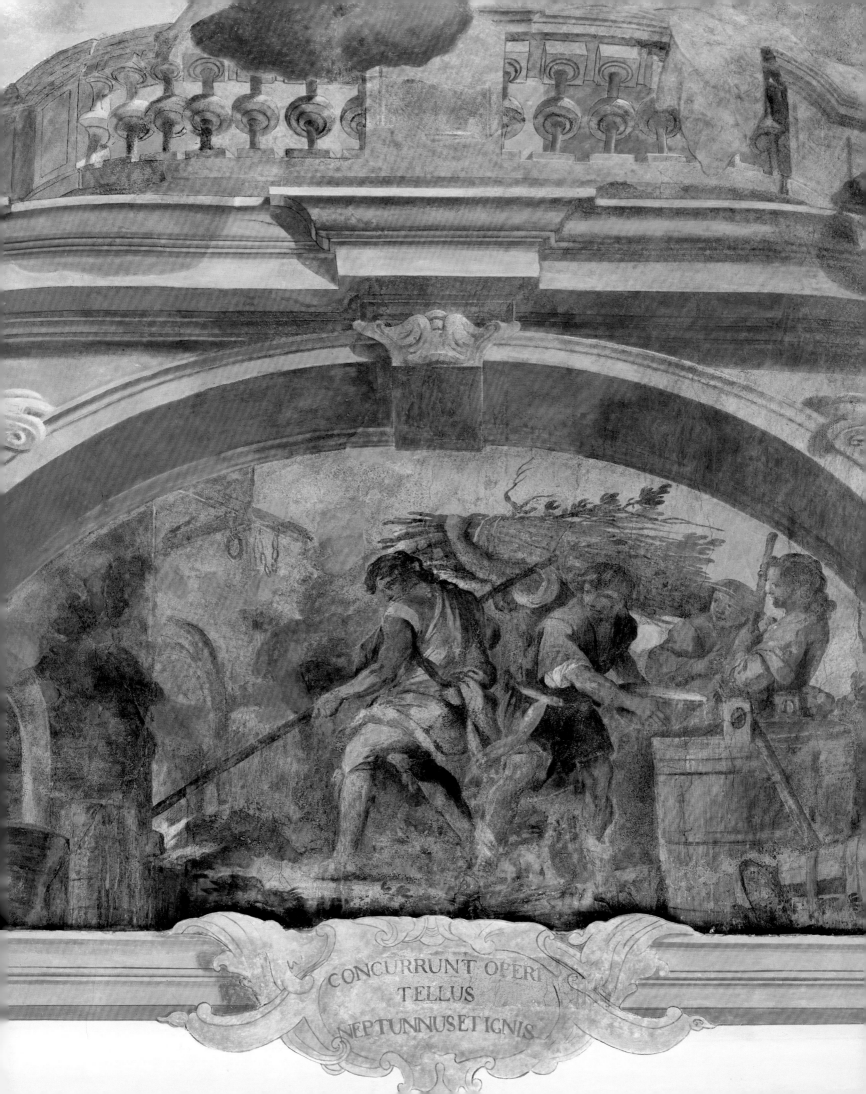

CONCURRUNT OPERI
TELLUS
NEPTUNNUS ET IGNIS

The Museo Richard Ginori
of the Doccia manufactory: history and safeguarding

CRISTINA GNONI MAVARELLI

With its large collection of majolica, porcelain, models, moulds and work tools, the Museo Richard Ginori embraces all the activity of the Doccia manufactory from the time of its founding to the present day and, together with the archives (of the Ginori family and of the manufactory), constitutes the primary source for a knowledge of the types of production undertaken, for an in-depth comparative study, and for the techniques of ceramists in relation to the factory.

Thanks to the didactic activity, scientific studies[1] and exhibitions, the museum – sadly, closed since 2014 – has come to be regarded as a dynamic organism, a point of reference for training the young and a generator of ideas for design, although these aspects will certainly need to be further enhanced by reopening and managing the collections once more.

The museum was born in close physical contact with the factory. Indeed, it was its founder, Marquis Carlo Ginori, who established the first collections, which were displayed in the Villa Le Corti purchased from Francesco Buondelmonti in Doccia as a site for the manufactory of porcelain, starting from 1737.[2]

On the ground floor of the villa, Marquis Ginori created a gallery for the display of the highest-quality artefacts in an attractive setting, enriched by the frescoes executed in 1754 by Vincenzo Meucci with the collaboration of Giuseppe Del Moro. On the ceiling, visitors could see the Allegory of the Four Elements used for the making of porcelain, while the seven lunettes set into the walls – of which four were monochrome with classicising bas-reliefs – revealed the phases of working the clay, also described in the scrolls beneath (fig. 1).[3] This sophisticated setting was destined to become a must for visitors to the factory and intended to highlight the most prestigious 'white gold' works, such as the reduced-scale versions of antique statues from the Galleria degli Uffizi: the *Venus de' Medici*, the *Knife Grinder* and the *Cupid and Psyche*.[4]

The monumental white porcelain fireplace (cat. 15)[5] was built into the gallery wall in 1754, and the adjacent spaces were used to house the models and plaster casts and also the so-called 'Museo delle Terre' (containing samples of clays and minerals collected in glass and blue majolica vases; fig. 2).[6]

The 'models gallery' included a sizeable nucleus of plaster, terracotta, bronze and wax sculptures purchased by the Marquis Ginori to serve as study models and prototypes for porcelain works taken from plaster casts employing a system in use for the execution of bronzes.[7] Carlo Ginori, a member of the Accademia delle Arti e del Disegno, sought to promote artistic techniques by implementing a specific training programme for young artists and integrating porcelain production with that of gemstones and silver (hinges for snuff boxes and so on).[8] It is worth mentioning the significant importance accorded to the museum's department of casts taken from classical engraved gems, made using the collection of gems and medals collected by Ginori in the factory museum since 1741 and used for translation into porcelain with a 'cameo' effect.[9]

The museum gallery and the production in Doccia immediately aroused great admiration among contemporaries, as attested to by the precise description of the complex written by Thomas Salmon in an encyclopaedic work (1757):

> With incredible profusion of money put together for the task, and disposed in several rooms of Doccia – as can still be seen today – a study of various wax moulds, terracotta and plaster works … With these so profitable aids, and with his skill Bruschi trained several students in a brief period, and was able to bring to this height of perfection a considerable amount of Porcelain

1. Vincenzo Meucci, *Allegory of the Four Elements*, fresco, Sesto Fiorentino, Biblioteca "E. Ragionieri", formerly site of the Museo di Doccia

2. Vases from the old Museo delle Terre, majolica and glass, Sesto Fiorentino, Museo Richard Ginori of the Docccia manufactory

> Bas-reliefs, Groups and Statues, expressing in natural and correct proportions not only the rarest ancient Greek Statues collected by the Princes of the Medici House, and those that are preserved in the Imperial Gallery of Florence, but also those that adorn the whole of Rome here and there.[10]

The exhibition created by Carlo Ginori, as has been rightly pointed out,[11] was not laid out as a museum, however, but rather as a private gallery, with a promotional and didactic character. With the successors of the founder (Lorenzo 1758–91, Carlo Leopoldo 1791–1837, Lorenzo II Ginori Lisci 1838–78), and with the increasing reputation of the factory at a European level, the collection was expanded. Thanks also to the accounts in the periegetical literature,[12] the villa became a frequented destination. For example, we may mention the visit of Maria Luisa of Austria, Duchess of Parma, in 1816, and in 1819 that of the Emperor of Austria Francis II, accompanied by the Grand Duke of Tuscany. In 1858, the collection saw the visit of the Habsburg-Lorraine princes, and also of specialists such as Conte Annibale Ferniani of Faenza in 1854, and of Gustav Kolbe, director of the Königliche Porzellan-Manufaktur in Berlin in 1855.[13]

The gallery continued to be enriched with pieces typifying the production of the manufactory, such as the Medici vase of 1851: a refined crater decorated with a view of the Doccia manufactory (figs 3–4).[14]

In 1861, King Victor Emanuel II visited the gallery and manufactory (which was then taken on as an official supplier to the Royal Household) for the Artistic and Industrial Exposition.[15] At the same time, the activity of the factory had diversified with a varied production of everyday objects, as Carlo Lorenzini (alias Collodi) wrote in 1861:

> Work is under way in Doccia on all kinds of porcelain and other earths for use in chemistry, pharmacy and photography, and stoves with refractory tiles are being built … The factory also manufactures porcelain insulators and battery cylinders for telegraphy, labels and nomenclature for plants, for gardening; signs for the names of streets and the numbering of houses, of which there are already several examples in our city of Florence.[16]

With the consequent growth of the plant, equipped with new furnaces and machinery, Lorenzo Ginori decided in 1864 to apply a more rigorous approach to the collections and opened it to

the public under the name of Musei di Doccia, comprising the Museo Ginori and the Museo Ceramico, which included products from other Italian and foreign factories, collected for a comparative purpose. The exhibition, as described in the "Gazzetta di Firenze" of 2 June 1865, was divided into five rooms in hierarchical order: in the first, the most common pieces such as stoves and raw clays used daily; in the second, modern tableware in painted and golden porcelain; in the third, the oldest pieces from the first attempts to the most 'remarkable' pieces, such as the two fruit bowls painted by Antonio Anreiter; in the fourth, "a lovely cabinet containing a precious collection of statues, for the most part of biscuit porcelain"; in the fifth, the frescoed gallery, containing all "the most beautiful and most artistic articles produced in the workshops of Doccia",[17] from bas-reliefs to porcelain statues, from the great lampholder with putti to the neo-Renaissance 'eggshell' majolica chandeliers. The inauguration of 1864, during which the museum was open to the public for fifteen days with "a large and highly select crowd of visitors", was celebrated as "a true artistic and industrial solemnity".[18]

In the 1870s, the museum expanded to allow the inclusion of the majolica production, that underwent a revival in the historicist climate of the post-unification years thanks to Giusto Giusti's chemical discoveries. Among the majolica of naturalistic inspiration, likewise sought-after for the refined manufactured quality of the Pittoria di Doccia, one of the museum's rooms displayed a vase of monumental proportions called 'the Colosso' (175 cm high), decorated with

3–4. Ginori manufactory, Vases with a view of the manufactory (left) and of Villa Ginori in Doccia (right), porcelain, Sesto Fiorentino, Museo Richard Ginori of the Doccia manufactory

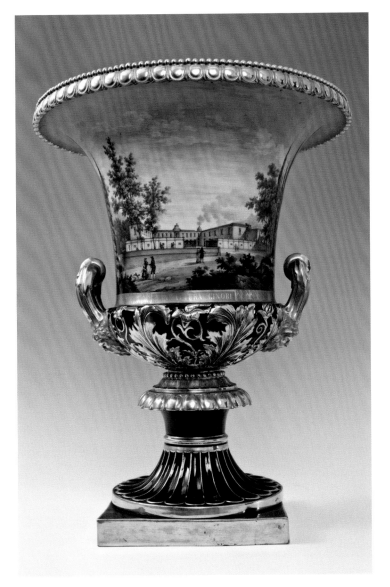
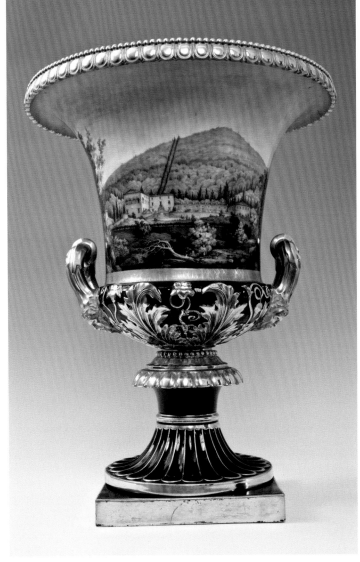

the Fire of the Pampas on the base after a drawing by Giuseppe Benassai, artistic director of the manufactory from 1871. The layout of the collection probably remained unchanged for the most part until the beginning of the 20th century, at which time the views illustrated here were produced (figs. 6–8).[19]

For the training of ceramists and decorators, in 1873 the Marquis Lorenzo Ginori Lisci promoted, together with the City Council of Sesto, the foundation of the local Istituto Statale d'Arte as a Scuola di Disegno Industriale.[20]

Production at Doccia continued at a fast pace, with exports and awards at the Universal Expos following on from each other, from the period of Lorenzo II Ginori (who died in 1878) until the mid-1890s when administrative difficulties prompted the Marquis Carlo Benedetto Ginori Lisci to sell the manufactory to Augusto Richard, owner of a porcelain factory in Milan (San Cristoforo). With the birth of the Società Ceramica Richard Ginori and a renewed organisational structure based in Milan, and with three factories covering the production of all types of ceramics, the 'historical' collection of the museum, still laid out in the gallery and in the spaces of the factory itself, remained the property of the Ginori family, which assigned it on a free long-term loan to the Company.[21]

During the course of the 20th century, the museum continued to acquire the most significant specimens from the factory as a sort of archive, including the extraordinary ceramic artefacts of Gio Ponti, who was the company's artistic director between 1923 and 1930, and 'global' innovator of the pottery production using poster graphics.[22]

Richard Ginori continued to add to the museum for a more complete documentation of Ginori's early production.[23] For the occasion of the bicentennial of the founding of the manufactory in 1935, an exhibition was organised in Palazzo Vecchio with the most representative pieces.[24]

Following the intention of the Marquis Lorenzo Ginori to "transfer the porcelain Museum in his possession at Doccia to his *palazzo* in Florence", the Ministero dell'Educazione Nazionale in 1936 applied the "constraint of important artistic interest" on the museum objects belonging to the Marquis Ginori and to the Richard Ginori company, recognising the historical formation of the collection and also "its current practical utility, still serving as models for the production of the Manifattura Richard Ginori next to the museum" (Decree of 14 February 1936, prot. no. 1182). The measure, accompanied by inventories of all the materials, is emblematic of the deep awareness of the value of the Doccia museum, linked as it was with the factory.

5. View of the Doccia manufactory, chromolithography, Sesto Fiorentino, Archivio Museo di Doccia (on loan to ASFi)

6. Museo Ginori, view of the room with one of the two fireplaces and a bust of Paolo Lorenzini, early 20th-century photograph, Sesto Fiorentino, Archivio Museo di Doccia (on loan to ASFi)

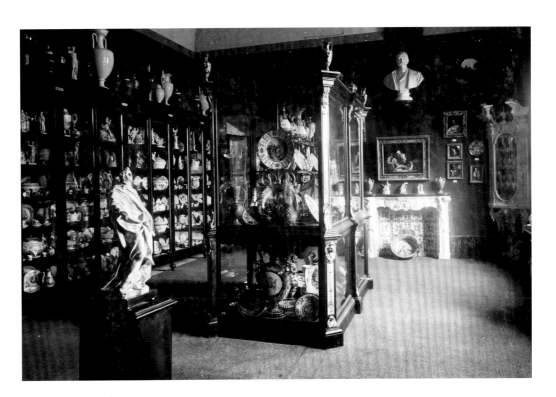

With the outbreak of the Second World War (1941), protective measures were implemented to safeguard the collections: the less valuable artefacts were protected on site, while the most significant group of works of the Società Ceramica and the Ginori family was packed and stored in safety by the Soprintendenza alle Belle Arti of Florence in the villas of Poggio a Caiano and della Petraia. Particular attention was paid to the waxworks, which were in part conserved in wooden cases – similar to the present ones – and restored by the Opificio delle Pietre Dure, where they were stored.

At the end of the war, only the collection belonging to the Richard Ginori company was returned to the Villa Buondelmonti in Doccia in 1948. The historical collection of the Ginori family remained in the premises of the Soprintendenza, while its final destination was arranged: Marquis Lorenzo Ginori sought to re-acquire possession directly in order to display it in the *palazzo* in Florence (as he wrote in a letter of 25 February 1943, to the Reale Soprintendenza delle Gallerie, enclosing a project for the accommodation of the Ceramic Arts Museum at Palazzo Ginori).[25]

In 1950, the Ministero della Pubblica Istruzione issued a decree pursuant to art. 5 of Law no. 1089 of 1939, declaring the Museo Richard Ginori di Doccia, made up of the collections owned by Marquis Lorenzo Ginori and the Società Ceramica Richard Ginori, to be a nucleus of exceptional artistic and historical interest for its "tradition, fame and particular environmental characteristics" (decree of 28 October 1950).

Meanwhile in those same years, in order to adapt the Doccia plant to modern industrial needs, the Richard Ginori firm transferred the production to the new plants on the Sesto Fiorentino plain south of the railway. Now detached from the factory, a move was also proposed for the museum. In 1956, the villa and the whole complex of the manufactory were sold by the Società Ceramica, a fact that provoked a great deal of controversy. A request was sent by the City Council of Sesto Fiorentino to the Ministero della Pubblica Istruzione to place a constraint on the villa Ginori in order to keep the historical porcelain and majolica museum in situ, the museum being "morally linked in a special way to the citizenship of Sesto, which over the centuries, with hard labour and sacrifice, has created such a thriving industry."[26] This request was not granted and the collection of the Società Richard Ginori was moved to the new headquarters in the area adjacent to the factory: the project was entrusted to architect Pier Niccolò Berardi (1904–89) under the direction of engineer Fabio Rossi of the San Giorgio studio (figs. 9–10).

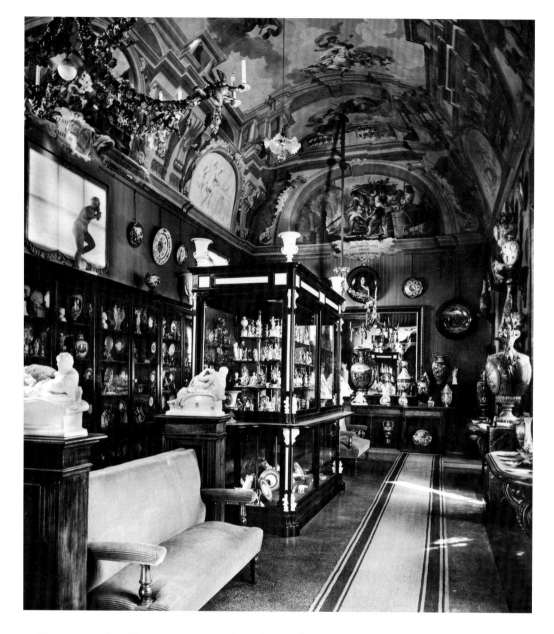

7. Museo Ginori, view of the gallery frescoed by Vincenzo Meucci (Giambologna's *Venus* on the top left), *c.* 1930 photograph, Sesto Fiorentino, Archivio Museo di Doccia (on loan to ASFi)

The museum's collection was reconfigured and then listed by the Ministry of Education in 1962 (Decree of 7 December 1962 issued pursuant to art. 5 of Law of 1 June 1939, no. 1089). After the death of Marquis Lorenzo Ginori Lisci in 1957, following a delicate negotiation with the family in 1962, agreement was reached whereby about three thousand artefacts were sold to the Società Ceramica, while a portion totalling about a thousand works (limited to duplicates and some sculptural pieces such as the *Mercury*; cat. 3) remained with the approval of the Ministry and the Ginori Lisci heirs.

The new museum, inaugurated in 1965, is a reinforced concrete building with brick infill walls, marked by the large Thermophane window wall, conceived as a sort of display showcase of the production in direct relation with the nearby establishment and the city of Sesto.

Concerning the project, we can turn to the architect Berardi's words:

> I thought of this parallelepiped shape like a casket for jewels. I approached the design of the new museum and its numerous functional, aesthetic, technological and service problems, studying a building that, similarly to a large display case, does not compete with the objects on show and was able to resolve the problem with great simplicity.[27]

8. Maria José of Savoy, Princess
of Piedmont, visiting the previous site
of the Musei di Doccia, *c.* 1933 photograph,
Sesto Fiorentino, Archivio Museo
di Doccia (on loan to ASFi)

On the ground floor there is a long longitudinal corridor, which was divided in 2003 with plasterboard elements to create offices, the archives and the library, together with a storeroom at the end. Via two specular staircases, one reaches the first floor where there is the exhibition gallery, with two small rooms at the end.[28]

The furnishings were also designed by the architects themselves: from the showcases with the hermetically sealed crystal cabinets, all equipped with their own lighting, to the chairs and tables for the rest and study areas.

The museum project was drawn up by a committee comprising Gino Campana, director of the manufactory, Leonardo Ginori Lisci, Elena Maggini Catarsi, appointed curator of the Museo di Doccia, by the historian of Florentine late-Baroque sculpture, Klaus Lankheit, Giuseppe Liverani, who at the time was director of the Museo Internazionale delle Ceramiche in Faenza and a collector, Roberto Bondi.[29] A chronological itinerary was created by dividing the history of the manufactory into the periods corresponding to the owners: the five historical periods of Doccia corresponding to the years of management by the Marquis Ginori, the birth of the Richard Ginori company, the 20th century with Gio Ponti (1923–30) and industrial design. For reasons of space, the sculptural sculptural models in plaster and the so-called ceramic museum were not displayed. The chronological itinerary, implemented in 1965, was subsequently supplemented with thematic sections (techniques, brands, distinguished buyers, oriental influences, etc.). About three thousand exhibits were on show out of a total holding of over nine thousand pieces.[30]

On the ground floor, the vases of the Museo delle Terre, a selection of majolica and 19th-century plaques, lithophanes and some examples of electrotechnical and chemical laboratory porcelain, are displayed in vitrines. There are also two elaborate carved wood cabinets of eclectic taste, formerly part of the display in the Villa Buondelmonti. In a room at the end of the first floor, the important and rare collection of waxworks are displayed. In the large gallery, the chronological itinerary goes from the large sculptures by Bruschi to the periods of the later Marquises Ginori, while a thematic section is dedicated to classical models, including lead bas-relief plaques, and a

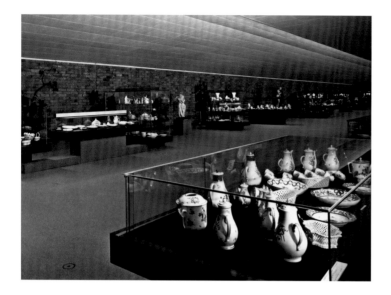

selection of 18th-century sulphur casts of gemstones and cameos, partly preserved in the original rosewood trays.[31] The room at the other end holds a selection of pottery designed by Gio Ponti: from the majolica plates of the series entitled "Le mie Donne", to archaeological-style urns in porcelain, 'prospect' pots, and the ironic hands with sculptural elements for centrepieces made for Italian embassies. Finally, on display in a showcase in the gallery are the porcelains of the 1940s and 1950s including the important specimens created by Giovanni Gariboldi, a collaborator of Gio Ponti since 1928, and a designer at Ginori for over forty years.

In consideration of the link between the collections and the specially designed building, in 2012 the Ministero per i Beni e le Attività Culturali (Ministry for Cultural Affairs) issued a decree (pursuant to art. 10 of Legislative Decree no. 42/2004) restricting the collection, archive and museum library in its entirety to the container, recognised along with the furnishings as being of cultural interest. Accompanying the decree was an updated inventory containing all the artefacts, including a nucleus of models and moulds currently in the factory, subdivided into seven categories: art-historical wares (waxes, bronze casts, works from the Doccia production and the so-called comparative "ceramic museum"), the Museo delle Terre, plaster casts, sulphur casts of cameos and medals, fragments and positives of historic plaster moulds, engraved metal plates, and chromolithographic plates used by the in-house laboratories to make prints for decorating objects. The inseparable set of articles has been recognised as culturally significant, indicating a "unique complex in terms of antiquity, rarity and typological variety". The assemblage is aimed at documenting the Doccia manufactory's activity over almost three centuries, its production processes, its history of the arts, of collecting, of technique, and of the company, from the Grand Duchy of Tuscany to the present day. Considering the large quantity of artefacts, it is permissible to "rotate the displays so long as the close connection between the building and the collection is maintained".

Richard Ginori's paper archive has also been registered by the Ministry of Cultural Affairs as being of great historical interest with restrictions enacted initially in 1979 and then in 1999. Finally in 2012, it was declared indissociable from the building and museum in order to secure the "memory of the company's production" and to maintain the integrity of the whole, which, precisely because of the comprehensiveness of the documentation of this kind of activity, constitutes an extraordinary case in the international context.[32]

With the bankruptcy of the proprietary companies and the closure of the museum in May 2014, as a result of lack of maintenance, the building, furnishings and conservation of the most delicate materials (archive and collection of waxes) were at risk. The general conditions are still worrying today even though some urgent measures of a "provisional" nature have been undertaken, as requested by the Soprintendenza responsible for the area.[33] The roofs have been

9–10. Internal and external views of the new site of the Museo di Doccia, designed by Pier Niccolò Berardi and inaugurated in 1965, Foto Villani, Archivio Museo di Doccia (on loan to ASFi)

repaired and thanks to the fundamental work of the Associazione Amici di Doccia and the Soprintendenza Archivistica, in November 2015 the archive was transferred to the Archivio di Stato of Florence. Additionally, the waxes beset by mould were partially restored and moved in July 2016 to the more climatologically stable spaces of the factory.[34]

The museum's condition was very delicate and complex after two unsuccessful auctions, but is now seemingly at a turning point: the Minister for Cultural Affairs has announced its acquisition by the state, which will hopefully be completed by summer 2017. Now there is also talk of a foundation to develop a management plan to ensure the restoration of the building, undertake the necessary modifications, and reopen the collections, thereby reuniting all the components of the oldest Italian company museum so as to ensure full accessibility to its entire heritage in the most efficient way possible.

Special thanks to Oliva Rucellai, director of the Museo della manifattura Richard Ginori of Sesto Fiorentino from 2002 to 2014, together with Rita Balleri for their generous advice in the preparation of the text and for the indispensable collaborative work provided in drafting an inventory of the museum's artefacts for the ministerial constraint of 2012.

1 For an essential bibliography on the manufactory and the museum, see the bibliography mentioned in this volume.

2 Regarding the transformation of the villa into manufactory, see Mazzanti 2012; concerning the early activity of the Ginori manufactory, see Ginori Lisci 1963, pp. 23–39; Biancalana 2005; Serafini 2008.

3 The following texts appear in the lunettes of the scrolls: INDURARE JUVAT | EX LUMPHIS | ET CERNERE CRIBRO; CONCURRUNT OPERI | TELLUS | NEPTNUS ET IGNIS; SOLLECITAT TAURUS | DIVERSO | HIC VOMERE TERRAM. See Lenzi Iacomelli 2014, pp. 84–5, 213–14, cat. 67.

4 See Ginori Lisci 1963, pp. 58–64; Visonà 2001; Firenze 2003; Zikos 2005ᵃ; Winter 2005; Biancalana 2009, pp. 49–50.

5 In this catalogue, see also the essays by Marino Marini and Cristiano Giometti on pp. 69–75.

6 A manuscript register with notes about the colours, provenance and the experiments carried out during firing is in the possession of this museum, and was assembled from 1738 onwards and originally placed on wooden pedestals in the gallery. Subsequently added to, it constitutes a document that is unique.

7 Concerning this subject, in this catalogue see the essay by Dimitrios Zikos on pp. 45–67.

8 See Visonà 2001, pp. 55–6.

9 See Biancalana 2009, pp. 49–50; D'Agliano 2008; Balleri 2014ᵃ, p. III.

10 See Salmon 1757, pp. 89–98; the quotation is on pp. 92–3.

11 See Bettio, Rucellai 2007, p. 19.

12 See, for example, Cambiagi 1790, cited in Casprini 2006, p. 48.

13 See Ginori Lisci 1963, pp. 104, 115, 135, notes 132–3, 136, note 153; news of the visits drawn from the Visitor's book conserved in the Richard Ginori manufactory archives.

14 See Bettio, Rucellai 2007, p. 74.

15 See Ginori Lisci 1963, p. 116.

16 Lorenzini 1861, p. 19; see Sesto Fiorentino 2001/2005. Carlo Lorenzini was the brother of Paolo, director of the Doccia manufactory from 1854 to 1891. Regarding the production for the domestic and industrial sectors, see ibid.

17 The description of the rooms of the museum is published in "Gazzetta di Firenze", 2 June 1865, quoted in La manifattura 1867, pp. 36–7, note 8; the quotation is on p. 37.

18 Ibid., p. 28.

19 See Balleri, Rucellai 2012.

20 See Addabbo [after 2008], p. 34.

21 See Antonini 2001.

22 See New York 2007, p. 87. Regarding the work of Gio Ponti and the Società Ceramica Richard Ginori there is ample literature, including the recent Giovannini 2009 (with previous bibliography) and Frescobaldi Malenchini, Giovannini, Rucellai 2015.

23 See Ginori Lisci 1963.

24 See Firenze 1935.

25 The information concerning the safeguarding of the collections during the Second World War and the negotiations between the Marquis Ginori, Richard Ginori and the Soprintendenza alle Gallerie is taken from the correspondence kept in the Archives of the Ufficio Vincoli Beni Mobili of the Soprintendenza Archeologia, Belle Arti e Paesaggio for the metropolitan city of Florence and the provinces of Pistoia and Prato.

26 Session of the City Council of 5 December 1956. Copies of the minutes of the Town Council of Sesto Fiorentino are kept at the Ufficio Vincoli Beni Mobili of the Soprintendenza Archeologia, Belle Arti e Paesaggio for the metropolitan city of Florence and the provinces of Pistoia and Prato. As eloquent testimony of the civic attachment of Sesto Fiorentino to the Ginori manufactory, it is worth mentioning another passage from the minutes of the Town Council of Sesto: "In recognition of how Sesto Fiorentino has, in more than two centuries of manufacturing activity in the field of porcelain and majolica, given economic impetus and prestige to Italy, and how, in the development of this, it has created an artistic tradition that cannot be cancelled out because it still lives in the spirit and the flesh of generations and generations".

27 The quotation is from Il museo di Doccia 1965, unnumbered pages. Since 1965, the museum's directors have been: Elena Maggini Catarsi (1965–92), Elisabetta Epifani (1994–8), Giulia Ligresti (1999–2001) and Oliva Rucellai (2002–14).

28 The building covers 2374 m² over two floors: 1195.8 m² on the ground floor; 1178.2 m² on the first floor. The surrounding property covers 18,725 m²; see Boccia 1965. The building has been classified as modern architecture 'of high quality' in the survey undertaken by the Tuscany Region; see L'architettura 2011, p. 67.

29 See Liverani 1967, p. 1 (not numbered).

30 See Museo Richard Ginori 2003/2008, pp. 5–6.

31 Ibid., p. 23; D'Agliano 2010; for the chronology of the acquisitions of the casts, see Digiugno 2011.

32 See Bettio, Rucellai 2015.

33 See the correspondence regarding bankruptcy proceedings from the Soprintendenza Belle Arti e Paesaggio for the metropolitan city of Florence and the provinces of Pistoia and Prato, dated 8 March 2016 (prot. no. 4441)

34 On this point, see Rossi 2016.

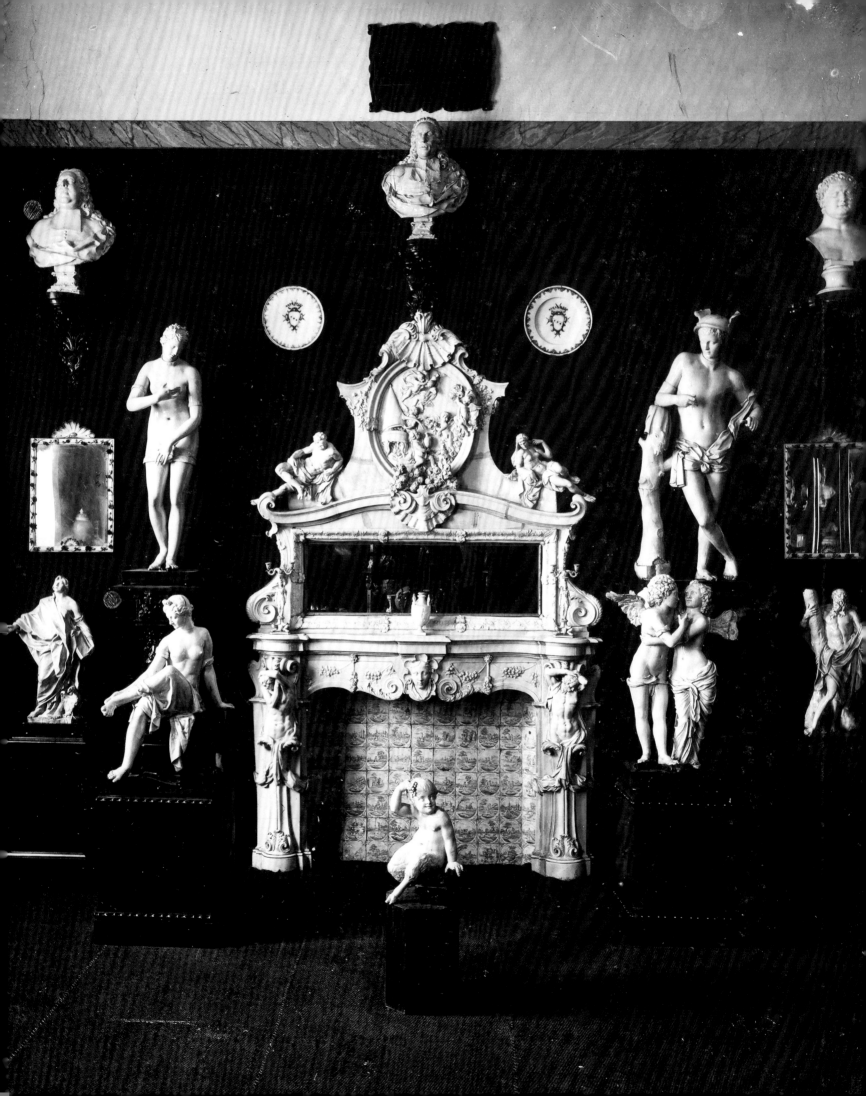

Carlo Ginori and his progeny of statues: an "Italian work"

TOMASO MONTANARI

> Porcelain is a material which likes to give way,
> and joining different pieces only serves to exacerbate the problem,
> since each joint is intrinsically weaker … Any potter knows this,
> but the dream of making something enormous in porcelain
> seems to exercise a constant attraction over time.
>
> Edmund de Waal, *The White Road. Journey into an Obsession*

"The same Marquis Carlo expressly built a large room in Doccia in which to place a collection he had created of models of the most precious ancient and modern sculptures: and he promoted the study of design and painting in every way, so that in their ornaments the porcelains of Doccia should reveal that they were *Italian work*."[1] These are words written in 1837 by Raffaello Lambruschini to remember the recently deceased Marquis Leopoldo Carlo Ginori Lisci, who had inherited from his grandfather Carlo – the founder of the manufactory – not only his name, but above all his cultural awareness.

And Lambruschini is precisely correct, because it had been the absolute centrality of the sculptural models and the study of drawing and painting that had made the Doccia enterprise – started exactly one century earlier, in 1737 – an "Italian work". The Ginori kilns had been used not only to produce highly popular *chicchere* ("treats") – cups, coffee pots, entire table services, dishes and tureens – but also a whole progeny of statues: human figures in which the finest expression of the great history of Italian art continued formally and spiritually.

This was by no means an obvious outcome. When one of Ginori's Viennese interlocutors had congratulated him on the founding of the manufactory, he had written (on 25 November 1737): "j'espere que dans 5 ou 6 ans on ne mangera plus à Florence qu'en porcellaine à la Ginori".[2] This was the expectation, this the ambition, one that naturally Carlo's entrepreneurial spirit shared deeply. But that was not all: something else would also emerge from all that work, from that research and intense international diplomacy.

In those same years, the most discerning Italians regarded the objects that came out of the Saxon and Viennese kilns with aesthetic and even moral condescension, matched only by their technical admiration. This clearly emerges in this superb passage from a letter written by Francesco Algarotti to Lord John Harvey on 30 August, 1739:

> In Frankfurt an der Oder, we crossed the river and came to Lusatia, a country full of woods and famous for its beautiful tablecloths, and then arrived in Dresden after seven days of walking. From which my Lord can deduce that in these countries the post does not hasten as in France or Italy. Dresden is not such a remote and uncommon place to make it necessary to describe it. I will point out that here all is cleanliness and that the elegance of the court is very great. And I am sure her ladyship's eyes would have a fine feast on the fine enamels, the many great diamonds of the king, the excellent china, both Japanese and Chinese that are kept in a palace called the 'Palace of Holland', which will one day be covered with porcelain tiles, in the manner of some Chinese buildings. Not to mention the embroidery work which in this city is made white and so famed that in the world of ladies the name of Dresden is held in high esteem. Some would like a quantity to be sold at a lower price, as occurs in Marseille, in order to increase the extent

1. The monumental fireplace and the large statues in the collection of Museo Ginori, in a photograph taken *c.* 1930, Sesto Fiorentino, Archivio Museo di Doccia, miscellaneous album

29

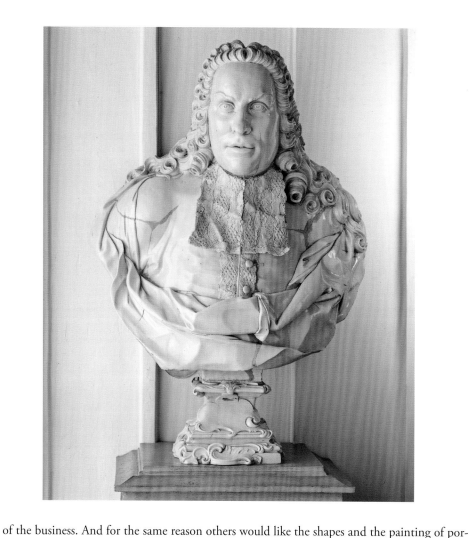

2. Gaspero Bruschi, *Portait of Marquis Carlo Ginori*, porcelain, Florence, Ginori collection

of the business. And for the same reason others would like the shapes and the painting of porcelain produced in Saxony to be of the highest quality. They turn up their nose on seeing those tiny miniatures, those gildings, and those human figures with moustaches and clothes steeped in various colours, those heavy shapes that do not follow the rules of lightness in what should all be lightness, they say. What Meissen would need is one of those French modellers working in the Chantilly factory. It would not be amiss if they were to copy much more than they do the ancient porcelain of Japan and China, whose shapes have something beautiful and exotic about them, like the animals and the plants that come from those places. But above all, I think they would benefit from the expanding business of these objects, if they were to imitate ancient subjects. What beautiful vases they could make! How beautiful it would be to have wonderful, white porcelain with some bas-reliefs, a set of medallions, statues of emperors and philosophers, and even the most beautiful statues known, such as the Venus, faun, Antinous, Laocoon on a small scale! I think all of England would like to decorate their salons and *desserts* with them. Finally, I am not aware if you know, my Lord, that we owe Saxony's manner of making porcelain to the obsession with making gold. Indeed, the present king's father delighted in alchemy and had a famous alchemist named Boettcher come from Berlin. The latter, looking for gold, discovered porcelain which, we can say, is as valuable as gold.[3]

Francis Haskell and Nicholas Penny established the link between the Ginori manufactory and these lucid remarks by the most intelligent expert in 18th-century Italy.[4] Evidently, Algarotti considered the very colourful German production to be in bad taste – kitsch, we would say today – and he thought of porcelain just as someone in the late 16th century would have thought of bronzes: as portable reproductions of the most famous classical statues plus a few

modern masterpieces, the *nobilia opera* that all Europe loved and knew through prints, casts, copies and marble and bronze reductions. But while bronze was classical by definition, the 'novelty' of porcelain and its exotic origin required time before forging a bond with the legacy of classical antiquity. And this encounter was the contribution made by Italy: indeed, by Carlo Ginori.

Of course, he did not succeed alone in changing the production of porcelain that had spread to the courts throughout Europe, and in 1763 the most Italian and the most 'antique' of the Germans – Johann Joachim Winckelmann – was able to counterpose the good taste of the colourful vases of the ancients with "all the precious porcelains, that nowadays adorn the apartments of the rich. These have no other merits than the beauty of the matter, and nothing ever seems to be remarkable and instructive; being mostly ridiculous and formless figures, from which originated that frivolous and incoherent taste that has spread so far and wide".[5] The analysis could not be cruder and clearer: porcelain as a useless trinket for ignorant rich people, and as an outburst of intimately anti-Italian Rococo taste. If only one significant exception could mitigate this judgment, that exception was Carlo Ginori and his very Italian company.

A sense of national competition was not, in those years, confined to the field of porcelain alone. Haskell emphasised the 'patriotism' of someone like Algarotti who in 1749 wrote to his brother Bonomo to encourage the Venetian sculptor Giovanni Marchiori, who was working on some figures for a Berlin church, to work well "for the honour of Italy, because here they generally believe 'hors de Paris, point de salut!'".[6] But there is no doubt that white gold, with its

3. Ginori manufactory, Gaspero Bruschi, *Knife Grinder* (after the Antique), porcelain, Sesto Fiorentino, Museo Richard Ginori of the Docccia manufactory

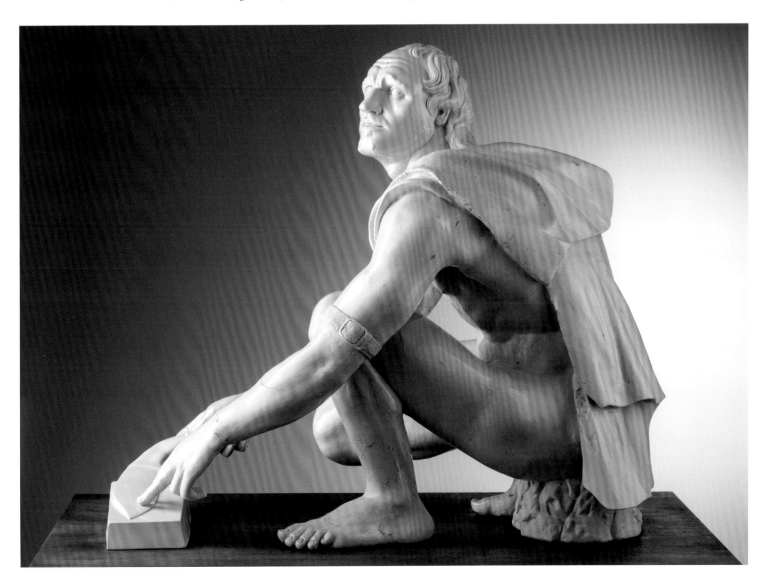

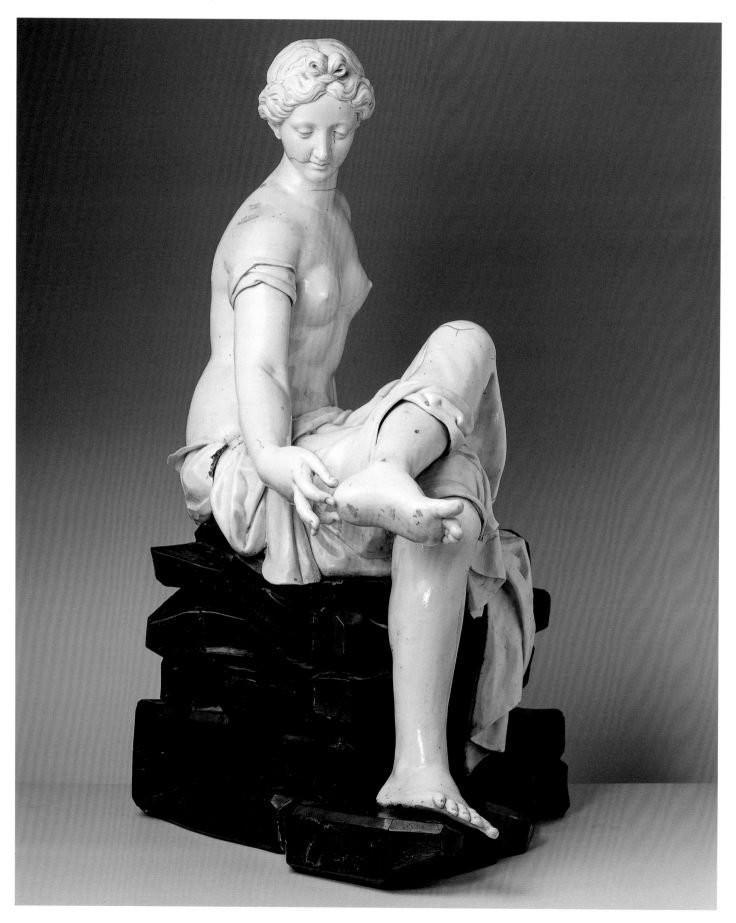

combination of German technique and French taste, had made Italy a consumer nation, not a producer: a state of affairs unprecedented in matters of art.

Now the Florentine Carlo Ginori had, at that very moment, very particular reasons for overturning this state of affairs, and resurrecting an Italian primacy.

The intolerance shown by the Electress Anna Maria Luisa de' Medici in 1737 (when Gian Gastone died, and Carlo founded Doccia) during the transfer of power to the emissaries of Lorraine is well-known: these were "starving people", from whom "little is to be hoped in terms of courtesy and attention".[7] In this contemptuous judgment, there was the awareness of the cultural inadequacy of the new rulers of Florence and of the Grand Duchy. At the end of that same year, the Electress wrote to Marchese Rinuccini, with a scathing criticism of their hanging their own pictures over the frescoes in Palazzo Vecchio, damaging these and yet careless of their own works: "I understand that the pictures hung in the painted rooms of Palazzo Vecchio were among those brought from Lorraine and so placed at risk the frescoes, but the Lorrainers care little and have no means to preserve that which they have brought and will ruin that which they have found".[8] And it is evident that this contrast is not only between Florentines and those of Lorraine, but between Italians and foreigners generally: or in other words, between the civilised and barbarians.

This was the climate in which the *Patto di Famiglia* (Family Pact) developed, with its crucial third article bequeathing to Florence all that we now would call the public portion of the dy-

4. Ginori manufactory, Gaspero Bruschi, *Venus Removing a Thorn* (after the Antique), porcelain, Florence, Ginori collection

5. Hellenistic sculpture, *Seated Nymph*, marble, Florence, Galleria degli Uffizi

6. Ginori manufactory, Gaspero Bruschi, *Venus de' Medici* (after the Antique; cat. 2), porcelain, Sesto Fiorentino, Museo Richard Ginori of the Doccia manufactory

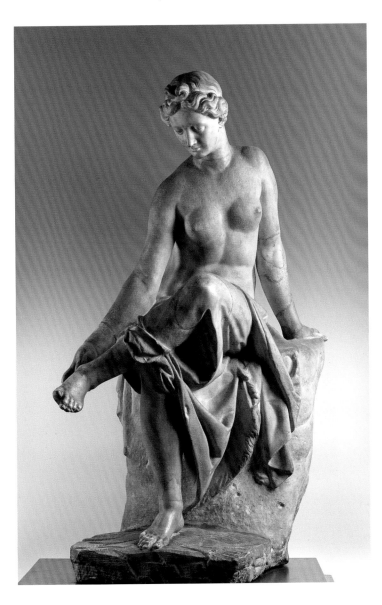

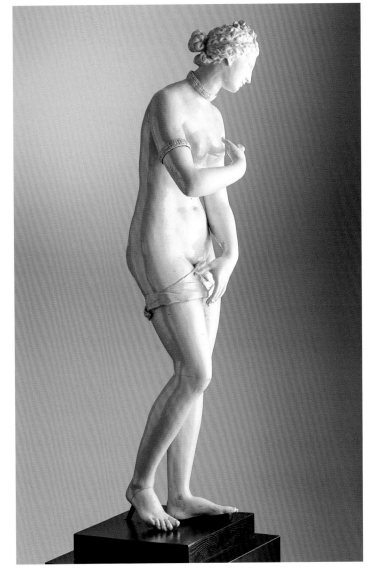

nasty's historical and artistic heritage: a climate in which Florentine cultural, and first and foremost figurative history was systematically scanned to the point of acquiring a programmatically national character. The year 1741 saw the publication of the *Ragionamenti istorici dei gran duchi di Toscana della real casa de' Medici protettori delle lettere, e delle belle arti* in which Giuseppe Bianchini exalted the "ancient legacy" of the "protectors of letters and fine arts" through which, "not only Italy, but all Europe has become more cultured and more learned".[9] Such praise applied to the Medici (with what far-sightedness!) that which Voltaire would a little later write about the papal government:

> The springs and minute circumstances of politics sink into oblivion; while wise laws and institutions, the monuments produced by the arts and sciences, continue forever. Of the immense crowds of strangers that now travel to Rome, not as pilgrims, but as persons of taste, hardly one takes pains to inquire anything concerning Gregory VII or Boniface VIII. They admire the beautiful churches built by a Bramante and a Michelangelo, the paintings of a Raphael, and the sculptures of a Bernini; if they have genius, they read the works of Ariosto and Tasso, and revere the ashes of Galileo.[10]

What directed the eye towards broader and more consoling horizons was a rather depressing series of events, as the memorialist Squarcialupi noted on 4 October, 1737: "the old tapestry manufactory was removed and thus all those excellent workers dismissed, Likewise all the workers in the Galleria were put on half pay, and some were dismissed".[11] The first steps of the Lorraine government seemed to be set on dismantling the centuries-old Medicean system of artistic production, breaking the link between the dynasty and patronage celebrated by Bianchini.

7. After Massimiliano Soldani Benzi, *Sacrifice of Jephthah*, plaster with traces of colour, Sesto Fiorentino, Museo Richard Ginori of the Doccia manufactory

8. After Giuseppe Piamontini, *Sacrifice of Isaac*, terracotta, Sesto Fiorentino, Museo Richard Ginori of the Doccia manufactory

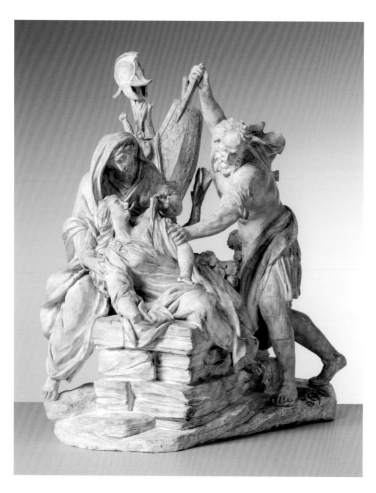

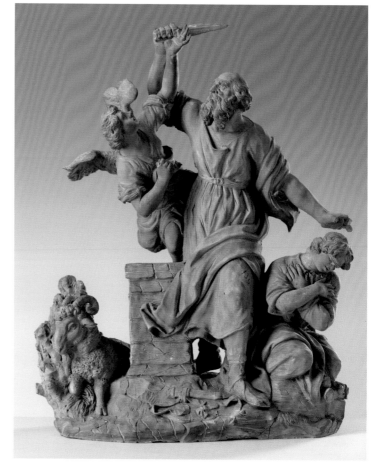

In the spring of the following year – when the Doccia kilns were producing their first hesitant results – a table, rug and chairs were brought to the Galleria degli Uffizi "for the Senators who have to watch the inventory being made".[12] Thus Carlo Ginori as senator was dragged by his own public role to be a direct witness to the capitulation of an unrepeatable artistic season that was now clearly and formally ended. This was almost a handbook on art history and taste to be delivered to the rest of humanity, and to future generations, possibly by translating it into porcelain.

It was precisely in this unusual state of affairs in Florence that we should seek the underlying motives of Ginori's enterprise, those that relate to the history of culture. The marquis clearly wanted to guarantee a continuity, at least on a symbolic level: just as they were closing the Medici manufactories in the gallery, other manufactories opened in Doccia. This was a dynastic consciousness which had some bearing on the family origin of Carlo's wife: she was a Corsini, a representative of the only Florentine family that – especially due to her being a member of the Pope's family at the time – could prove at least a cultural continuity with the enormous prestige of the Medici family.

One detail perhaps more than any other reveals the pro-Italian motivation for Doccia. The first to take advantage of the partial decommissioning of the grand-ducal workshops by the "Lorrainers" was Charles III, who, in order to be recognised as king of Naples, had to forgo the right of succession to the Grand Duchy, but "he always considered himself heir to the Medici: not able to be so physically, he nevertheless considered himself their spiritual imitator, incorporating the arms of the ancient Grand Duchy into his own coat-of-arms".[13] In fact, already around 1737 Charles founded a *pietre dure* workshop in Naples with "craftsmen who had worked in the famous Gallery. The director of this handful of Florentines in the Bourbon capital was Francesco Ghinghi, a student of Giovan Battista Foggini".[14] In 1745, Carlo Ginori also opened a *pietre dure* workshop alongside his porcelain manufactory, which produced lovely *bagatelles* such as tobacco

9. After Agostino Cornacchini, *Judith with the Head of Holofernes*, terracotta, Sesto Fiorentino, Museo Richard Ginori of the Doccia manufactory

10. After Agostino Cornacchini, *Judith with the Head of Holofernes*, plaster, Sesto Fiorentino, Museo Richard Ginori of the Doccia manufactory

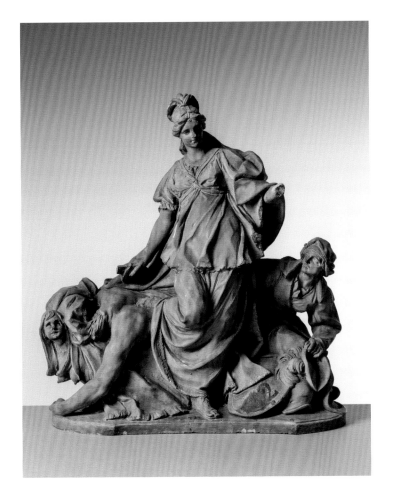

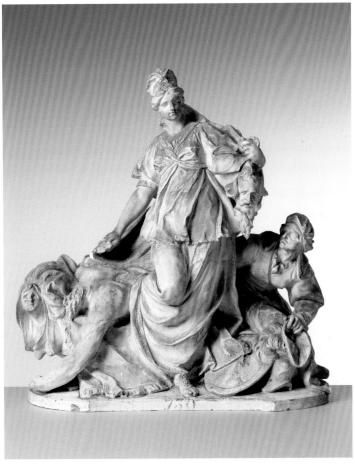

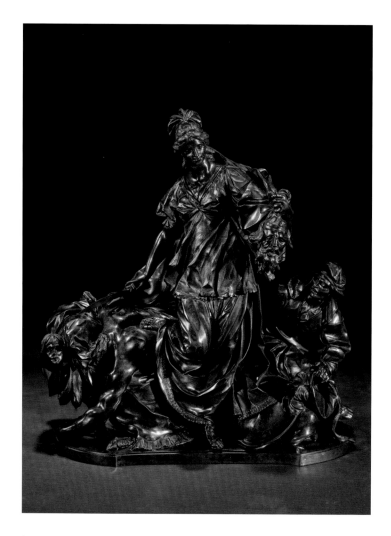

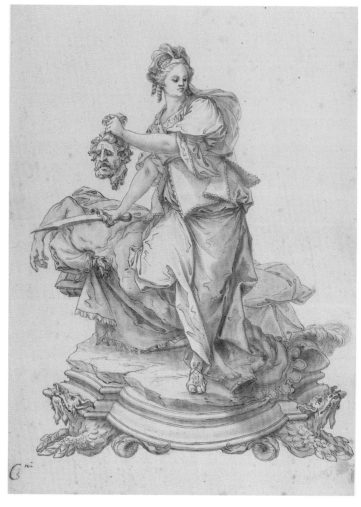

boxes, but also large tables (two of which, for example, sold to the king of Prussia): this was an explicit sign of continuity with the Medici tradition. Thus, just as the Electress was gradually disappearing from the world stage, focusing mainly on the great dynastic pantheon of San Lorenzo, it was above all Carlo Ginori who gathered the standard of the centuries-old Florentine ability to be universal, drawing on its specific artistic and cultural identity. His genius was to realise that this good old wine could be poured into new bottles, and namely that the forms and figures that populated the Medici collections, and the Florentine art tradition generally, could return to live in porcelain: a new material, and unknown to the history of Italian art, even though 'foreseen' in some way (in Renaissance Florence no less) via the glazed terracotta of the Della Robbia dynasty.

The lack of a complete edition of Carlo Ginori's correspondence and accounts between 1737 and his death in 1757 – and also the fragmentation and the marked discontinuity of the scholarly bibliography in terms of quality which has nevertheless highlighted some important passages[15] – do not yet allow us to write a true story of the birth of porcelain sculpture at Doccia; however, we can discern the main features of this extraordinary cultural enterprise.

After five years of hard technical work on the 'arcane' or secret aspects of porcelain manufacture, in 1742 the manufactory was ready to start work. But to produce what?

At this point a choice had to be made, and Ginori did not turn to a ceramic and majolica specialist, nor to a painter, but to a sculptor: Gaspero Bruschi, a pupil of Girolamo Ticciati who worked on monumental sculpture (such as the great triumphal arch at Porta San Gallo, which Carlo Ginori had suggested be erected in anticipation of the arrival of the new Grand Duke Francis I, in Florence). It was not an obvious choice but one that opened the door to the innovative presence of the human figure in porcelain production.

11. Agostino Cornacchini, *Judith with the Head of Holofernes*, bronze, Birmingham, Museums and Art Gallery

12. Agostino Cornacchini, *Judith with the Head of Holofernes*, pen and grey ink with wash, Birmingham, Museums and Art Gallery

The second step was less obvious, and of even greater consequence: between September 1743 and December of the following year, Ginori acquired (in several phases, and through different intermediaries) a large number of the moulds made by the last great Florentine sculptor, Massimiliano Soldani Benzi, who had died in 1740.[16]

The significance of Ginori's project lies in these initial moves: that of translating into porcelain a repertoire of forms and inventions that was in some way closed and completed. Ginori's subsequent choices confirm this reading. Even when (in 1741)[17] he turned not to the heirs of a now closed workshop but to the owners of a still active, glorious *atelier* (that of Vincenzio Foggini, the son of Giovan Battista), he did so not to commission new inventions designed specifically for porcelain, but instead to hoard previously created figures with other purposes in mind.[18] And in this he was driven by a view of 'inventorising' – that is to say in some way summarising knowledge of – the Florentine artistic tradition that hung over Florence at the end of the Medici era.

It is this summarising attitude that marks the two main aspects of porcelain sculpture produced in Doccia in the first twenty years of activity: that of the single monumental figures reproducing the famous ancient statues of the Medici collections, and that of the small and complicated Baroque *console* groups.

The first is perhaps what differentiates Doccia from any other European porcelain manufactory, for the great Meissen animals appear very different to these classical figures, which are about a metre high. The *Mercury* was probably already made in 1744 (Ginori collection, cat. 3), followed in 1745 by the *Knife Grinder* (fig. 3), still in the Museo Ginori today, and in 1746 by the *Ganymede* (Paris, Musée Jacquemart-André). In February 1747, these were followed by the group of *Cupid and Psyche* (Museo Ginori) and in May by the *Venus Removing a Thorn* (Ginori collection; fig. 4) and perhaps the *Venus de' Medici* (Museo Ginori, cat. 2). The *Dancing Faun* (Turin, Palazzo Madama) must also have been made before 1748.[19] This was a highly select museum, and a Florentine one too (because only later would Carlo and subsequently his son look to the statues of Rome): all the originals that these great porcelain works reproduced were to be found in the Grand Ducal galleries. And it is possible to note (as it would seem has not been done before), that all these statues are illustrated in the engravings of the *Museum florentinum exhibens insignioria vetustatis monumenta quae Florentiae sunt* dedicated in 1734 by Anton Francesco Gori to the dying Gian Gastone.[20] And the fact that the contrasting presence of Benvenuto Cellini's *Ganymede* appears both in Gori's volume and in the first nucleus of works made in Doccia, suggests that this publication was the main source of inspiration for Carlo Ginori.

On the other hand, sculpture had never undergone such a scale of production, and the very strong technical capacity had to now be matched with an equally vivid imaginative one. Precisely when Ginori set up the manufactory, Algarotti found himself no longer vaguely wishing but eagerly anticipating to a concrete programme for a series of porcelains: a large table service for Maria Theresa of Austria; in other words, for the reigning Grand Duchess of Tuscany, the commission for which had come from Nikolaus Joseph Esterházy von Galántha, the Hungarian resident at the court of Dresden (Maria Theresa was also Queen of Hungary). It is unclear whether the invitation should have been sent to Dresden – i.e. to Meissen – or Vienna, and the Du Paquier manufactory. This is the proposal of Algarotti, written on Christmas Eve of 1742:

> I could not spend a better day than this, which I used to a large extent in fulfilling your requests. Here then, *signor conte*, are the subjects for the porcelain statuettes that are to form the *dessert* of our august sovereign [Maria Theresa of Austria], which will be inspired in the pose and soul, so to speak, by the story of the princess herself. Four rivers personified, the Danube, Po, Moldava and Scheldt, lying on boulders half-covered in grass, raising their eyes, with some in the act of giving thanks and some asking for grace. The Danube can be symbolised with a pennon bearing a crescent moon; the Po with a handful of wheat ears and a trophy; the Moldava with an image of Saturn, God of mines; and the Scheldt with some piece of military architecture. A Pallas Athene with a face resembling as far as possible the queen, with the Gorgon depicted on the shield, seated on a grand eagle. The eagle will bear a bolt of lightning in its claw, and, stretching a wing, will

cover a Hercules in a cradle throttling the snakes; it is with this emblem that the learned *signor* Bertoli has depicted the infant archduke in his medal.

Several groups of soldiers, one in the act of surrendering its arms, another kneeling in supplication, with some figures looking back, others lying on the floor, one well-combed, another uncouth, one with a military uniform, another half naked. And as for reference to the forms of the weapons and types of military clothing, Trajan's column can provide an excessive number of examples.

Pannonia with the flaps of the mantle frayed and covered with fur coat, crowned with vine leaves woven with laurel, with rich spoils at the feet, and in the act of receiving the weapons from the hands of Amor.

Austria with a skylark lying at its feet (I believe this be its sign), with a spear in hand, and a zephyr alongside, which will gently ruffle her garment.

Britannia with her naval crown, and with one foot over a ship armoured with three rams, and behind her Mercury. In addition, a prism and a tablet on which the orbits of planets and some comets are marked could be added to her feet; for, as you know, these are the emblems of the English philosopher.

Italy crowned with towers, with at her feet a cornucopia, sword, lute, and various instruments for the fine arts taken from antiquity. With her left arm, Italy should lean on a cliff, while the other arm rests, almost to point out that the old valour is not dead yet.

These various statues, arranged here and there on the panel, can adorn a *dessert*, and they can also, grouped together, form the main centrepiece in the middle of the table. The four rivers in a circle; the Pallas Athene in the middle, and highlighted with around her the various groups of soldiers, together with Pannonia, Austria, Britannia and Italy, after having added palms, laurels, depictions of towns and castles captured, according to what looks best.

In addition to this, at the sides and around the central piece one could place other small statues here and there in order, as is done in gardens.

Harpocrates, one of the divinities that protects enterprises, with his finger on his lips but in a female dress, with two words on the pedestal from the Georgics' fourth canto: *Transformat se. se.*

Horatius Cocles, who alone defended the Sublicius bridge against all Tuscany; on whose pedestal is represented the same Sublicius bridge in bas-relief.

A Victory with one foot on a helmet, and with a shield on which is written: *Dux. Foemina. Facti*, from the first book of the Aeneid; and on the pedestal a laurel wreath.

Augustus; and the eagles recovered from the Parthians, *signa recepta*, depicted on the pedestal to symbolise the honour of restored weapons.

Trajan, and a votive *clipeo* in the pedestal to wish good health to the excellent prince.

Titus, with the besieged province on the pedestal.

Julius Caesar, with trophies that can be seen in his medals.

Camilla with an arm placed over a hound, and with the motto: *Agmen. Agens. Equitum*, which Virgil says of Camilla in the eleventh book.

Atalanta with the head of the boar at her feet, and with the words *Erubuere Viri*, which are Ovid's words about her in the eighth book of Metamorphoses.

Cornelia, mother of the Gracchi, leaning on a piece of column, in the pose of an orator; on the pedestal, a medal with the heads of the two Gracchi.

Sappho, and a lyre on the pedestal.

Livia veiled, and an altar on the pedestal.

To further decorate the *dessert*, other items may be added to these small statues: various trophies of weapons and spoils, some groups of Genii holding garlands of myrtle woven with laurel; And vases, not moulded according to the strange forms of those of Japan and China, but according to the beautiful silhouettes of antiquity and of Polydorus. Mattielli, who we have here, and who is a great scholar of his compatriot Valerio Bello, will be able to model each subject: and I will have the honour of obeying you, *signor conte*, who in this court with great decorum represents a sovereign who with equal delight is the praise of her peoples, and the admiration of foreigners.[21]

The extremely interesting aspect of this text is that Algarotti was thinking in monumental terms, although he knew very well that these were "statuine" (little statues) for a table. He proposed that the modelling of the figures be done by a sculptor accustomed to a monumental scale: Lorenzo Mattielli. He alluded to a crypto-portrait of Maria Theresa, explored the mottos and attributes and explicitly stated that his model was that of garden statues. This is a perspective that also applies to the vases as he did not want them to be Orientalising or *rocaille*, but in the manner of antiquity, or neo-Renaissance in style.

We may lay our money that Ginori would have subscribed to every word. But he went further by not limiting himself to only making the Italian art tradition emerge from the small figures of a table service, albeit a spectacular one. His ambition was to make enormous ones in terms of what was then standard for porcelain. One may wonder what prompted him to inaugurate the manufacturing activity by embarking on the storm-tossed voyage to these monumental figures because firing such large and such complex works was very difficult and technically extremely risky. Even from an entrepreneurial point of view, the choice seems peculiar because everything seems to suggest that he never thought of a serial production of these large porcelain statues, evidently conceived as unique pieces, in flagrant contradiction to one of the reasons for establishing a porcelain manufactory. The answer to these pressing questions should perhaps be sought in what we have noted above about Ginori's desire to fill the void created by the end of Medici patronage. It is almost as though he were thinking of rebuilding another Tribuna degli Uffizi in his Doccia villa, a tribune – unique in the world – of classical sculpture in porcelain. This was a monumental aspiration, which in some ways legitimised that retreat to the private dimension and small format that the manufactory would inevitably encompass with its serial production shortly afterward.

On the other hand, alongside the nationalistic chrestomathy of Gori, another filter acted on Ginori's imagination: that of the last, splendid season of Florentine Baroque sculpture. It is probable that at least some of the great porcelain works after the antique were derived from preexisting moulds, namely the ones made by Soldani to replicate the *Venus de' Medici* (cat. 1) or the *Dancing Faun* in the sumptuous bronzes commissioned by the Prince of Lichtenstein.[22]

And there is no doubt that this chosen core of remarkable ancient statues revived in porcelain has an unmistakably Baroque flavour. It is not an obvious point, since all that whiteness has led scholars to see the first signs of a new, Neoclassical aesthetic. But the *sprezzatura* of these pioneering and rather unsuccessful firings, and the uncertainty of a still very imperfect white – that is, the very features that make the large sculptures of Doccia unique and which John Winter has so delicately described[23] – combine with a softness and a sweetness of modelling that make each of these figures so close to life and flesh that they cannot leave us in any doubt as to their forming part of the artistic season we call Baroque. This aspect of their style is made evident in the exhibition by the comparison between Soldani's *Venus de' Medici* in bronze and that in porcelain, both of which were probably made from the same moulds.

The possibility of showing the superb *Mercury* to the public is especially felicitous as this is the only one of the great figures from the first period of Doccia never to have been exhibited or, indeed, published. To appreciate it to the full, we should try to look at this work through the eyes of the 18th century; an eye conscious of the enormous fortune of the marble prototype, which came from the legendary Cortile del Belvedere and which by the mid-16th century (and then uninterruptedly until the time of Ginori), had already been often translated into bronze, including in full-size versions.[24] Gori had devoted two well-crafted plates to it, and had defined it a masterpiece of Greek sculpture, adding how "statuarii ac pictores nostri tamquam artis absolutissimum exemplar observent, summamque cum admiratione et voluptate omnes contemplentur".[25] That figure, therefore, combined the prestige of its noble provenance, the proof of an exceptional fortune, and the conviction of an extraordinary formal quality: values that a modelling clearly undertaken by Soldani translated into the languor of the late Florentine Baroque.

These two suggestions – the explicit connection with the finest Medici collecting and the formal adherence to the language of the last great season of Florentine sculpture – program-

matically interweave in the production of the complex and articulated narrative table groups. The series begins very early, with the translation of the celebrated *Pietà* that Soldani modelled in 1708 (cat. 9), which Ginori produced in porcelain between 1744 and 1745 to give to Cardinal Neri Corsini (cat. 8), the head of the only Florentine dynasty able, at least in moral terms, to continue the Medici legacy.[26]

This connection is made explicit by the fact that Ginori's factory immediately began to replicate in porcelain the bronze groups that had adorned the antechamber of the Electress of the Palatinate at Palazzo Pitti: the last great Medici sculpture commission.[27] An important document published by Zikos shows that in the autumn of 1744 two of these bronze groups – which had in the meantime been bequeathed by Anna Maria Luisa to the families of the Florentine aristocracy most closely connected to her – were taken to Palazzo Ginori to have casts taken. They were the *Sacrifice of Jephthah* by Soldani and the *Judith with the Head of Holofernes* by Cornacchini (fig. 11).[28] The Soldani bronze (now known only through a late version at the Metropolitan Museum in New York) was the one on which the Medici group was based in 1722, and the Cornacchini group was also part of the first four. It was a group composed of two symmetrical pairs of Old Testament subjects: two scenes of human sacrifice, one of a woman

13. Ginori manufactory, *David and Goliath* (after Giovan Battista Foggini), porcelain, Sesto Fiorentino, Museo Richard Ginori of the Doccia manufactory

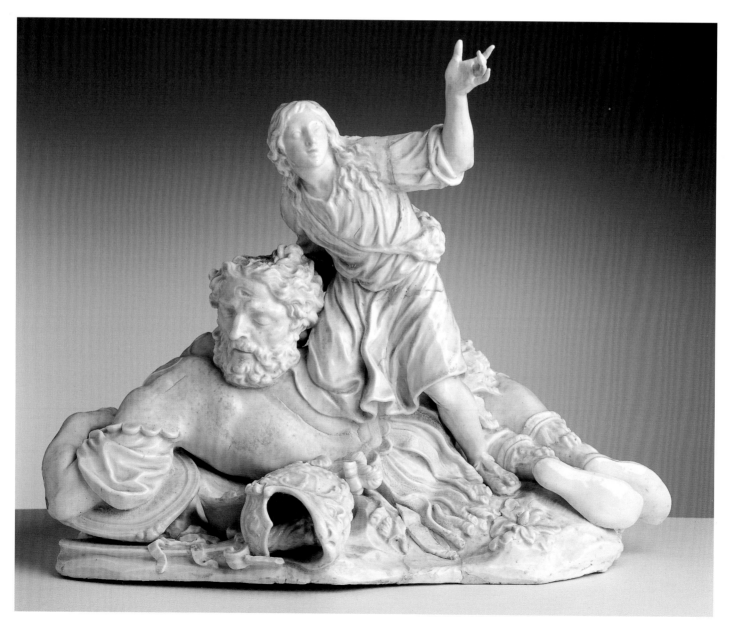

(the daughter of Jephthah) and one of a male (Isaac, made by Piamontini); and two scenes of decapitation, one that sees a woman triumph (Judith), the other a man (David, by Giovan Battista Foggini). Ginori's choice was clearly deliberate. In deciding to reproduce in porcelain the first two groups that have a woman as protagonist, he evidently intended to trace out a sort of moral portrait of their patron, the Electress of the Palatinate.

As an aside, we may even wonder if Ginori's choice may not help us shed some light on the meaning (assuming there is a single one) of Anna Maria Luisa's twelve bronzes, one of the more obscure aspects of the matter. At least in the case of Jephthah's sacrifice (a very rare iconography), there is a strong temptation to see a direct allusion to the story of the last of the Medici. The Book of Judges tells the story of this Jewish leader who tied his hands and made a terrible vow to the Lord: "If thou shalt without fail deliver the children of Ammon into mine hands, then it shall be, that whatsoever cometh forth of the doors of my house to meet me, when I return in peace from the children of Ammon, shall surely be the Lord's, and I will offer it up for a burnt offering."[29] But his only daughter (unnamed in the Bible) came to him, and so Jephthah "did with her according to his vow which he had vowed".[30] It is possible that the biblical text did not intend to allude to a human sacrifice, but to a religious consecration. Yet the Electress, and with her Soldani, must have had no doubt about the interpretation of the matter, which in the group is resolved in a kind of cruel sacrifice of Iphigenia. One may ask if Anna Maria Luisa did not see something of herself in this story. Designating her as his heiress on the death of Grand Prince Ferdinand, her beloved father, Cosimo III, had 'sacrificed' her to the needs of state, placing the enormous weight of the end of the dynasty and the future of the Grand Duchy on her shoulders. And in the Baroque tradition (for example, in the oratory dedicated to her by Giacomo Carissimi in 1648) Jephthah's daughter laments above all being sentenced to death without having children: another aspect with which the Electress could identify.

In any case, alongside possible personal references, the overall group of the Electress' first four bronzes seems to have an easily legible one concerning family patronage. It was not inappropriate that the story of Medici patronage should end with two sacrifices, a David and a Judith in bronze. The allusion was, of course, to the great 15th-century bronzes commissioned or owned by the family, and preserved in the Grand Duchy's collections. These were much celebrated in

14. After Giovan Battista Foggini, *David and Goliath*, plaster, Sesto Fiorentino, Museo Richard Ginori of the Doccia manufactory

15. After Giovan Battista Foggini, *David and Goliath*, wax, Sesto Fiorentino, Museo Richard Ginori of the Doccia manufactory

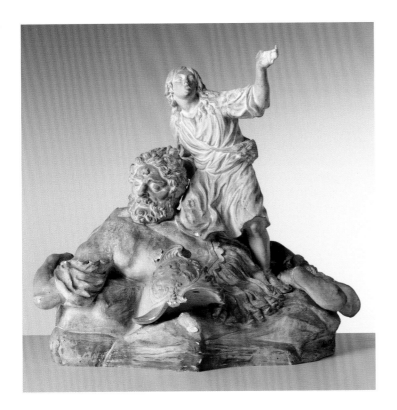

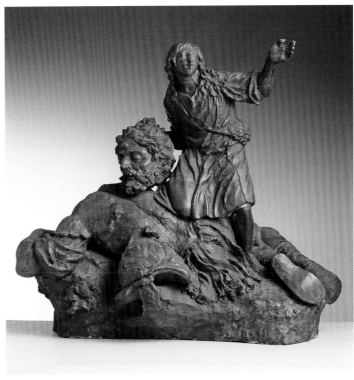

the literature, by Vasari onwards: "If only Brunelleschi, Ghiberti … Donatello were able to return among us!" Bianchini had exclaimed shortly before in his *Ragionamenti*.[31]

An ideological thread therefore joins the part of this exhibition displaying the *Venus de' Medici* and the *Mercury*, itself from the Medici collections, to the section with the superb autograph terracotta of Cornacchini's *Judith* (cat. 10) and its spectacular porcelain version (and it is a great shame that the difficulties of the Birmingham Museum did not allow the bronze version to be displayed too). That thread is the will of Carlo Ginori to present the two faces of Florence's sculpture: that of the new Rome able to bring some of the most famous and beloved antique figures in Europe to Florence, and that of the tireless creative workshop, able to impose once again with the finest in art and style (but this really would be the last time).

There is something inevitably imitative in all this. The manufactory was not thought of as the *atelier* of a creative artist (Bruschi certainly did not fit this picture), but as a great multiplier of figures originally invented and shaped to be made of other materials, especially bronze. The Ginori repertoire was created as a sort of great epitome of Florentine sculpture, bringing with it – in later periods too – an eclectic openness; a repertoire comparable to that of the De' Rossi publishers, whose catalogue of prints in those same years represents a sort of vast archive of the Roman artistic heritage.

With the benefit of hindsight, namely, the possibility of taking a long view, it is impossible not to think that Ginori's technological and entrepreneurial genius was objectively moving towards that 'exploitation' of a heritage that was now terminated and which would henceforth be the dominant feature of the long decline of Florentine culture. Already in the 1750s, some works have a programmatically eclectic flavour, almost like an intentional pastiche. The magnificent *Fireplace* (cat. 15) comes to mind, and the use of figures invented by Michelangelo for the Sagrestia Nuova, now extracted from their terrible and tamed character and reduced to pure decoration.[32] Nor did it lack the fundamental ingredient of the next phase in the Florentine situation, namely that of becoming a favourite tourist destination, in this case still a *grand tourist* eager to take home a piece of Florence in that brand new technical medium that was porcelain.

From a strictly art-historical point of view, it is evident that Ginori's eclecticism is also explained by the end of the season of Baroque sculpture in Florence and beyond: even if he had wanted to think of a strictly original production conceived specifically for porcelain, it would have been difficult to find an artist able to supply it.

On the other hand, there was an important precedent, and in Florence itself: Davide Gasparotto noted that it was "only with Giambologna and his followers that the potential of multiple reproductions of the same sculpture begin to be massively exploited".[33] It is at this moment that bronze becomes the means to reproduce simultaneously both ancient works (often reduced in size) and the latest sculptural inventions of Giambologna himself and his students, the same combination as would characterise the launch of Doccia's production. And the analogy does not only concern the industrialisation of the creative process of sculpture, but also its close correlation with the closure of an unrepeatable creative season. While Giambologna had brilliantly interpreted the repertoire of the high Renaissance, with his pupils a decline in creativity took hold (albeit splendidly illuminated by figures like Pietro Tacca) from which Florentine sculpture recovered only with the opening of the Academy by Cosimo III in Rome in 1673.

Around 1740, not even eighty years after that change, another cycle in the history of Florentine sculpture came to a close and again, at the same time, a serial production flourished, this time not in bronze, but in porcelain. A visit to the Museo Ginori di Doccia is also a way to understand the extraordinary formal continuity that links the style of Giambologna and his followers to that of the imitations of Soldani and Foggini (and it is not by chance that Algarotti compared porcelain to the works of Valerio Belli, as we have seen).

John Shearman wrote that "in the eighteenth century… there occurred a resurrection of the spirit of Mannerism, not just of its bodily forms. In Rococo decoration, or furniture, there was a direct revival of the most extravagant grotesque-work of the sixteenth century; and decora-

tion lost once more the qualities of energy and structure as its function returned to giving pure delight, to simply being beautiful… and surely something of its elegance and grace returned with Giambattista Tiepolo and the Sicilian sculptor Giacomo Serpotta";[34] and with the white statues of Doccia, we might add. Carlo Ginori's preoccupation was that Cortona's *Tempietto* (cat. 4) – that incredible Rococo transposition of Bernini's baldacchino, decorated with the colours of a Della Robbia and crowned with the very symbol of the artistic era of Giambologna – should be assembled properly, so it could be turned and admired from all sides. In it, we read an aesthetic that was by now far from that of the great Roman Baroque, and indeed profoundly neo-Mannerist.

In effect, 'something of elegance and attenuated grace' (to borrow Shearman's words again) of the bronzes of the late 16th century was imbued also by the porcelain of Ginori, but with the enormous differences dictated by such a different material and so new to the Italian tradition; a material that little by little was revealing the peculiarities and enormous possibilities that the Museo Ginori documents – and, hopefully, will continue to do so for a long time. For as Henri Focillon wrote, the matter of an artwork "cannot be acquired once and for all. From its very first appearance, it is transformation and novelty, because artistic activity, like a chemical reaction, elaborates matter even as it continues the work of metamorphosis".[35]

1 [Lambruschini] 1837, p. 8 (my italics).
2 Quoted in Ginori Lisci 1963, p. 228.
3 Algarotti ed. 1823, III, pp. 107–9.
4 Haskell, Penny 1981.
5 Winckelmann 1776, I, p. 39: "als alle so sehr beliebte Porcellangefäße, deren schöne Materie bishero noch durch keine ächte Kunstarbeit edler gemachet worden, so daß auf so kostbaren Arbeiten noch kein würdiges und belehrendes Denkbild eingepräget gesehen wird. Das mehreste Porcellan ist in lächerliche Puppen geformet, wodurch del daraus erwachsene kindische Geschmack sich allenthalben ausgebreitet hat".
6 Haskell 1963.
7 Quoted in Casciu 2006, p. 49; Verga 2006, p. 27.
8 Quoted in Casciu 2006, p. 49.
9 Bianchini dedicates the preface of the book to the Electress of the Palatinate (1741, unnumbered pages).
10 Voltaire 1771, III, p. 100: "La foule des étrangers qui voyagent aujourd'hui à Rome, non en pèlerins, mais en hommes de goût, s'informent peu de Grégoire VII et de Boniface VIII; ils admirent les temples que les Bramante et les Michel-Ange ont élevés, les tableaux des Raphaël, les sculptures des Bernins; s'ils ont de l'esprit, ils lisent l'Arioste et le Tasse, et ils respectent la cendre de Galilée".
11 Quoted in Waquet 1990, pp. 548–9.
12 Quoted in Meloni Trkulja 1983, p. 338.
13 González-Palacios 2006, p. 28.
14 Ibid.
15 Above all in Lankheit 1962; Ginori Lisci 1963; Lankheit 1982; Zikos 2005ᵃ; Biancalana 2009; Zikos 2011; Balleri 2014ᵃ.

16 See Zikos 2011 (with previous bibliography).
17 As Dimitrios Zikos documents in this catalogue on pp. 45–67.
18 See Zikos 2011.
19 See Winter 2003; Winter 2005; Biancalana 2009 (with previous bibliography).
20 Gori 1734 (*Ganymede* pl. V, *Venus de' Medici* XXVI–XXVIIII, *Venus Removing a Thorn* XXXIII, *Mercury* XXXVIII–XXXVIIII, *Cupid and Psyche* XLIII–XLIIII, *Dancing Faun* LVIII–LVIIII, *Knife Grinder* XCV–XCVI).
21 Algarotti ed. 1823, III, pp. 291–4.
22 See Zikos 2005ᵃ.
23 Winter 2003, pp. 26–7.
24 See Haskell, Penny 1981.
25 Gori 1734, p. 44.
26 See cat. 9 in this catalogue on pp. 128–9.
27 See entries in Firenze 2006ᶜ, pp. 296–315.
28 Zikos 2005ᵃ, p. 176, note 9.
29 Jud 11,30–1.
30 Jud 11,34–40: 39.
31 Bianchini 1741, p. XIV.
32 See entry 16 in this catalogue on pp. 146–8.
33 Gasparotto 2015, p. 291.
34 Shearman 1967, p. 185.
35 Focillon 1934, p. 38: "Car la matière d'un art n'est pas une donnée fixe, acquise pour toujours : dès ses débuts, elle est transformation et nouveauté, puisque l'art, comme une opération chimique, élabore, mais elle continue à se métamorphoser".

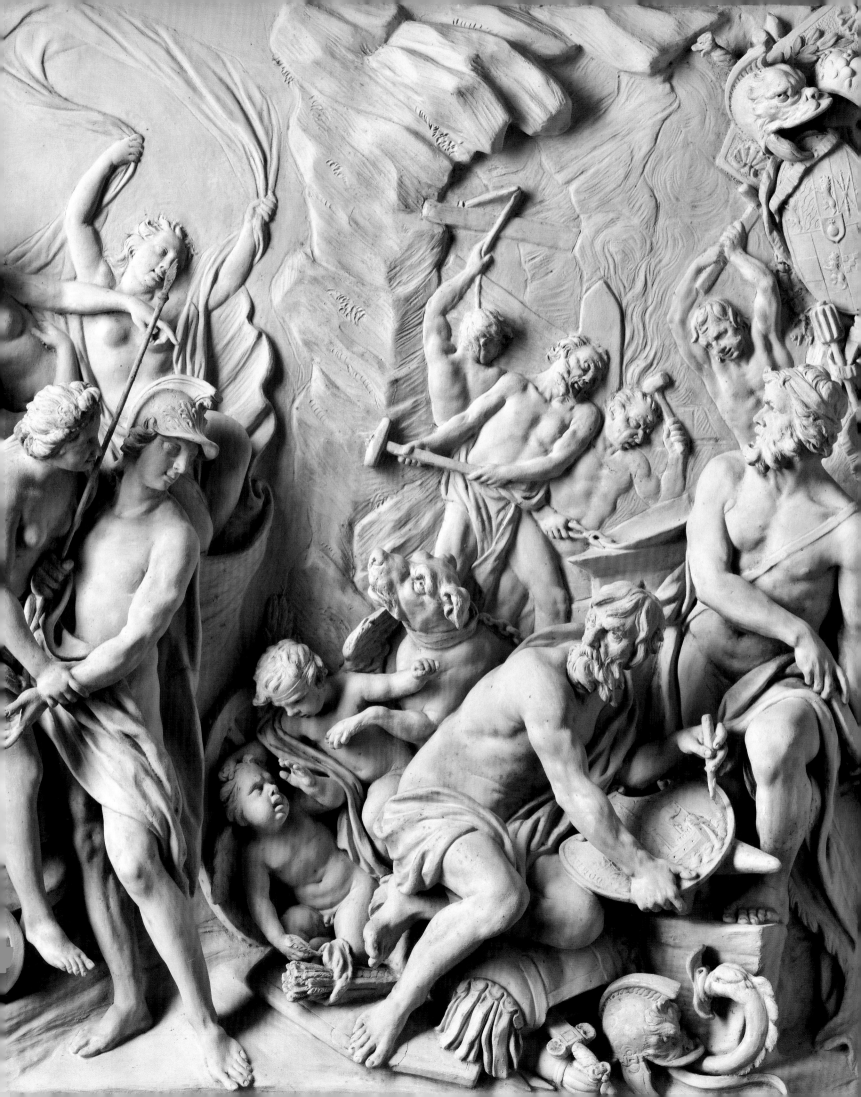

"Il decoro della nostra Italia in ragione di scultura"

The importance of the models made by the Ginori Factory for Florentine *Kleinplastik*

DIMITRIOS ZIKOS

[I.] *"Mirabile artifizio". Modelling and casting in pieces in late Baroque Florence*

In a note attached to a letter written to Giovan Giacomo Zamboni in London on 25 April 1725, the Florentine sculptor Massimiliano Soldani (1656–1740) describes how he made his bronzes:

> … in making bronzes, no welding is done because they have to be worked on in pieces to better fashion the works where it is impossible to reach to chisel them; these pieces are attached together with molten bronze of the same quality so that the color is the same, and this is done with admirable artifice that is not easy to describe.[1]

Casting in pieces that would be assembled at a later stage permits the chiselling of sections that would have been difficult or impossible to reach once the pieces were fitted together. This is a process dear to the bronze sculptors of late Baroque Florence also because it guaranteed a complex composition with significant undercutting. A comparison of the front and back of Soldani's 1711 bronze relief of *Winter* in Munich (part of a set representing the *Four Seasons*; figs. 2–3), reveals the cast-on metal that keeps the parts together.[2]

The technique of casting in parts had a long tradition in Florence. Pietro Tacca practised it in his large bronzes.[3] So did his fellow-assistant of Giambologna, Antonio Susini, as well as Susini's nephew and heir to his workshop, Giovan Francesco Susini.[4] As a new generation of Tuscans who had received their training in Rome brought new vigour to Florentine sculpture in the late 17th century, they adapted this 'local' technique to a new style. The Baroque figures, groups, and reliefs of Giovan Battista Foggini, his pupil Giuseppe Piamontini, and Soldani are cast in pieces. But only Soldani went so far as to make his clay models in separate parts as well; these parts were moulded separately for bronze casting and then fitted together to recompose the model.

This was discovered by chance. In 1967, the Victoria and Albert Museum bought a terracotta relief representing an allegory of Fra Manoel de Vilhena, Grand Master of the Order of Saint John between 1722 and 1736, and a patron of Soldani.[5] The relief arrived in the London museum in pieces and underwent restoration, which revealed that the breaks were not accidental fractures but joins between parts which had become loose during shipment. Fingerprints on the back of some sections proved that these had been pressed into a mould. However, the remainder of the sculpture is freely modelled. The relief had been cut into sections before firing and these were moulded before being combined with plaster or fish glue and placed on a slab of clay to make the entire work stable. Soldani's *terracruda* of the *Death of Saint Joseph* (cat. 12) was made in the same way. Not all Soldani clay models are assembled from parts. But the realization of a composition with a complex and sophisticated structure in bronze could be more easily achieved with a model made in parts, as must have been the case with the *Winter* in Florence (fig. 1).

1. Massimiliano Soldani Benzi, *Winter* (detail), terracotta, Florence, Palazzo Pitti, Tesoro dei Granduchi

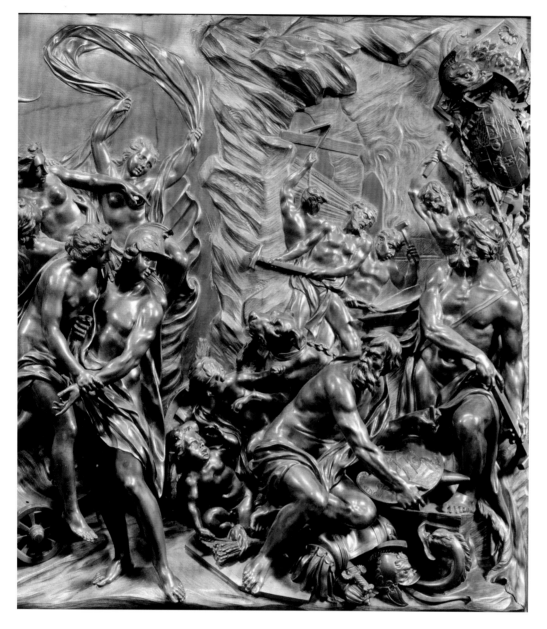

According to his biographer Prospero Maria Conti, Soldani started modelling and firing terracotta figures in a glass-melting furnace in his native Montevarchi at the age of ten, and as a boy used to "draw and obtain the models" after the glazed terracotta reliefs in the Pieve di San Giovanni Battista in Galatrona near Montevarchi.[6] In that area – so rich with works by the Della Robbia and their followers – Soldani could have become aware that these reliefs were made of parts sectioned before firing and assembled with plaster – in exactly the same way as the relief in London.[7]

At his death, Soldani had more clay *bozzetti* than models.[8] A request by Zamboni in 1717 for terracottas could not be met.[9] In his reply, the artist says that "many more of my works in terracotta are in the hands of gentlemen friends of mine, who do me the honour of preserving them" implying that these were given away rather than sold. Indeed, in some cases the documented owners of a Soldani terracotta had a connection with the commission of the bronze for which that very model was made. Those for the *Seasons* were with Prince Ferdinando di Cosimo III, who had commissioned the bronze versions (today in Munich). Framed and behind a glass, the terracotta models for the *Seasons* were displayed in the Audience Room of his apartment in the Palazzo Pitti. Indeed they remain there, in what has recently been baptised

2. Massimiliano Soldani Benzi, *Winter* (detail), bronze, Munich, Bayerisches Nationalmuseum

3. Massimiliano Soldani Benzi, *Winter* (detail of the back), bronze, Munich, Bayerisches Nationalmuseum

the 'Tesoro dei Granduchi'. There are similar cases of gifts of models. To those already record-ed, we can now add the terracotta models for the bronze oval portrait of Ridolfo de' Bardi and its pendant *Allegory of Generosity* (see cat. 15) in the oratory of San Niccolò in Vernio, last documented in 1772 with Count Flaminio di Orazio di Flaminio de' Bardi in a palazzo he was inhabiting in the Borgo Santa Croce, Florence.[10]

Lost ownership of a model did not compromise replication. Besides another bronze set dat-ing from 1715 of the *Seasons* for Lord Burlington, Soldani also made a pair of *Summer* and *Au-tumn* in bronze.[11] He could do so because he had kept the moulds, which could also be used to make versions in less costly materials. In another letter of 1717 to Zamboni, the artist enquires:

> If you were to fancy that I send you some group or bas-relief in wax, obtained from any of my moulds, I would oblige, and I would only need you to pay for the wax and whatever time it takes for an assistant of mine to cast and finish them.[12]

More layers of wet paper (after drying and stiffening) would protect the fragile works dur-ing travel, and Soldani appears confident that they would not be damaged. Yet it would be

necessary to put the waxes in water after their arrival in London in order for the paper to soften and be more easily removed. It might even be necessary to brush the surface to assure complete removal of all stains. But this effort is nothing compared to becoming the owner of works "moulded on my originals which are made with some study".[13] There is some irony that the works of which Soldani proposes to send humble wax copies are his magnificent bronzes of the *Sacrifice of Jephthah* and *Simon in the House of Pharisee* which he had only a couple of years earlier made for Anna Maria Luisa de' Medici, dowager Electress Palatine, who kept them on superb bases of gilt bronze and lapislazzuli in another audience room in the Palazzo Pitti, in her own apartment.[14]

Compared to a terracotta, a wax was easier and less dangerous to dispatch abroad as evidence of the artist's skill. The young Soldani had sent cast wax reductions after the Antique to Johann Adam Andreas I, Prince of Liechtenstein, in lieu of the requested terracotta models. However, their rough surface did not please, and Soldani's attempt at obtaining a commission backfired. Earlier, however, the wax version of a *Bacchanal* had convinced the same patron to commission a bronze version, although the wax had arrived in Vienna damaged and in pieces.[15]

The production of wax copies was not reserved for foreign commissions. If the wax *Pietà* (cat. 9) from Villa La Quiete in the Tesoro dei Granduchi, Florence, is indeed the *Pietà* first documented in 1741 with Giovan Battista Gondi, it is a work made for the domestic devotion of a member of the Florentine aristocracy.

Clay and wax were not the only materials Soldani employed for copies of his own works. A large number of his compositions cast in plaster appear in the artist's posthumous inventory of 1740, including "four full sized plaster models representing Venus, the Faun, etc…", that is, plaster copies after ancient *opera nobilia* preserved in the Uffizi Tribuna of which Soldani had made copies for foreign and Italian patrons.[16] These plasters were placed on bases "the colour of various types of marble" within niches painted "the colour of yellow Siena marble". The artist, who in late Medici Florence had cast free, gleaming, and polished bronze copies after the ancient white marbles in the Tribuna, such as the Liechtenstein *Venus de' Medici* (cat. 1), later created his own Tribuna in the most prominent space of his country house in the Valdarno. Soldani had retreated there in 1737, the year the last Medici Grand Duke died and the Ginori Factory was founded.[17]

For Soldani, bronze was the primary and most noble material. But this did not stop him from championing reproductions of his compositions with varying aesthetic impact, from waxes like the *Pietà* (which may allude to the reddish golden varnish of his bronzes) to white plasters. These versions in different materials could be achieved as long as he kept the moulds.

It was the acquisition of these moulds by Carlo Ginori, founder of the Doccia porcelain manufactory, that led to the foundation of one of the world's most important collections of sculptural copies: the models for porcelain which are still preserved in Sesto Fiorentino, at the successor to the original factory, the Richard Ginori, and its now-closed museum.

[2.] *"Bronze for – white – gold". Sculptural copies as models for porcelain statuary*

It is still not clear when Carlo Ginori decided he wanted his factory to produce porcelain statuary. In July 1737, he began employing a sculptor, Gaspero Bruschi.[18] Forty years later, Bruschi's own workshop in the factory was filled with "fragments in plaster such as feet, hands, heads and other parts, etc. for the study of sculpture", along with moulds connected with the porcelain that Bruschi was modelling at the time.[19] Initially, however, he seems to have had other more pressing duties.[20] Three years before he began working for Ginori, Bruschi became an Accademico del Disegno.[21] In 1739, he carved a *Mercury* in *pietra serena* for the triumphal arch erected at Porta San Gallo for the entry of Francis Stephen of Habsburg-Lorraine and his wife Maria Theresa, the new grand ducal couple of Tuscany.[22] As this was his only monumen-

tal sculpture, Bruschi must have received the commission thanks to Ginori, who oversaw the building and decoration of the arch.[23] But apart from this and a lost bust of the last Medici Grand Duke Gian Gastone, Bruschi's only works are the porcelain figures, groups, and reliefs he modelled for Doccia.[24]

Bruschi was, however, not the source for sculptural models for porcelain.[25] For these, Ginori turned to the estates of the two leading sculptors under the last Medici, Massimiliano Soldani and Giovan Battista Foggini, and started buying moulds that had served for bronzes or commissioned casts from the moulds. Because Bruschi's teacher had been Girolamo Ticciati, who had also made some bronzes, it has been suggested that it was thanks to Bruschi that models of his teacher's *Seasons* became available for reproduction in Doccia. However, these models were acquired as wax casts from Vincenzo Foggini.[26] Vincenzo was not only the son of Giovan Battista but also his successor as First Sculptor to the Grand Duke and as such he lived and worked in the same premises as Giambologna and Pietro and Ferdinando Tacca, who had occupied the position before him. In this property in Borgo Pinti there were still many large-scale *gesso* models, including that for Giambologna's *Rape of the Sabines* (for which Leonardo Ginori had been the model for the figure of the standing Roman) and those for the *Four Slaves* in Livorno, of which Ginori became governor in 1746.[27] Like Bruschi, Foggini carved a statue for the Porta San Gallo triumphal arch.[28] Ginori lent Foggini some money for this project in 1739.[29] Two years later it was Foggini who was first paid for "moulds that serve for porcelain" on 4 September 1741.[30] The receipt issued by the artist does not detail what these moulds were, nor does the next one which simply reports the delivery of "some casts of *gesso*, and of wax" on 27 February 1742.[31] But these two earliest testimonies establish a pattern that would be followed for preparing three-dimensional models for porcelain which could be either a positive produced from a negative or a new negative taken after a positive, as a rule, a *gesso* or wax cast. Great care was taken to preserve the original moulds and models, a task entrusted by Ginori to Bruschi.[32] It was derivatives of these 'originals' that were used to make porcelain statuary.[33]

Initially Ginori also appears to have thought of acquiring sculptural models commercially. After the acquisition of the first Foggini casts, a certain Giuseppe Ricci was paid on 23 December 1741 for a terracotta relief, twenty plaster busts, and some other sculptures.[34] It has been proposed to identify him with an otherwise undocumented member of a Prato family of painters or even with the sculptor Giuseppe Gricci, later active in the Capodimonte porcelain factory.[35] However, we can demonstrate that Giuseppe Ricci worked for the Magistrato de' Pupilli which sold the works to Ginori.[36]

The reasons for Ricci's mistaken identity lie in the fact that scholars have previously consulted only the known documents relating to Ginori factory expenses. Ginori's personal accounts contain the reference to Ricci.[37] Indeed, we can only surmise from the successive acquisitions of this type that the sculptures acquired from Ricci served as models. Three terracottas by Soldani acquired from Marquis Clemente Vitelli in 1752 were the only original works Ginori bought with the declared intention of employing them as models.[38] Apart from these two instances, the available documentation mentions only sculptors and artisans as purveyors.

Ginori's expenses for moulds and models are documented under the heading "Spese per le porcellane e maioliche" ("expenses for porcelain and maiolica").[39] Although these have long been known, they were never published integrally and in chronological order. Nor have they always been read together with the receipts issued by those who sold them to Ginori. A comparative reading is key to understanding what was acquired since the receipts contain more information than the entries. This information can provide more precise descriptions of what was delivered, for instance, when we are told that the four red wax "medaglie" ("medals") for which Foggini was paid on the 22 June 1750 are actually oval reliefs of "one Ecce Homo, one grieving Madonna, one Samaritan woman" and "one Madonna, with Jesus and Saint John as infants", and not actually medals.[40] The receipts also detail the time it took to make a model

49

or a mould, and reveal their price. Time and cost have been neglected in scholarship but often help identify the prototype, especially when several artists dealt with the same theme. Information deriving from payment records and receipts should be checked against records relating to the production of porcelain statuary as these provide a *terminus ante quem* for the presence of a model in Doccia. To do this we need a scholarly edition of Ginori's correspondence, as has been rightly proposed by Tomaso Montanari in this volume.

Perhaps by chance, but certainly with symbolism, the section "Spese per le porcellane e maioliche" in Ginori's accounts starts with an entry dated 4 September 1743 and refers to the acquisition of "two groups amounting to 39 plaster moulds by Massimiliano Soldani" from Anton Filippo Maria Weber, the younger brother of Lorenzo Maria, a pupil of Soldani.[41]

How Weber had come to sell moulds by Soldani to Ginori is implied by his brother's short autobiographical note, which explains that Lorenzo and Anton Maria were "always conforming to each other in their actions".[42] They had the desire "for large works; and for this we purchased all the plaster moulds from the heirs of signor Soldani, amongst which were the Greek statues from Galleria and Buonarroti's famous Bacchus". It seems that besides *gesso* figures they also acquired plaster moulds, including probably, as we shall see, those Soldani had used to make large bronze copies after the Antique (cat. 1). Curious as the means for the realization of this ambition for grand works may appear, they are emblematic for this moment of transition following the death of Soldani and the end of the activity of Piamontini, two great sculptors of late Baroque Florence.[43]

In 1739, the same year Ginori assisted Foggini, he had bought also "23 large steel letters and a hammer" from Anton Filippo Weber and in 1740 a "bronze seal" from Lorenzo Maria Weber.[44] Ginori was therefore well acquainted with both brothers, and although he paid only Anton Filippo for moulds and models, it was probably both of them who contributed to the building of the models collection for Doccia.[45] If the Webers bought also – as it seems – moulds from Soldani's heirs, then they did not buy all of them, as Ginori was able to acquire the moulds for Soldani's *Pietà* (cat. 7) on 25 September 1744 directly from the artist's son Ferdinando. These were paid an extraordinary 20 ruspi which corresponds to 38 scudi – the costliest acquisition Ginori made for a single model.[46]

Three months later, Soldani's son sold "numerous plaster moulds representing reliefs and other works" by his father for the price of 100 scudi, the highest price Ginori paid for models.[47] These are probably the moulds listed in a note published by Biancalana.[48] The same moulds, in the same order, appear in the *Nota delle forme che sono restate nella casa in Borgo S. Croce* [Soldani's house], first published by Lankheit.[49] The latter *Nota* includes, however, more moulds than the ones sold to Ginori, as, for instance, those of the "large statues from the [Uffizi] Gallery", the *gessi* of which the Webers have bought from Soldani's estate.[50] The different contents of these two lists appear to imply that the Webers bought some or all moulds that no longer appear in the list published by Biancalana. This must have been done before 4 September 1743, when they sold to Ginori moulds by Soldani.

Indeed, Anton Filippo's first task after that date was to make the moulds of the *Hagar and the Angel* by Soldani.[51] These moulds figure only in the *Nota* but not in the list of the moulds acquired by the factory published by Biancalana.[52] If this assumption is correct, that would also explain why Ginori had to bring Soldani's bronze *Sacrifice of Jephthah* to the factory, probably to have moulds made of it.[53] Its moulds must have been bought by the Webers (they figure only in the *Nota*), who might have not agreed to make a copy after this group. The only other moulds possibly after a Soldani model made by Weber for Ginori are those for a *Summer* and *Autumn* which could have been the two reliefs from the set of the *Seasons*.[54] A series of moulds clearly taken from reductions after the Antique which were all paid the same low price of 6 lire could also have its origin in Soldani's *fonds d'atelier* as he was the first Florentine late Baroque sculptor to market such works after models done by one of his assistants before 1701.[55]

As we have seen, of the three acquisitions of Soldani's moulds, only that of the *Pietà* details the subject. As a rule this is done when a mould is acquired or commissioned, and it is interesting that the moulds are said – in the language of the documents – to 'represent' a certain theme. But to find out what Soldani's other cumulatively described moulds contained, we have to turn to those casts in wax or *gesso* that were produced inside the factory. And here we can make extraordinary discoveries, even about an artist long thought to have been well researched.

Among a series of waxes which belong to the Museo di Doccia, but are today preserved in the Richard Ginori factory for reasons of conservation, there are five small figures of saints. These humble images, cast in a poor material and displaying in the cast lines a lack of care in their crafting, are the sole remains of four reliquaries that belonged to one of the most extraordinary sculptural commissions promoted by Grand Duke Cosimo III: the series of reliquaries with gold statuettes of saints in action in a setting of hardstones and gilt metal ornaments, probably destined for the Grand Duke's Cappella di Camera.[56] These statuettes were the most important commission the young Soldani received directly from Cosimo III, and he met the challenge brilliantly as proven by four pieces from the set which survive in the treasury of the Cappella dei Principi, today part of the Bargello. These are the reliquaries of Saint Paschal Baylon (fig. 4), Saint Alexius (fig. 7), Saint Louis of Toulouse (fig. 9), and Saint Raymond of Penyafort (fig. 11).[57] The waxes in the Museo di Doccia that belong to this series are Saint William of Acquitaine "wearing a helmet decorated with foliage, and dressed in a long coat of mail leaving the arms and feet uncovered" (fig. 8); "Cardinal Saint Bonaventura dressed as a friar and wearing the mozzetta (fig. 5); "Saint Roch in pilgrim's garb with a dog at his feet" (fig. 10); "A naked Saint Benedict throwing himself into the thorns" (fig. 12); "Saint Louis Bertrand holding a pistol from which a Crucifix comes out" (fig. 6).[58] A number of these reliquaries were placed on lapislazzuli bases, like four of the religious bronze groups made a quarter century later for the Electress Palatine.[59]

Some wax figures after the gold statuettes that belong to this series are listed in a well-known document that forms the basis for the study of Doccia models: the undated *Inventario dei Modelli* preserved in the Ginori family archive together with a related *Inventario delle Forme*; the former inventory has been published by Klaus Lankheit in 1982.[60] As I will demonstrate, these two inventories can now be safely dated to the fall of 1778.[61] To analyse them properly would require also a knowledge of the acquisitions made by Carlo's son, Lorenzo Ginori, but these are more difficult to account for as the documents are less eloquent. Moreover, we would need to know all moulds and models preserved in Doccia, but no complete inventory of them has ever been prepared.[62] The waxes after the Soldani gold statuettes that are mentioned in the relevant entry of the 1778 inventory do not correspond precisely to the surviving ones illustrated here. Had we known all the copies and all the moulds that Doccia contains, we would have been able to tell how much of what was actually acquired was catalogued (and of course how much was added later). Herein lies the core of the problem of this kind of study. As long as we do not know what exists, we cannot assess our primary archival sources. And we are liable to incur error and to miss discoveries of lost models which are in fact copies after earlier sculptures.

Anton Filippo Weber was the most active artist making moulds.[63] He also modelled reliefs of his own invention, including a metal *Bacchanal* ("Bacchanal in metal") that could have been based on an engraved steel made by his brother Lorenzo which is mentioned in the autobiographical note.[64] Later in his association with Doccia, he turned to his own art, engraving puncheons, mostly after lead models of another Soldani pupil, Antonio Selvi.[65] Ginori also employed him as a *formatore* ("mould-maker") after ancient statues. Indeed, Weber was the first artist documented in the accounts to have taken moulds after Uffizi statues for Doccia: on 17 September 1745 he was paid for the moulds of the *Pomona* on which he had worked since 29 July.[66] And on 13 December of the same year he was paid for moulds of the *Venere Celeste*, also in the Uffizi, on which he had worked for thirty-five days.[67] Weber's contributions continued until 1749, two years before his death.[68] All of his documented work was for Doccia.

The other artist most commonly employed by Ginori in his quest for late Baroque models was Vincenzo Foggini. In 1753 he sold a plaster after the Uffizi *Hermaphrodite*, a statue which Soldani had offered to cast in bronze for Johann Adam Andreas I, and of which Giovan Battista Foggini as First Sculptor to Cosimo III could have obtained the *forme* ("moulds").[69] This was exceptional, as were the 1741 and 1743 moulds and *gessi* ("plasters"), and, later, a plaster *Crucifix* sold to Ginori in 1751.[70] Instead, Foggini concentrated on providing Doccia with red waxes, mostly after the works of his late father. Vincenzo remained the custodian of Giovan Battista Foggini's heritage until his own death in 1755, thirty years after that of his father. Vincenzo Foggini's activity was characterized less by the production of sculpture than by teaching.[71] The only notable exception is his large marble *Samson and the Philistines*, today in the Victoria and Albert Museum. Greek pitch, oil and coal and some red clay are the typical ingredients itemized for the waxes in Foggini's receipts. More such documents have been issued by him than by Weber and they contain useful information on the daily practice of this sculptor turned mould-maker. In a receipt of 28 April 1750 referring to three red waxes representing "Aiax killing himself", Mucius Scaevola, Lucretia, and a *gruppettino* ("small group") of Perseus and Medusa, he itemizes retouching the cast as well as retrieving the moulds.[72] If

4. Massimiliano Soldani Benzi, *Reliquary of Saint Paschal Baylon* (detail of the saint), gold, Florence, Museo delle Cappelle Medicee

it was necessary to spend time to retrieve the moulds, this indicates that they were not used often, which is confirmed by the next receipt, paid on 16 May 1750, when the sculptor is again reimbursed for "remaking the missing parts.[73]

Finally, we have proof that Foggini could supply moulds not only of his father's and his own work, but also after works by other artists, as, for instance, the "two ancient bas-relief from the [Uffizi] Gallery", which the receipts specify as copies after the Lombardi reliefs in the bronze base of the so-called *Idolino*.[74] For "four figures representing the four seasons", for which he was paid on 15 March 1749, he itemized the reimbursement of the "padrone delle forme" – the moulds' owner.[75] These *Seasons* have been wrongly identified with those in ivory by Balthasar Permoser.[76] It would have not been necessary to pay Ginori because he was the owner of Permoser's ivories, as attested by Francesco Maria Niccolò Gabburri in his brief biography of Permoser, first published by Lankheit in 1962: "unbelieveably beautiful are the Four Seasons, and other ivory figurines, high approximately one *palmo*, preserved in the museum of the Senators Ginori".[77] Moreover, Soldani's *Seasons* are reliefs, whereas a similar series by Piamontini for which his son Giovan Battista had issued an undated receipt to Ginori consisted of busts, as indicated by other sources.[78]

That an artist could obtain, by paying a fee, permission to take moulds after another artist's moulds, throws light onto a practice that must have been common even if it is not documented. It is therefore possible that moulds after the "Jndiomene" for which Weber was paid by Ginori on 14 May 1744 are those after the only sculptural *Endymion* of the Florentine late Baroque, by Agostino Cornacchini. As Cornacchini had migrated to Rome years before, Weber could have either copied the marble owned by Gabburi or the bronze cast produced by Jacopo Filippini.[79]

The heir to the third great Florentine sculptor of the late Baroque, Giovan Battista, son of Piamontini, enters the scene as another purveyor of moulds.[80] He was first paid by Ginori

5. After Massimiliano Soldani Benzi, *Cardinal Saint Bonaventura*, wax, Sesto Fiorentino, Museo Richard Ginori of the Doccia manufactory

6. After Massimiliano Soldani Benzi, *Saint Louis Bertrand*, wax, Sesto Fiorentino, Museo Richard Ginori of the Doccia manufactory

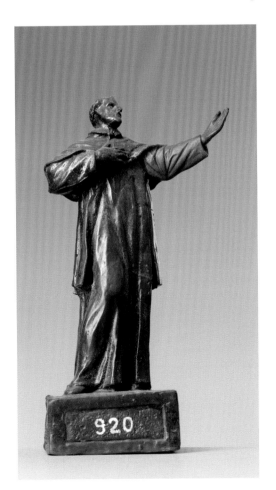

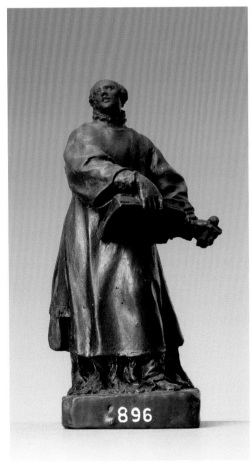

"for having cast Giambologna's *Venus* and a bas-relief representing the Massacre of the Innocents".[81] This *Venus* by Giambologna has been incorrectly identified with a Sleeping Nymph.[82] A lost bronze version is described as a "femina nuda in atto di dormire" ("naked sleeping woman") in a 1584 inventory or as "ninfa che dorme" ("sleeping nymph") in the well-known 1611 list of Giambologna bronze statuettes owned by Marcus Zäch.[83] In an instance where the *bronzetto* is identified as a representation of Venus, it is described, appropriate to its size, as a "Venerina" ("small Venus").[84] And even if it is true that in the *Inventario dei Modelli* there is a model of this type described as "Venere e un satiro che stà osservandola" ("Venus and a Satyr observing her"),[85] it is still qualified as a small one. However, Piamontini's receipt shows that this *Venus* was large in scale. If it took Giovan Battista seven days to cast in wax the *Massacre of Innocents* – a complex model by his late father – then it cannot have taken him just a day less to just produce a diminutive group.[86] Giambologna's *Grotticella Venus*, still preserved in the storage of the Museo di Doccia (inv. 1983), is the most likely candidate for the model provided by the younger Piamontini.

In an era when there was no copyright, moulds were available and copies could be obtained with a certain ease. And so probably inventions by Piamontini's father had already reached Doccia before he started to supply them to Carlo Ginori, probably as a consequence of Weber's death. The "Sacrifice of Abraham" and the "Bacchanalian group", for which the professional *gessaio* ("mould-maker"[87]) Girolamo Cristofani from Lucca was paid by Ginori on 31 December 1744, could have indeed been by Giuseppe Piamontini.[88] And so could the *Fall of the Giants*, sold by Weber on 28 May 1744.[89]

Another artist who sold works by others was Giovan Battista Vannetti. As I demonstrated in 2005, it was he who arranged the sale of Soldani's largest set of moulds to Ginori.[90] This confirms what Lankheit had ascertained: that he was an assistant to Soldani and he figures together with Selvi among those members of the Soldani workshop who contributed to the

7. Massimiliano Soldani Benzi, *Reliquary of Saint Alexius* (detail of the saint), gold, Florence, Museo delle Cappelle Medicee

8. After Massimiliano Soldani Benzi, *Saint William of Aquitaine*, wax, Sesto Fiorentino, Museo Richard Ginori of the Doccia manufactory

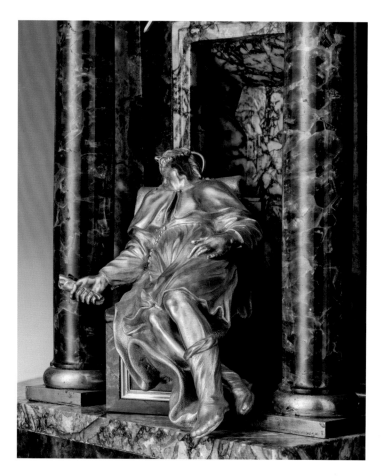
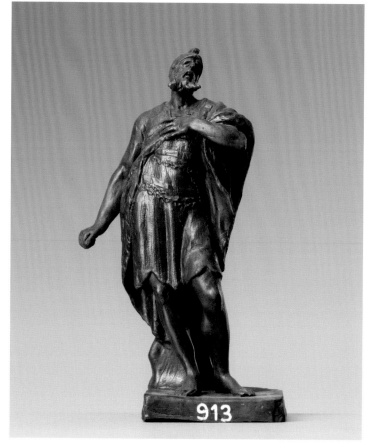

making of the magnificent tomb of Fra Manoel de Vilhena in the co-cathedral of La Vallet-ta.[91] I do not see why he should not be identical – as has recently been claimed[92] – with the sculptor of the same name enrolled in the Accademia del Disegno. We cannot reconstruct Vannetti's original works, and his waxes sold to Ginori cannot be identified.[93] But it shows the common habit of owning models by other sculptors that Vannetti sold to Ginori a group by Giovanni Baratta and two models by the son of Antonio Selvi, Benedetto.[94] Described as "persona di età avanzata" ("elderly") on 10 May 1756, Vannetti appears to have worked for Vincenzo Foggini for eighteen years after Soldani's death.[95] He was therefore a member of the Borgo Pinti workshop when he came into contact with Ginori, and had also worked for Soldani.

If the financial documents reveal much about the sources of the models, they are laconic about the use of these moulds. We have seen the casting lines on Soldani's *Saints*, which would have been done in the factory as opposed to Foggini's retouched waxes. But there are a couple of cases where an external purveyor of moulds after a recently furnished model is doc-umented. In one case, Foggini delivered wax and mould.[96] But when he delivered four wax reliefs and shortly afterwards Cristofani produced moulds of bas-reliefs, we can be fairly cer-tain that these are the moulds for the reliefs that had just been bought from Foggini.[97] And the same is probably true for the model *Baptism of Christ*, which was also sold by Foggini and moulded by Cristofani.[98] The same relation between delivery of a model and preparation of a copy can be established, as we have seen, when Selvi made lead reliefs and immediately after-wards Weber engraved a puncheon. The Ginori accounts provide therefore evidence against the recent argument that moulds could be taken only from sectioned models.[99] Against this argument speaks also that there are many Florentine terracottas made in one piece of which a bronze version exists. Finally, many of these non-sectioned waxes are said to have their related moulds in the *Inventario dei Modelli* published by Lankheit. It is certainly more dif-

9. Massimiliano Soldani Benzi, *Reliquary of Saint Louis of Toulouse* (detail of the saint), gold, Florence, Museo delle Cappelle Medicee

10. After Massimiliano Soldani Benzi, *Saint Roch*, wax, Sesto Fiorentino, Museo Richard Ginori of the Doccia manufactory

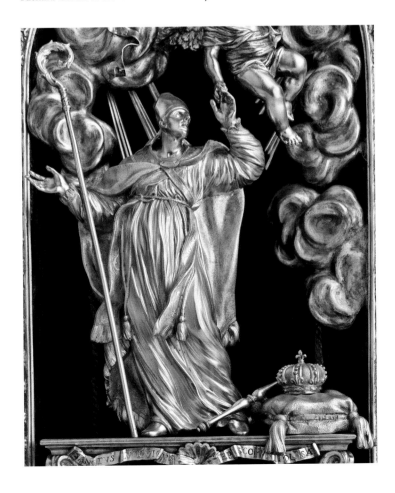

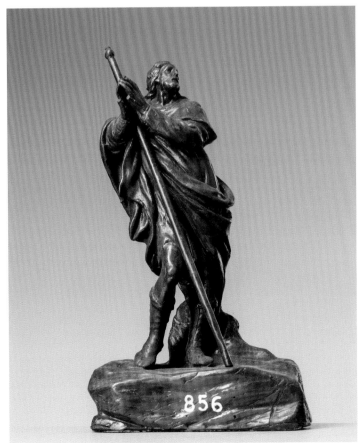

ficult to produce a mould from a non-sectioned model, but it is possible. This issue is raised by Bruschi in an often-cited passage on moulds made in Rome after the Antique.[100] Bruschi complains that moulds were impossible to use because they are not as detailed as those he was accustomed to working with, which originated from workshops of the artists who knew how to assemble complex works from separately cast pieces.

Carlo Ginori's decision to conquer the demands of the material and Gaspero Bruschi's obstinate pursuit of porcelain sculpture prolonged the life of late Baroque bronze sculpture produced under the last Medici. Instrumental in this was an army of *Kleinmeister* who supported the production. These included the sons or assistants of major sculptors whose daily work in their master's workshop had been confined to the auxiliary tasks of preparing models, taking moulds, finishing casts, and so on. If it were not for Doccia they and their work would never have come to light. The only article devoted to Selvi bears the appropriate title, *Who Was Antonio Selvi?*[101] The same question can be asked about Cristofani, the Webers, Vannetti, and a few others who make an occasional appearance in the documents. Serious scholarly research can partly answer these questions of artistic identity, which in turn sharpens our understanding of late Baroque sculpture in Florence. The study of Doccia can help us discover the commission behind Soldani's "San Giovanni di Malta" ("Saint John of Malta");[102] amplify our understanding of Foggini's art by showing that in addition to his magniloquent mythological groups, he delighted in modelling the *Caccine* (small hunting groups), rendered so charmingly in porcelain;[103] add solid proof to the attribution to Piamontini of a *Seated Hercules*, and see what his elephant with a putto looked like;[104] realize that it was Giuseppe Broccetti who made the small scale *Samson and the Philistines*.[105] As scholarship has guessed fifty years ago, in Doccia lies the secret of appreciating that the 'twilight' of the Medici is no less fascinating than their dawn and zenith.

11. Massimiliano Soldani Benzi, *Saint Raymond of Penyafort*, gold, Florence, Museo delle Cappelle Medicee

12. After Massimiliano Soldani Benzi, *Saint Benedict Throwing Himself into the Thorns*, wax, Sesto Fiorentino, Museo Richard Ginori of the Doccia manufactory

[**3.**] *In the wake of Giambologna*

Even as he was assembling sculptural models from the estates of the last Medici bronze artists, Ginori turned his attention to Antiquity. Although he did not have the moulds for the full-scale bronze copies Soldani had made after the ancient statues in the Uffizi, Ginori could turn to the Webers. Those for the *Wrestlers*, which was sold by Weber to Ginori on 9 July 1744, were probably based on Soldani's *gessi* or moulds after the ancient marble.[106]

Foggini was another possible supplier of copies after the Uffizi's ancient sculptures. His father had made a series of large bronze copies for Thomas Wentworth, first Earl of Strafford.[107] He could therefore avail himself of the moulds of the *Knife Grinder*, which he lent to Bruschi for reproduction but then claimed back – putting at the factory's disposal the sections of a *gesso* that was cast employing these moulds instead.[108] The *gesso Hermaphrodite* sold by Foggini in 1754 was probably a positive like the *Knife Grinder*, whereas the *Wrestlers* described as by Foggini in the 1778 inventory was a reduction by Giovan Battista after the Antique.[109]

As we have seen, Weber also took moulds directly from the Uffizi's *Pomona* and *Venere Celeste*, but when Ginori later required the models of other antiquities from the same collection, he turned to the professional *formatori* Niccolò Kindermann and Gaetano Traballesi (who had also made moulds after Jacopo Sansovino's *Bacchus*, now in the Bargello but then in the Uffizi.[110] There must have been other ways of acquiring moulds from renowned Uffizi statues, for example, those that served for the magnificent porcelain *Seated Venus*, but the sources remain silent about them.

Acquisitions of moulds and models from ancient and later sculptures preserved in Rome started in 1745 and intensified in the last years of Ginori's life.

They have recently received more attention in an attempt to catalogue the models after the Antique, almost all of which have a Roman provenance.[111] In his quest for copies after Roman antiquities, Ginori was assisted by Guido Bottari, the brother of Monsignor Giovanni Gaetano, a notorious enemy of the Baroque. Ginori's Roman correspondence also occasionally refers to marbles of other dates, for instance, a set of bronze reductions made for Doccia, including copies after Bernini and Legros.[112] The presence of the moulds for this set of bronzes in Rome helps determine whether these bronzes, which were acquired in Italy by George Parker, second Earl of Macclesfield, are Roman or Florentine.[113] The fact that they were acquired in Rome proves that the Macclesfield bronze reductions after the Antique, and other copies like the *Marsyas* by Pierre Legros, today in the Liechtenstein Princely Collections, are most likely extremely rare early 18th-century Roman bronzes.

Ginori's Roman acquisition campaign is but a footnote in the more complicated story of the Neoclassical phenomenon. By the time his attention turned to Rome, Ginori had come to align himself with the mainstream, in an obvious attempt to meet the requirements of a changing international taste. Among the statues preserved in Rome of which Ginori desired a copy was the *Mercury* by Giambologna, then in the Villa Medici and today in the Bargello. In 1747, an anonymous writer informed Ginori:

> As the models of the rarest statues in this, His Imperial Majesty's villa, have been formed on behalf of His Beatitude to dispatch them to Bologna, I send you this information and would be delighted if through this path Your Excellency would be able to take advantage of the desired model of the Mercury.[114]

If the letter's date is indeed 1747, as suggested by its editor, this would be the earliest instance of a cast taken from this bronze, which epitomizes the style of Giambologna and that of late Mannerist sculpture. The cast commissioned by "Sua Beatitudine", that is, the Bolognese Pope Benedict XIV Lambruschini, is documented in 1766 in the Accademia Clementina, which benefited greatly from the pope's patronage.[115] In Doccia, the model does not seem to have survived, although there are several versions recorded in the 1778 inventory.[116]

Forgotten in the Villa Medici for which it was made and where it had arrived in 1580, the *Mercury* became one of the most widely reproduced Renaissance statues after its 1784 removal from the Roman setting for which it had been conceived and became the centre of a newly arranged room for modern bronzes in the Uffizi.[117] This rediscovery marked a new turn in the *Fortleben* of Giambologna, whose works had never ceased to be admired and reproduced, in Italy and abroad. It is significant that Soldani's patron, Johann Adam Andreas I of Liechtenstein, requested from the Bolognese sculptor Giuseppe Mazza in 1693 terracotta statues of "ratti di Sabini o le forze dell'Hercole, anche Venerine" ("Rapes of the Sabines or Labours of Hercules, also small Venuses"), all subjects typical of the Giambologna small bronzes.[118]

In Florence, the spirit of Giambologna's art was never extinguished. This was not only because of the presence of his works but also because of the survival of his workshop where his large-scale models were kept into the 18th century, and where they could be studied and copied. Moreover, Giambologna's *fonds d'atelier* survived until the end of the Seicento. Pietro Tacca had appropriated the small-scale models against the wishes of Giambologna's heirs and had bequeathed them to his son Ferdinando.[119]

But it is unclear whether Tacca or Susini had kept the moulds. In a letter to Belisario Vinta dated 6 August 1605, Giambologna says that Susini had cast in his (Giambologna's) moulds a series of statuettes for Germany.[120] These were, he adds, among the most beautiful things that can be had from my hands. These words not only anticipate Soldani's high esteem of everything that was cast in his moulds but suggest that perhaps Susini was the person who physically possessed them. Indeed, he continued to reproduce his master's small bronzes up to his death in 1624, as did his nephew Giovanfrancesco and his son Antonio the younger. Antonio's ownership of the moulds for Giambologna's *bronzetti* seems to be confirmed by the fact that Pietro Tacca had to resort to actual Giambologna *bronzetti* in order to make a series of copies for Henry, Prince of Wales, and also because only one series of Giambologna copies in small size is known to have been made by Ferdinando Tacca.[121]

From these successors to the style and the estate of the great sculptor there is a direct link to Doccia. After relating the acquisition of all the *gessi* from Soldani's heirs, Lorenzo Maria Weber adds that he had bought "from Tacca's heirs many models by Giambologna".[122] The Webers were therefore able to supply moulds after these models, but the heirs of Ferdinando Tacca were not their only source, as we shall see. And it is possible that they also acquired moulds or models by the Taccas themselves.

Such a model is, in my opinion, the *Bacchus on a Barrel* (fig. 13), an adaptation of Giambologna's 1583 *Dwarf Morgante* (Museo Nazionale del Bargello), of which a bronze cast in the Louvre has been attributed to Antonio Susini by Bertrand Jestaz, who suggested this was the original model by Giambologna for a statuette of the Dwarf Morgante.[123] A sugar sculpture of this model was made by Pietro Tacca for the wedding banquet of Henri IV and Maria de' Medici.[124] A bronze version with the Bardi in the late 18th century, when it is described as by Giambologna, could possibly be identical with the Louvre cast, which does not have a French royal provenance as do most bronzes by Giambologna's followers in the Louvre.[125]

Other Tacca models are five *gesso Labours of Hercules* (figs. 14–17, 19) preserved in the Richard Ginori factory.[126] These impressive plaster sculptures form a set of which only the model of *Hercules Carrying the Globe* has been published by Lankheit, who identified it as an Atlas.[127] The remaining four labours were illustrated in a recent publication without recognizing in these figures one the most remarkable sets of bronzes ever made in Seicento Florence: the *Labours of Hercules* commissioned from Pietro Tacca, Orazio Mochi, and Andrea di Michelangelo Ferrucci by Grand Duke Cosimo II for the King of England.[128] Simonetta Lo Vullo Bianchi had published in 1931 two archival references to "five Labours of Hercules, that is, models to cast in bronze, which were to be used for the king of England", made by Tacca.[129] A later discovery, by Anthea Brook, provided more information on this commission, a claim to payment by Francesco Mochi on behalf of his father Orazio.[130] This reports the size of the two *Labours*

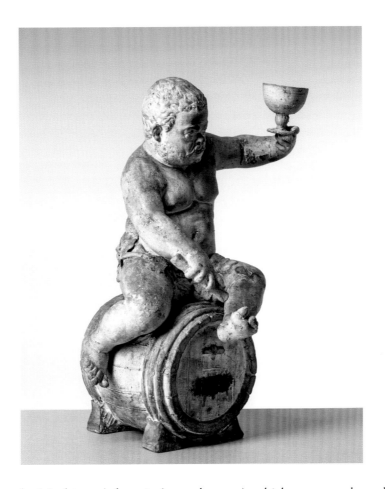

13. After Pietro Tacca, *Bacchus on a Barrel*, painted terracotta, Sesto Fiorentino, Museo Richard Ginori of the Doccia manufactory

by Mochi: 1–1/3 braccia (around 77 cm), which corresponds to the Doccia set. Two bronze versions of *Hercules Carrying the Globe* are known.[131] That in the Liechtenstein Princely Collections (fig. 18) has a provenance from the French royal collection.[132] Both bronzes have been securely attributed to Ferdinando Tacca after models by his father and correspond stylistically to the Doccia *gessi*. The discovery of the latter is not only important for better understanding the work of Pietro. It also makes it possible to see how the son, Ferdinando, developed the theme in a truly Baroque fashion in his *Hercules Carrying the Boar* and *Hercules with the Stag* (these two bronzes were in the French royal collection bronzes and are today in the Louvre).[133]

The provenance of these *gessi* may appear in the Ginori accounts which report the delivery of "four plaster statues" on the 24 December 1751 and another four on the 28 February 1754, by Orazio Filippini.[134] Orazio, was the son of Jacopo, who was Foggini's assistant in making bronzes and cast a bronze version of Cornacchini's *Endymion*.[135] As only the *Hercules Carrying the Globe* is listed in the 1778 inventory together with its moulds, it is possible that only the latter was moulded and that it had a different provenance than the others. This is plausible since others sources for such models may have existed in Florence.

For instance, the professional *gessaio* (maker of plasters) Cristofani was paid in 1744 for a series of moulds, the subject of which suggests they are Giambologna models as well as "for the price of 4 plaster moulds of the 4 Slaves that are at the Leghorn dock".[136] But the most likely source for models by Giambologna and his followers besides the Tacca heirs had escaped attention and involves – again – the Webers.

After saying in the autobiographical note that they bought Soldani's *gessi*, Lorenzo Maria Weber adds that they also bought "all wax by the Fleming [François Duquesnoy], by Algardi, and other things".[137] At first I was surprised by this affirmation but later realized that these waxes must be those Soldani described as preserved in his workshop when he sent Prince Jo-

hann Adam Andreas I a list of all the models he owned.[138] As he had been in Rome and studied with Ercole Ferrata whose atelier contained an encyclopaedic collection of models with an academic purpose that in many ways anticipates that formed by Carlo Ginori, Soldani could have obtained these models from Rome. His *Nota de' modelli di figure et altro di cera che mi ritrovo nel mio studio* (*Note of the figures "et alia" in wax that I have in my workshop*) includes a series of Giambologna models. Among these there are two animal fighting groups, "un Gladiatore in atto di tirare la stoccata" ("a Gladiator represented as he is about to make a thrust with a *stocco*, or sword"), which can be identified with Giambologna's *Mars*; "un Gladiatore ferito sedente dell'istesssa grandezza" ("a seated wounded Gladiator of the same size"), which could be the Susini reduction after the *Dying Gaul*; "un Mercurio volante" ("a Flying Mercury"); "una Venerina tutta nuda in piedi" ("a naked, standing small Venus"); "un Gruppo di Ercole e Anteo" ("a group of Hercules and Antaeus"). The list shows that Soldani owned a large number of Giambologna models, which may have reached Doccia through the Webers. How difficult it is, however, to establish the provenance for a single model, is shown by the fact that Foggini also had Giambologna models, the two animal fighting groups and *Hercules and Antaeus*.[139] Through Weber, Doccia also acquired a model of the *Polizena*, which Lankheit has identified with a model attributed to Pietro Tacca, the *Tarquin and Lucretia*, as well as a pair of bronzes representing Minerva and Mercury, attributed to Francesco Fanelli, but in fact by Ferdinando Tacca, who was paid for a bronze version of the latter (private collection, Genoa).[140]

In the mid-1960s, the director of the factory, Gino Campana, had moulds cast in biscuit and these include the occasional Giambologna model which is not immediately identifiable in the inventory.[141]

14. After Pietro Tacca, *Hercules and the Lion*, plaster, Sesto Fiorentino, Museo Richard Ginori of the Doccia manufactory

15. After Pietro Tacca, *Hercules and the Hind*, plaster, Sesto Fiorentino, Museo Richard Ginori of the Doccia manufactory

16. After Pietro Tacca, *Hercules and the Boar*, plaster, Sesto Fiorentino, Museo Richard Ginori of the Doccia manufactory

17. After Pietro Tacca, *Hercules and Cerberus*, plaster, Sesto Fiorentino, Museo Richard Ginori of the Doccia manufactory

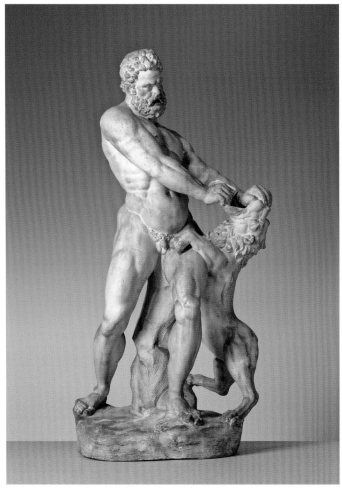

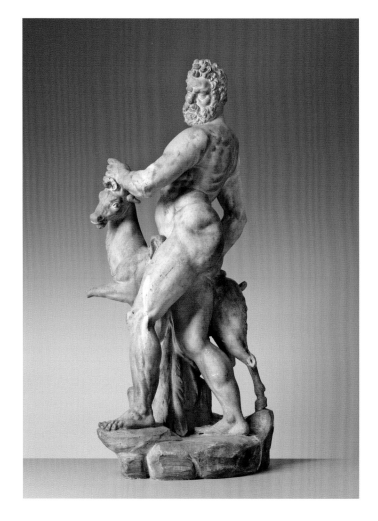

At Carlo's death, no inventory of the moulds and models was drawn up. There is therefore no means of ascertaining the size of the collection in 1757. An inventory was made only in 1778 with a view to dividing Carlo's estate between his heirs, the brothers Bartolomeo, Giuseppe, and Lorenzo. An inventory dated 6 October 1778, which I recently discovered in the Ginori family archive, is preserved next to a copy written in the same calligraphy as the long-known, undated *Inventario dei Modelli* and *Inventario delle Forme*: it has been recently suggested that these two complementary lists were drafted on the occasion of Lorenzo's death.[142] But if the last will of Lorenzo had been consulted, it would have emerged that he did not request such an inventory.[143] A partial inventory of the moulds, where it is noted that certain moulds had been added after the *divise* (partitions) prompted the discovery of the 1778 inventory.[144] This new document is central to the history of the factory; we learn that the six rooms in which the moulds and models were kept were located in a wing on the left-hand side of the building. They would have been moved there after Lorenzo had rebuilt the factory in 1766. In 1754 the room for them had been next to the galleria where they were displayed.[145]

From the 1778 inventory, it appears that plaster prevailed in the models collection. This explains why in the undated inventory the word "cera" ("wax"), is added to distinguish the exceptions. Lankheit says he was unaware of the existence of the *gessi* in the factory.[146] Hence, at its opening in 1965, the Museo di Doccia came to house a collection of waxes. This created the impression that the Doccia model collection was essentially a collection of waxes, although it was actually more of a *gipsoteca*. The newly discovered inventory is the first document that offers an overall view of the factory and of the collection, and it provides a fixed *terminus ante quem* for the presence of certain models.

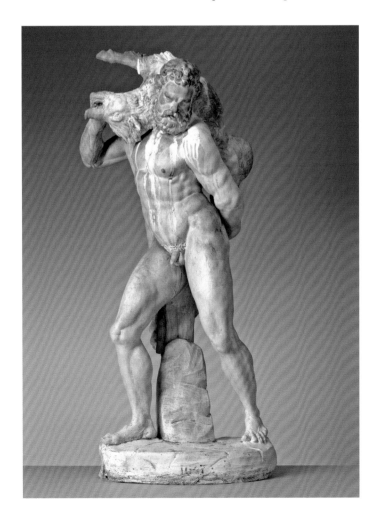
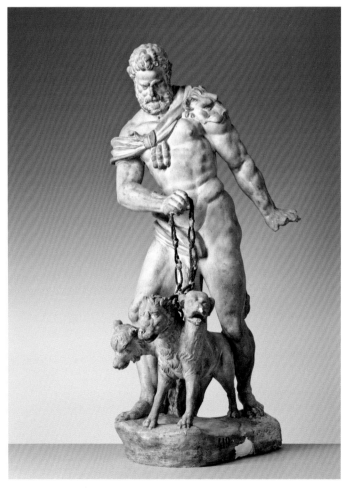

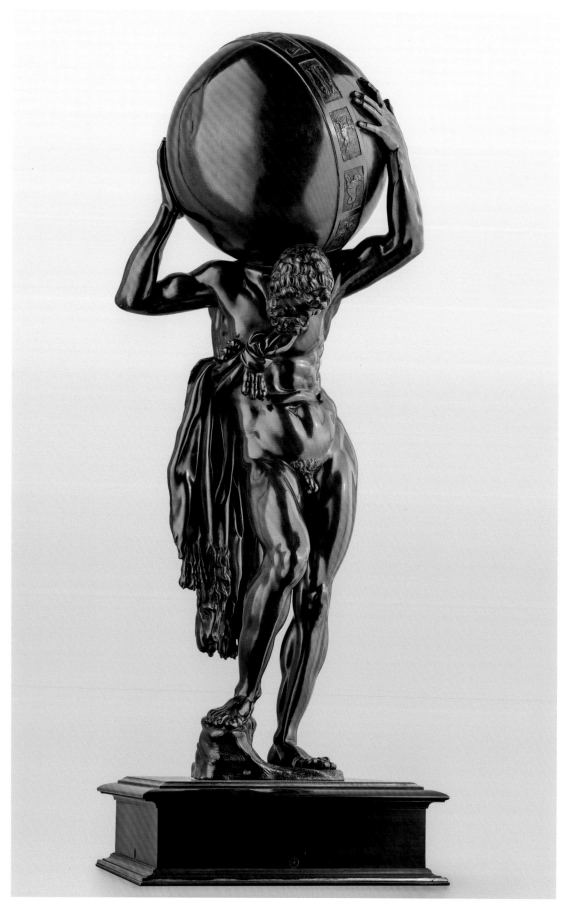

18. Ferdinando Tacca, *Hercules Carrying the Globe* (after Pietro Tacca), bronze, Vaduz-Vienna, Liechtenstein, The Princely Collections

19. After Pietro Tacca, *Hercules Carrying the Globe*, plaster, Sesto Fiorentino, Museo Richard Ginori of the Doccia manufactory

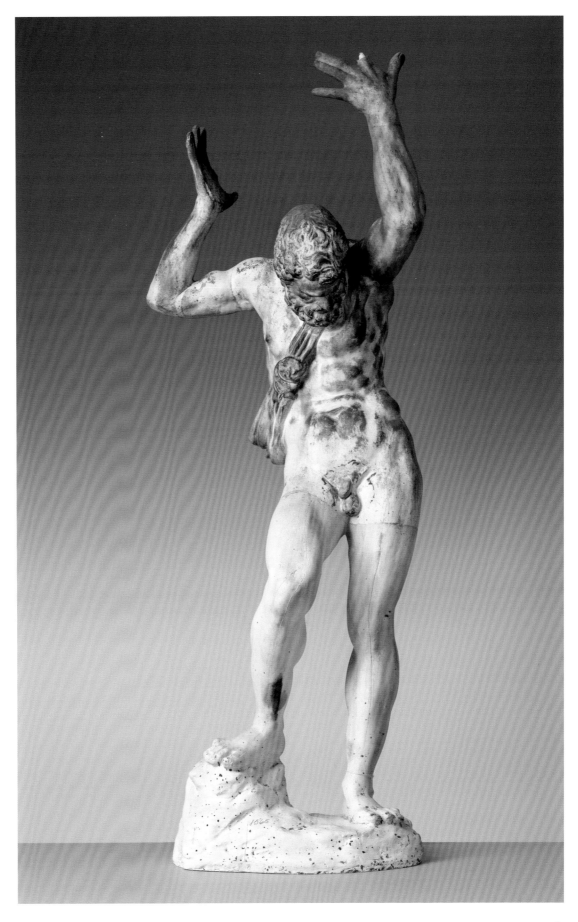

In one of the many publications issued on the occasion of the legal dispute between Carlo's sons, the following sentence appears:

> the factory was since that time equipped with models and the relevant moulds of every life-size statue, and reliefs, which constitute the dignity of our Italy with regards to sculpture, and which can be described as a truly unique collection of every rarity that can be found both in our city, and in the Medici Gallery [the Uffizi], and in the city of Rome.[147]

These lines, written twenty years after Carlo Ginori's death, reflect the pride of having achieved an ambitious plan as part of an eminently Italian enterprise.[148] As the moulds and models preserved in the factory first became widely known to scholars after 2004, the true meaning of these lines began to acquire substance.[149] Scholars face an arduous task in reconstructing this enterprise. We have tried here to outline the main tasks for future research, its most difficult problems, but also its rewards. If the reconstruction of Ginori's grand project can be accomplished, at least on paper, perhaps it might become easier to explain how true these words are, and how important for Italy that its "decoro … in ragione di scultura" might survive for future generations.

I am greatly obliged to Marquis Lionardo Lorenzo Ginori Lisci for generously granting me access to the Ginori family archive and to his archivist Elena Mattioli for her constant help and patience.
My sincere gratitude goes also to Dr. Hans Kräftner, Director Liechtenstein. Princely Collections, for allowing me the use of the reproduction of Ferdinando Tacca's *Hercules Carrying the Globe*.

1 Oxford, Bodleian Library, Mss. Rawlinson, Letters, 132, fol. 250v. In transcriptions from documents, I have normalized the orthography to modern standards and expanded the abbreviations.

2 For the Munich set see – besides the literature referred to in the most recent entry by Riccardo Spinelli (in Florence 2009, pp. 120–2, cat. 29) – Avery 1995a, pp. 7–8 (for the relief frames designed by Soldani), and Avery 1998b, pp. 8–9, and Avery 1998a, pp. 30–2, for the iconography. For Soldani's separately cast large bronzes, see Zikos 1996, p. 133. For casting in pieces, see Penny 1993, pp. 248–52.

3 See Zikos 2007.
4 See Bewer 1996, pp. 72, 469; Smith 2013, pp. 36–9.
5 See Zikos 2005a, pp. 159–64.
6 Lankheit 1962, p. 240.
7 For the technique employed, see Gentilini 1996, pp. 78–80.
8 According to the full version of his posthumous inventory.
9 Zikos 2005a, p. 159.
10 ASFi, Bardi, Prima serie, S.I.1. The two terracottas are first mentioned and described generically as "two oval reliefs, each some two feet high, of which one depicting the count Ridolfo and the other with several figures" in a 1730 posthumous inventory of Flaminio de' Bardi as being in his bedroom (in the same filza of the ASFi). It is only in the 1772 inventory that the two reliefs are described by Soldani and identified as the models for the two bronze ovals in Vernio. Another branch of the Bardi, the Bardi Alberti, owned a terracotta version of Soldani's *Pi-

età (cat. 7), possibly the same as the one referred to in the *Inventario dei Modelli* (Lankheit 1982, 2:3). It is first documented in the estate of Pier Maria Bardi in 1749; AG, Bardi, H no. 6, ins. 34.

11 For the Burlington set, see Avery 1998[a], pp. 30–2; for the pair, Avery 1998[b].

12 Oxford, Bodleian Library, Mss. Rawlinson, Letters, 132, fol. 243v.

13 Ibid.

14 Zikos 2005[b], pp. 4–36.

15 Prince Johann Adam Andreas I of Liechtenstein to Soldani, dated Vienna, 30 March 1695: "But with great displeasure we found that the wax relief was broken in a thousand pieces and seemed impossible to fix, but by the look of a few pieces it must have been a beautiful thing"; Lankheit 1962, p. 327, doc. 658.

16 Zikos 1996.

17 The date of Soldani's retreat can be evinced from his often-cited correspondence with Zamboni.

18 Bruschi received his first monthly salary of 10 scudi on 27 July 1737 (AGL, 210, fol. 266dare/sinistra). See Ginori Lisci 1963, p. 24. He was born in Florence on 27 October 1710; Bellesi 2003, p. 17. Ginori Lisci (1963, p. 86) says he died in 1780.

19 These were both his personal property and that of the factory. See p. 124 of an 1778 inventory which I discovered in the Ginori archive, which will be discussed below.

20 See Biancalana 2009, pp. 41–2.

21 See Zangheri 2000, p. 52.

22 See Roani Villani 1986; Roani 2006, pp. 67–71.

23 See Roani Villani 1986, pp. 61–2, note 9; Roani 2006, p. 68.

24 Gian Gastone's portrait was carved for the Accademia del Disegno; F.M.N. Gabburri, *Vite di pittori*, ms., BNCF, Palatino, E.B.9.5., III, fol. 135v. A bronze group previously attributed to him is in fact by Piamontini; D. Zikos in Vienna 2005, pp. 457–8, cat. 308.

25 I use the term as established by Lankheit 1982, p. 17: "der Begriff "modello" [ist] stets im Hinblick auf die beabsichtigte Verwendung für die Porzellanplastik zu verstehen".

26 See below, p. 53.

27 For Ginori in Livorno, see R. Balleri in Sesto Fiorentino 2006, pp. 34–7. *Gessi* by Giambologna and Pietro Tacca in Borgo Pinti are listed in a 1687 inventory; Lankheit 1962, p. 269, doc. 258.

28 Foggini carved the equestrian monument to Francis Stephen, which crowned the arch; Roani Villani 1986, p. 55; Roani 2006, p. 69.

29 Foggini received 10 scudi on 10 April "a conto dei lavori di statue che fa per servizio dell'Arco Trionfale alla Porta a San Gallo"; AGL, 210, fol. 289dare/sinistra.

30 AGL, 210, fol. 338dare/sinistra; and AGL, Carlo Ginori Conti & Ricevute 1738–1741, no. 673. In the receipt Foggini itemized twenty-five days work of a *formatore*; Biancalana 2009, p. 63, who however does not note the involvement of the *formatore*.

31 AGL, 210, fol. 348dare/sinistra; and AGL, Carlo Ginori Conti & Ricevute 1741–1746, no. 67.

32 See Biancalana 2009, p. 42.

33 See the essay of Cristina Maritano in this volume, pp. 100–2.

34 See Biancalana 2009, p. 63.

35 Ibid.

36 AGL, 210, fol. 345dare/sinistra: "to Giuseppe Ricci from the Magistrato de' Pupilli as price for a terracotta relief with its pearwood frame, and other plasters".

37 Biancalana refers only to the receipt in AGL, Carlo Ginori Conti & Ricevute 1741–1746, no. 25.

38 See Balleri 2007.

39 AGL 210, 213, 216, and 220 are the ledgers that contain a section devoted to similar expenses.

40 AGL, 216, fol. 201v; and AGL, Carlo Ginori Conti & Ricevute 1749-1750, no. 221; Biancalana 2009, p. 66.

41 AGL 210, fol. 200r; Zikos 2010, p. 21. First published but not discussed in Biancalana 2009, p. 67.

42 Weber's autobiographical note was first published by Lankheit 1962, pp. 243–4, doc. 52.

43 The last documented works by Piamontini date from 1740; Bellesi 2008, pp. 75–6.

44 The former were probably the puncheons of the letters of the alphabet. My thanks to Lucia Simonato for this explanation.

45 This is suggested by Lorenzo Maria's use, in the above-mentioned autobiographical note, of the third person ("si fece"), also for those "punzoni, modelli e forme" commissioned by Ginori.

46 It is by inference from the price of this large and complex group that we can say that the first set of Soldani moulds probably related to only two sculptural groups.

47 AGL, 210, fol. 200r, and AGL, Carlo Ginori Conti & Ricevute 1741–1746, no. 637; Lankheit 1982, p. 14.

48 Biancalana 2009, p. 70.

49 Lankheit 1962, p. 284, doc. 351. This *Nota* was republished by Biancalana 2009, pp. 72–4, but without reference to Lankheit.

50 Lankheit 1962, pp. 243–4, doc. 52.

51 AGL, 210, fol. 200r, and AGL, Carlo Ginori Conti & Ricevute 1741–1746, no. 396. Biancalana (2009, p. 67) erroneously ascribes the model to Ticciati. For this see Lankheit 1982, 39:108.

52 See Biancalana 2009, p. 70.

53 See Zikos 2005[a], p. 176, note 9.

54 If these were indeed two reliefs from the Soldani set, then Weber would have taken moulds from the waxes cast in the factory unless he had already produced a copy in his workshop before selling the moulds to Ginori.

55 See Zikos 1996, pp. 134–8.

56 See Conti 1977, p. 198.

57 See E. Nardinocchi, in Florence 2015, pp. 134, pp. 134, 136, 138, 140, cats. 29–32.

58 The descriptions follow the invoice referred to by E. Nardinocchi, in Florence 2015, p. 134, cat. 29.

59 On these see the relevant entries in Florence 2006[c] and the essay by Tomaso Montanari in this volume, pp. 29–43.

60 Lankheit 1982. See the reviews by Avery 1982; Montagu 1983.

61 See below pp. 61–2. They do, however, contain later additions as was already recognized by Lankheit 1982, p. 19. See also Balleri 2014[b], pp. 55–74.

62 A partial inventory of the moulds was drafted in 2012 when the works and other objects pertaining to the Museo di Doccia were listed. See the essay by Cristina Gnoni Mavarelli in this volume, p. 27.

63 Weber figures fifty-three times in the Ginori accounts as supplier of moulds and models, as opposed to twenty-five times for Foggini. Nevertheless, Biancalana 2009, p. 63, claims that "it is, though, Foggini's the most recurrent name in these years".

64 Lankheit 1962, p. 243, doc. 52: "He engraved in a piece of steel a Bacchanal of his own invention, the size of a *soldo*, with a gilt bronze frame and steel ornaments of vine leaves and grapes".

65 This is implied by a sequence of alternating payments to Selvi and Weber between 29 May (AGL, 210, fol. 233v) and 17 December 1746 (AGL, 213, fol. 203r).

66 The first expense on that invoice dates from 29 July 1745; AGL, Carlo Ginori Conti & Ricevute 1741–1748, no. 800; Biancalana 2009, p. 69. A *gesso* copy is still preserved in the museum (inv. 1558).

67 AGL, Carlo Ginori Conti & Ricevute 1741–1748, no. 849; Biancalana 2009, p. 69.

68 Anton Filippo Maria Weber died on 4 October 1751 (ASFi, Ufficiali della Grascia, 202, Libro di morti, gennaio 1750–dicembre 1759). He was born on 12 November 1699 (AOD, Registro 72, fols. 8v–104r).

69 The artist was paid on the 20 January; AGL, 216, fol. 208r, and Biancalana 2009, p. 67.

70 AGL, 216, fol. 203v; Biancalana 2009, p. 67.

71 An interesting and, as far as I see, unpublished set of 1753 documents proves that Foggini was teaching drawing classes in an "Accademia del Disegno" in

his Borgo Pinti premises (ASFi, Scrittoio delle Fortezze e Fabbriche, Fabbriche Lorenesi, 1968, fasc. 93).

72 AGL, Carlo Ginori Conti & Ricevute 1749–1750, no. 188, paid 28 April 1750; Biancalana 2009, p. 65.

73 This receipt refers to the figures of the "giorno" (Day), "note" (Night), and "tempo" (Time), and to a group of Hippomenes and Atalanta; AGL, 216, fol. 201r; Biancalana 2009, p. 66, who wonders whether the figure of Time refers to the group representing *Time Abducting Beauty* of which a porcelain version is in the *Ginori Tempietto* (cat. 4). It does not, of course, refer to that group but to the *Allegory of Time* in the same *Tempietto*.

74 AGL, Carlo Ginori Conti & Ricevute 1746–1749, no. 426, paid 8 June 1748; Biancalana 2009, p. 64.

75 AGL, Carlo Ginori Conti & Ricevute 1746–1749, no. 564.

76 See Biancalana 2009, pp. 64–5.

77 Lankheit 1962, p. 229, doc. 29.

78 Ibid., p. 289, doc. 398.

79 Zikos 2005[b], p. 15 note 27.

80 See Roani Villani 1993.

81 AGL, 216, fol. 201v.

82 Balleri 2014[b], p. 10

83 D. Zikos, in Munich 2015, pp. 196–8, cat. 17.

84 Ibid.

85 Lankheit 1982, 72:6.

86 AGL, Carlo Ginori Conti & Ricevute 1749–1750, no. 223. The wax is listed in the 1778 inventory (Lankheit 1982, 32:56).

87 AGL, 210, fol. 217v.

88 AGL, 210, fol. 219v. The *Sacrifice of Abraham* is after the model for the bronze made for the Electress Palatine (Zikos 2005[b]). And the description "gruppo di baccanali" fits the bronzes and small marbles Piamontini made with such subject.

89 AGL, 210, fol. 204r. Both a marble and a bronze of this subject by Piamontini are known.

90 Zikos 2005[a], p. 158, note 10.

91 Lankheit 1962, p. 313, doc. 517.

92 See Balleri 2014[b], p. 23.

93 Vannetti sold waxes to Ginori between 7 December 1751 and 18 July 1752; AGL, 216, fol. 204v and 207r, and Biancalana 2009, pp. 69–70.

94 For Vannetti's sale of Giovanni Baratta's group of the "Virtù che opprime il vizio" (AGL, 216, fol. 205v), see now Balleri 2014[b], pp. 23–4. She considers the work sold by Vannetti "after an original by the sculptor Giovanni Baratta from Carrara" (ibid.), but it should be underlined that the entry in the Ginori account book does not refer to a copy but simply to a group by Baratta. Another question is of course whether the *gesso* today in the factory is an autograph work or not. Inexplicably Biancalana (2009, p. 70) omits the name of the sculptor Benedetto Selvi from the quotation from AGL, 216, fol. 209v: "for the price of two reliefs representing Saint Catherine's betrothal to Our Lord, and Justice and Peace, by Benedetto Selvi", the son of Soldani's pupil Antonio; see Zangheri 2000, p. 297.

95 ASFi, Scrittoio delle Fortezze e Fabbriche, Fabbriche Lorenesi, 1969, fasc. 15.

96 "… for making the wax cast and the mould of a group representing Time abducting Beauty" (AGL, 210, fol. 205r; Biancalana 2009, p. 63). For a hitherto unpublished porcelain version of this, see the essay by Gonzàlez-Palacios in this volume.

97 Cristofani was paid "for having moulded 4 large bas-reliefs" on 9 April 1745 (AGL, 210, fol. 221v), not long after Foggini had delivered "four wax bas-reliefs" on 29 March (ibid. fol. 220v; Biancalana 2009, p. 69, who however does not connect the delivery of the waxes and the making of the moulds).

98 Cristofani is paid on 12 February 1745 for having made, among others, "more moulds of the Baptism, of Our Lord"; AGL, 210, fol. 220r. Although Foggini was paid for his wax of the same model on 10 March 1744 (ibid., fol. 220v), it is still likely that he had delivered it in order for Cristofani to take moulds of it, and the connection was noticed by Biancalana 2009, p. 69.

99 Balleri 2014[b], p. 9.

100 In a letter to Ginori dated 27 July 1754 and published by Biancalana 2009, p. 54.

101 Avery 1995[b].

102 A "a group of St. John the Baptist and an allegory of the Order of St. John of Malta" figures in Soldani's inventory and confirms the unmistakeable stylistic evidence that this Doccia model is by Soldani and not by Ticciati, as has been recently claimed; Balleri 2014[b], p. 50.

103 Zikos 2014[a], p. 44.

104 Ibid., p. 59 (for Piamontini's *Seated Hercules and Cerberus*), p. 60 (for Piamontini's *Elephant*) of which there is a biscuit in the Museo di Doccia (inv. 969).

105 See Avery 2008, p. 67.

106 Weber was paid on the 9 July 1744 for the "making the moulds of the Wrestlers" (AGL, 210, fol. 204v; Biancalana 2009, p. 68). Full-scale bronze copies after the Uffizi *Wrestlers* had been made by Soldani for the Duke of Marlborough; Zikos 1996, pp. 131–34.

107 D. Zikos, in Christie's, London, 1 December 2005, *The Macclesfield Sculpture; the Fruits of Lord Parker's Grand Tour*, p. 27.

108 See Biancalana 2009, p. 50.

109 If the *Hermaphrodite* were the result of a Ginori commission for moulds, as has been recently suggested (Balleri 2009, p. 134), then Ginori would also have paid for the mould and not only for the plaster. It is therefore likely that Foggini already had the moulds of this statue which Soldani had offered to copy for Johann Adam Andreas I of Liechtenstein; Zikos 1996, p. 132.

110 On these two "formatori" ("mould-makers"), see Balleri 2014[b], pp. 133–5.

111 Ibid.

112 Ibid., pp. 81–2., and figs 73–6.

113 I had raised this question in D. Zikos, in Christie's, London, 1 December 2005, *The Macclesfield Sculpture; the Fruits of Lord Parker's Grand Tour*, p. 31, note 11. Although Balleri has connected some Doccia *gessi* with the Macclesfield bronze reductions (after Bernini's *Apollo and Daphne*, and after the *Rape of Proserpina*), she did not realize that they share a common origin with the model of Pierre Legros' *Marsyas* (Balleri 2014[b], p. 46 and fig. 45) and those of the *Venus Callipyge*, and the Villa Medici *Apollino* (ibid., figs. 257 and 258) in the Roman workshop which produced the Macclesfield bronze reductions.

114 Biancalana 2009, p. 76.

115 See Pagliani 2003, p. 162.

116 See Lankheit 1982, 29:34, 80:10,2.

117 See D. Zikos, in Munich 2015, pp. 146–8, cat. 3.

118 See Arfelli 1934 p. 427, doc. IV.

119 See Zikos 2010, pp. 186–99.

120 See Zikos 2013/2014, p. 204, where this long-known letter is discussed in context.

121 For the bronzes for Henry, Prince of Wales, see Watson, Avery 1973. For Ferdinando's copies after Giambologna, see G. Zanelli, in Genoa 2004, p. 534, cat. 142.

122 See Lankheit 1962, p. 244, doc. 52.

123 Jestaz 1979, pp. 78 ff.; AG, H.27, ins. 57.

124 See Watson 1978, p. 25.

125 "… a bronze group representing a Bacchus on a barell, on an ebony base with a white profile, by Giambologna" is documented with Carlo Bardi di Vernio in the 1770s; AG, H. 27, ins. 57.

126 First published in Balleri 2014[b], pp. 41–2, figs. 33–7.

127 Lankheit 1982, 30:40.

128 See Balleri 2014, p. 41: "the theme of the Labours of Hercules was common in the bronze sculptors' workshops, hence it is difficult to refer them to a specific circle. The might of the figures and their marked musculature could suggest a possible northern influence". This analysis is the more surprising as the author had already stated that the gessi were "can be approached, but only as far as the composition is concerned, to some bronzes by Tacca [sic] and by Antonio Susini".

129 Lo Vullo Bianchi 1931, p. 208, doc. XVIII.

130 Brook 1986, p. 291.

131 For the cast in the Robert H. Smith collection, see Radcliffe, in Radcliffe, Penny 2004, pp. 254–9, cat. 45.

132 See Vienna 2010, p. 270.

133 Paris 1999/2001, pp. 176–7, cat. 306, and p. 177, cat. 307.

134 AGL, 216, fols. 205r, and 120r.

135 Orazio di Jacopo di Bartolomeo was born on 1 March 1700 (AOD, Registri battestimali 73).

136 AGL, 210, fol. 217v (3 October 1744); fol. 217v (10 October 1744: "for four moulds of a Satyr, a Faun, an Apollo, and a Venus"); ibid. (12 October 1744: "for the moulds of two horses, and a small gesso bull"); fol. 219v (31 December 1744: among others for the moulds of "a Centaur").

137 See Lankheit 1962, p. 244, doc. 52.

138 Ibid., pp. 334–5, doc. 671.

139 AGL, Carlo Ginori Conti & Ricevute 1741–1746, no. 409 (2 October 1743: "two hunting groups, one of a horse and a lion, the other of a bull and a lion"), and Carlo Ginori Conti & Ricevute 1746–1749, no. 273 (27 May 1746: "Hercules and Anteus"); the latter also in Biancalana 2009, p. 64.

140 Weber was paid for the moulds of "Polizena" on 7 November 1743 (AGL, 210, fol. 201v). For the attribution of the composition to Tacca, see Radcliffe,

Penny 2003, p. 240, cat. 43. Balleri (2014b, p. 15) maintains the inventory's unlikely attribution to Foggini. For the Ferdinando Tacca *Mercury*, see Montagu 1983, p. 759, and G. Zanelli, in Genoa 2004, p. 534, cat. 142, fig. 1.

141 Among the Campana biscuit figure, among others, a *Kneeling Venus*, an *Apollino*, and a *Venerina* – all models represented through bronzes in the Bargello.

142 Balleri 2014b, pp. 55–6.

143 AGL, LXIV, no. 25, dated 23 July 1791.

144 This inventory is discussed by Balleri 2014b, p. 56.

145 See Mazzanti 2012, p. 141.

146 Lankheit (1982, p. 18) speaks of "die – sämtlich verlorenen – Arbeiten in Gips".

147 *Brevi note fatte per ora alla sfuggita per supplire occorrendo alla scrittura intitolata Osservazioni sopra la serie dei fatti riportati nella Scrittura pubblicata per parte del Clariss. Sig. Senat. Marchese Lorenzo Ginori*, Florence 1779, p. 2; AGL, LVIII.

148 As is evoked in Montanari's essay on Carlo Ginori in this volume.

149 The occasion was a visit organized by the Amici di Doccia in the manufactory on 18 May 2004.

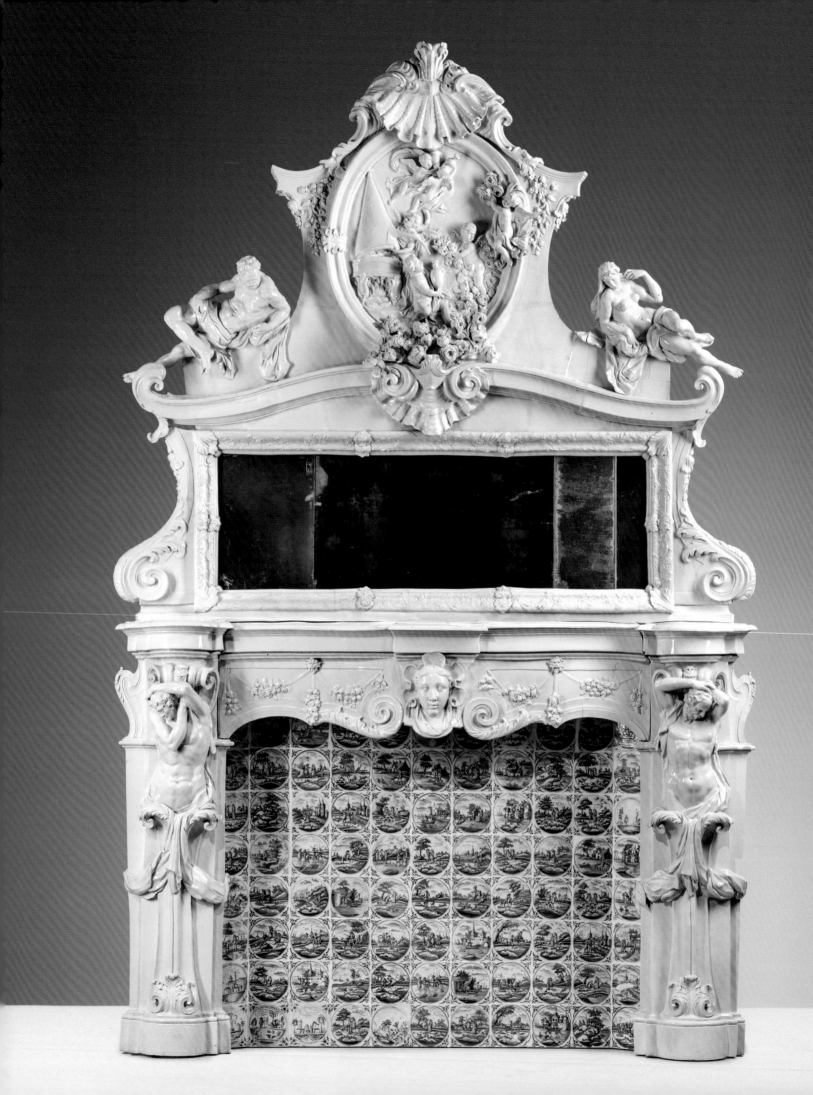

The Marquis' *Fireplace*

MARINO MARINI AND CRISTIANO GIOMETTI

In 1754, Carlo Ginori opened an exhibition gallery at Villa Le Corti near Doccia (formerly the Villa Buondelmonti) showing the manufactory's finest productions in which, of course, a special place was reserved for sculptures and large sculptural groups.[1] Documents confirm that among the displays was the monumental *Fireplace* that is now the pride of the sadly inaccessible Museo di Doccia (fig. 1; cat. 15). As in the case of all the monumental sculptures, Gaspero Bruschi supervised the work although, as we shall see, Domenico Stagi, a painter of *quadrature* of some repute who was actively involved with the porcelain factory at this juncture, also played an important role.

The lower part of the monumental structure must have already been completed by early March 1754, as on the 10th of the same month Gaspero Bruschi wrote to Carlo Ginori asking if he could "brick up the porcelain fireplace in the gallery, and if Your Excellency wants those *ambrogette* (square tiles) as you explained to me in Florence, I would be most grateful if you would arrange to have them sent here".[2] On 6 April, the majolica tiles finally arrived at the factory where "they [were] being put in place with the rest of the Fireplace".[3]

Those same *ambrogette* are still preserved on the back wall of the hearth (fig. 2); they are square tiles with country scenes or 'villages' painted in blue monochrome produced in Delft factories.[4] These imports were not confined to the purely decorative function of the fireplace but served as a model for the workers in Doccia to make similar tiles soon after. Many of these are still preserved in the ancient palaces of Florence and its environs (fig. 3).[5] From a close observation, it was possible to verify that among the 88 *ambrogette* in the fireplace, Ginori had made some in imitation of the Delft style, probably to complete the allotted space; those traceable to the Doccia factory (10 *ambrogette*) are placed in the less visible spaces, such as the splays or ends. The structure of the local products is similar to that of the Dutch prototypes with the figuration contained within a central tondo with double line and floral motifs at the corners. However, it is obvious at first glance that the artist had had some difficulty in drawing the figures and landscapes compared to the reference model.

This type of *ambrogetta* was probably painted in the *pittoria* (paint shop) of the manufactory while the tiles made *a stampino* (in a mould and thus cheaper), did not require particularly skilled workers.[6] A peculiarity of the Ginori specimens is the fact they they were almost exclusively used to cover the side walls; today there are only two examples known of tiles used for floors (the Piccolomini Library in Siena, the Loggia delle Benedizioni in the Vatican),[7] though a systematic survey of Ginori's majolica floors has never been undertaken.

An interesting point about this production is revealed in a report prepared in 1760 by Johannon de Saint Laurent for the children of Carlo Ginori. The scientist says that "for majolica you must seek to economise on paint, for which effect it is best to have works done that can be sold at a higher price through the added ornament of painting, or works that consume little paint, as in the case of the *ambrogette*, which for this reason constitute a very good article".[8] Indeed, the production of majolica on a large scale (whether for dishes, stoves, devotional plaques or tiles) served to finance the more expensive production of porcelain.[9]

Going back to the work in question, its next mention in the documents is dated 18 May 1754 when Bruschi and Giovanni Battista Fanciullacci advised Marquis Ginori that they would not be sending "the drawing of the mantelpiece of the fireplace [to Livorno], because we have hung it in expectation of Signor Stagi, who comes Monday to give his opinion".[10] So the wait for this appraisal suggests that Domenico Stagi was in some way involved in the design of this

1. Ginori manufactory, Gaspero Bruschi and Domenico Stagi, *Fireplace* (cat. 15), porcelain, Sesto Fiorentino, Museo Richard Ginori of the Doccia manufactory

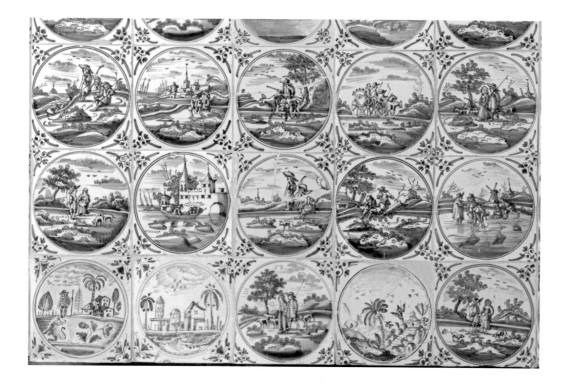

very complex structure, one quite unique of its kind, and we can plausibly infer that it was at his suggestion that the overall effect was rendered so sumptuous and theatrical. A native of Pietrasanta and pupil of Pietro Anderlini, Stagi was remembered by Gabburri for his qualities as a "painter of architecture and perspectives in fresco and tempera",[11] but above all, it is in the field of set designs that he expressed his finest talent, especially for the variety and realistic effects of his inventions.[12] In 1753 Antonio Galli Bibiena arrived in Florence, commissioned to produce ten scene changes for the Teatro della Pergola, and this experience proved crucial for the rest of Stagi's career, who from 1755 took part in the modernisation of the same theatre on commission to Francis Stephen of Lorraine and in accordance with a project by Giulio Mannaioni.[13] Therefore, the markedly theatrical design of the pediment is attributable to Stagi, who recomposed some of the elements of Bibiena's formal vocabulary in a measured fashion. The disruption of the traditional structure can already be noted in the mirror which, usually square in shape, framed in wood and placed above the lintel of the hearth, was in this case inserted in the lower part of the pediment and framed at the sides by two elegant plant motifs. Above, a mixtilinear tympanum, with a very slender and elongated line, introduces the apex where sculpture plays a dominant role: within a moulded frame in the central tondo, overwhelmed in several places by the overflowing composition, we see pictured an "a bas-relief oval of putti scattering flowers" by Massimiliano Soldani Benzi. Its wax cast is preserved at the Museo di Doccia, while a bronze version adorns the oratory hall of the Compagnia di San Niccolò at San Quirico di Vernio (figs. 4–5).[14] To complete the composition, at the ends of the cornice, we find the scaled-down replicas of *Dusk* and *Dawn* sculpted by Michelangelo for the tomb of Lorenzo, Duke of Urbino, in the family shrine in the Medici Chapel. The model, perhaps made by Gaspero Bruschi, is of particular interest for the history of sculptures in the manner of Michelangelo as they are shown with the bronze 'loincloths' commissioned by Cosimo III. They were sculpted by Giovan Battista Foggini to cover their genitals and only removed at the beginning of the 19th century.[15]

However, the presence of sculptures that follow and emphasise the architectural framework is also reflected in the frame of the hearth, on which two telamons were modelled in high relief and dynamic pose (fig. 6) with the torsion of the arms very similar to the powerful figures found on the facades of some 17th-century aristocratic palaces. For the purposes of compari-

2. Ginori manufactory, *Fireplace* (cat. 15; detail with *ambrogette*), Sesto Fiorentino, Museo Richard Ginori of the Doccia manufactory

3. Ginori manufactory, *Ambrogette*, majolica, Florence, private collection

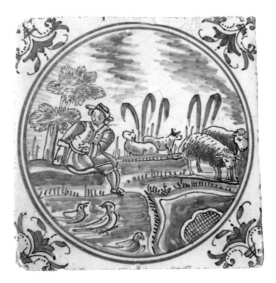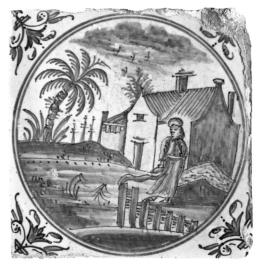

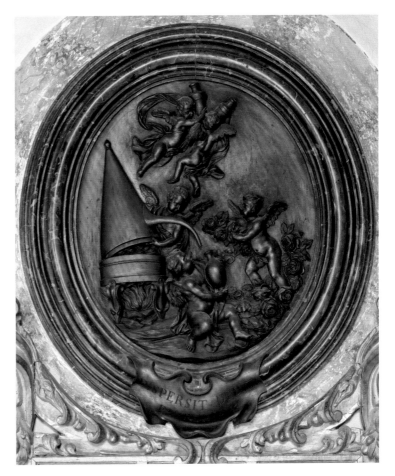

4. Ginori manufactory, Gaspero Bruschi and Domenico Stagi, *Fireplace* (cat. 15; detail after Massimiliano Soldani Benzi), porcelain, Sesto Fiorentino, Museo Richard Ginori of the Doccia manufactory

5. Massimiliano Soldani Benzi, *Putti Distilling Roses*, bronze, Vernio, oratory of San Niccolò

6. Ginori manufactory, Gaspero Bruschi and Domenico Stagi, *Fireplace* (cat. 15; detail of the telamon on the left), porcelain, Sesto Fiorentino, Museo Richard Ginori of the Doccia manufactory

son, it is useful to note the solutions adopted in Palazzo Davia Bargellini in Bologna (by Gabriele Brunelli and Francesco Agnesini) and Palazzo Gio Carlo Brignole in Genoa (by Filippo Parodi); perhaps the prototypes of these original compositions may be found in the studies and works of Pierre Puget and Alessandro Algardi, the teachers of Parodi and Brunelli, respectively. Unlike the examples mentioned above, however, the telamons in the Ginori *Fireplace* do not replicate the powerful bodies, made tense by the weight they hold, nor the strained facial expressions; it seems almost as though the effort required to hold up the massive pediment is being endured with quiet dignity.[16] Upon closer examination, in this case too, the intervention of Domenico Stagi must have been fundamental: a closer comparison can also be traced in certain Bibienesque scenographic solutions, in which the use of both full-length and half-length gesticulating telamons is very frequent. In our case, the half-length telamons, the cut-off at the height of the hips is resolved with a variably draped cloth. In this regard, see the drawing in the Metropolitan Museum attributed to the workshop of Giuseppe Galli Bibiena depicting three oriental-style pavilions with a fountain of Neptune at the centre (fig. 7):[17] in the sequence of pilasters framing the scenic space, we find a row of a telamons (more decorative than load-bearing) in the upper part, supporting the vases at the top which are posed just like the two figures in the fireplace's frame. The sharing of inventions and compositional forms within the Bibie-

7. Workshop of Giuseppe Galli Bibiena, *Three Pavillions with "Oriental" Cupolas with a Large Fountain Surmounted by Neptune*, pen, brown and grey ink over black chalk, New York, Metropolitan Museum of Art

nas' creative melting pot may explain Domenico Stagi's use of certain forms, as he would have been able to study them directly from Antonio Galli Bibiena's drawings and prints during their Florentine collaboration.

It is also very interesting that the same telamons are reproduced in a handsome fireplace – also in porcelain – in Palazzo Ginori on the Florentine street of the same name, and are very similar in composition and structure to those of Doccia, albeit without the architectural pediment and mirror (fig. 8).[18] In this case, one can note some variants starting with the two figures, which here are no longer contained within the stringcourse between levels, but instead cover it with their heads and the movement of their raised arms.

However, there is no equivalent in the Corsini inventories of a Doccia porcelain fireplace placed in the room of the same name in the family palace in Rome (now the Galleria Nazionale d'Arte Antica in Palazzo Corsini).[19] Sporadic archival mentions of a fireplace neither indicate the material used nor the manufactory, while such Ginori porcelain products as the two vases and the famous *Pietà* (cat. 9) are instead recorded and described.

From its first years of operation the Doccia manufactory demonstrated a notable commitment to translating the most famous classical and Renaissance sculptures taken from plaster or wax casts into snow-white porcelain and meticulously reproducing life-size or reduced-scale

8. Ginori manufactory, *Fireplace* (detail of the telamon on the left), porcelain, Florence, Ginori collection

replicas.[20] As for the fireplace in question, it is worth comparing this with the pendulum clock donated by Emanuele D'Azeglio to the Museo Civico of Turin in 1874.[21] In this composition by the famous French bronze sculptor Ferdinand Barbedienne (1810–92) the reference to the tomb of the duke of Urbino in the Sagrestia Nuova is evident; *Night* (which replaces *Twilight* in the original layout) and *Aurora*, both made of Doccia porcelain and dating from the early years of Ginori's production (*c.* 1753), appear at the sides of the bronze figure of Lorenzo.[22]

In the 18th century, the production of highly decorated fireplaces flourished, in which the functionality of the structure is combined with an extremely refined aesthetic form.

Mid-18th century Rome, for example, witnessed the emergence of a production of fireplaces using architectural inserts and fragments of ancient sculptures found in the increasingly frequent excavations; with the successful spread of this new fashion, the copies of torsos *all'antica* became commonplace and were sold as genuine pieces to be skilfully and carefully inserted into a contemporary structure.[23]

The Doccia manufactory produced not only just fireplaces but also majolica stoves from 1765. This type of heating was not used in Florence at the time, but the Duke Pietro Leopoldo of Lorraine commissioned one to heat the Pietro da Cortona part of Palazzo Pitti and so stimulated the rise in popularity of this form of heating. The orders followed one another over

time and documents of 1766 show records of payments to Ginori for stoves made by Giovanni Pleiher and Sigismondo Villiger (referred to subsequently as "Giovanni e Simone Tedeschi") "Fabbricatori di stufe al servizio della Real Corte" ("Makers of stoves at the service of the Royal Court").[24] Once they arrived in Florence, the two Austrian technicians needed logistical support and therefore entered into an agreement with Ginori to teach the workforce of the manufactory how to make these stoves.[25] In the documents, there is one particularly interesting order from the "Terra di Monte Carlo" (Lucca), that proves the models made for the Grand Duke were of the finer *masso bastardo*, while all the stoves noted in Florentine palaces at the time were of cold-painted coarse ware or majolica.[26] After the first experiments, the use of such stoves to offset the cold temperatures of the aristocratic Florentine palaces spread rapidly, as seems to be confirmed by the six stoves present in Palazzo Corsini.

An inventory drawn up after the death of Lorenzo Ginori in 1791 indicates that a room in the manufactory was set aside especially for the production of stoves.[27]

1 For the genesis of the gallery, on which building began in April 1753, see Mazzanti 2012, esp. pp. 136–7, 140.

2 AGL, Ginori Sen. Carlo. Lettere diverse dirette al medesimo dal 1765 al 1760, Filza 23, XII, 5, fol. 34 cited in Biancalana 2009, p. 53.

3 AGL, Ginori Sen. Carlo. Lettere diverse dirette al medesimo dal 1765 al 1760, Filza 23, XII, 5, fol. 36 cited in Biancalana 2009, p. 53.

4 See Moore Valeri 2014, p. 239.

5 Numerous production rejects were thrown onto the factory's scrap heap and recovered in the early 21st century by the Gruppo Archeologico Fiorentino. See Moore Valeri 2007[b], p. 81.

6 See Moore Valeri 2014, p. 242.

7 See Moore Valeri 2006; Moore Valeri 2007[a].

8 *La manifattura* 1970, p. 25; Moore Valeri 2014, p. 239–40.

9 See Biancalana 2009, pp. 27–8; Moore Valeri 2011, p. 34.

10 AGL, Ginori Sen. Carlo. Lettere diverse dirette al medesimo dal 1765 al 1760, Filza 23, XII, 5, fol. 43 cited in Biancalana 2009, p. 53.

11 F.M.N. Gabburri, *Vite di pittori*, MS, BNCF, Palatino E.B. 9.5, II, fol. 723r. For an examination of Domenico Stagi's career (1712–83), see Bertocci, Farneti 2002, p. 185–98. It is significant that in 1765, on the site for the Gabinetto Ovale in Palazzo Pitti designed by Ignazio Pellegrini, Stagi should be nominated to paint "over the stuccoes of the vault … in festoons in the manner of porcelain flowers" (Chiarelli 1977, p. 609; Colle 2009, p. 144).

12 See Farneti, Bertocci 2002, p. 188.

13 Together with Stagi, who worked on the decoration of the proscenium vault, Giuseppe Zocchi and Domenico Giarrè were also involved. See Tosi 1997, p. 181; Bertocci, Farneti, 2002, p. 185. Regarding Antonio Galli Bibiena (1697–1774), the son of the famous Ferdinando, founder of the dynasty of set designers of European fame, see Lenzi 2000, pp. 29–31.

14 Lankheit 1982, 40:116. For the bronze by Vernio, see Marchini 1982, p. 71; Bellesi 1999, pp. 273–4. In that context, the iconographic significance of the *Putti distilling roses* apparently alludes to the charitable nature of the client, Ridolfo de' Bardi, in the decorative layout, as is confirmed by the inscription in the elegant scroll at the base of the frame, which states: DISPERSIT, DEDIT PAUPERIBUS.

15 For the reconstruction of the matter of the 'loincloths' mentioned by Baldinucci, see Middeldorf 1976. Recently, four late-19th century biscuit sculptures reproducing the sculptures of *Twilight*, *Dawn*, *Day* and *Night* for the monumental Medicean tombs, appeared on the market. See Pandolfini, Florence, 19 November 2015, *Importanti mobili, arredi e oggetti d'arte, porcellane e maioliche*, lot 54 (45 × 55 × 30 cm).

16 See also the composition in Palazzo Baldeschi–Balleani in Jesi (1720).

17 The pen and grey and brown ink over black charcoal drawing is attributed to the workshop of Giuseppe Galli Bibiena (Parma 1696–1756) and measures 42.2 × 56.7 cm (New York, Metropolitan Museum of Art, Bequest of Joseph H. Durkee, by exchange, 1972; Accession Number: 1972.713.65). See also the drawing, also by Giuseppe, depicting a *Scenographic view and stairway* (GDSU, inv. 91578), in which the telamon on the balustrade next to the central arch appears in the same position as the one on the left in our fireplace.

18 See Frescobaldi Malenchini 2013.

19 See website: <http://galleriacorsini.beniculturali.it/index.php?it/103/sala-4-camera-del-camino>.

20 On Michelangelo's critical fortune, see Balleri 2014[a].

21 See Maritano 2012[a], p. 20; the inventory number of the clock is 3297/C.

22 See Maritano 2009.

23 See Valeriani 2016.

24 We wish to thank Anna Moore Valeri who, with her customary generosity, made available these unpublished documents that will be the subject of her forthcoming research.

25 In particular, concerning the production of stoves in the Ginori manufactory, see Balleri 2014[b], pp. XIV–XV.

26 See R. Balleri, in Pandolfini, Florence, 20 April 2016, *Importanti mobili, arredi e oggetti d'arte*, lot 81.

27 AGL, Filza XXXVII (inventories drawn up in 1791), quoted by R. Balleri, in Pandolfini, Florence, 20 April 2016, *Importanti mobili, arredi e oggetti d'arte*, lot. 81, note 1.

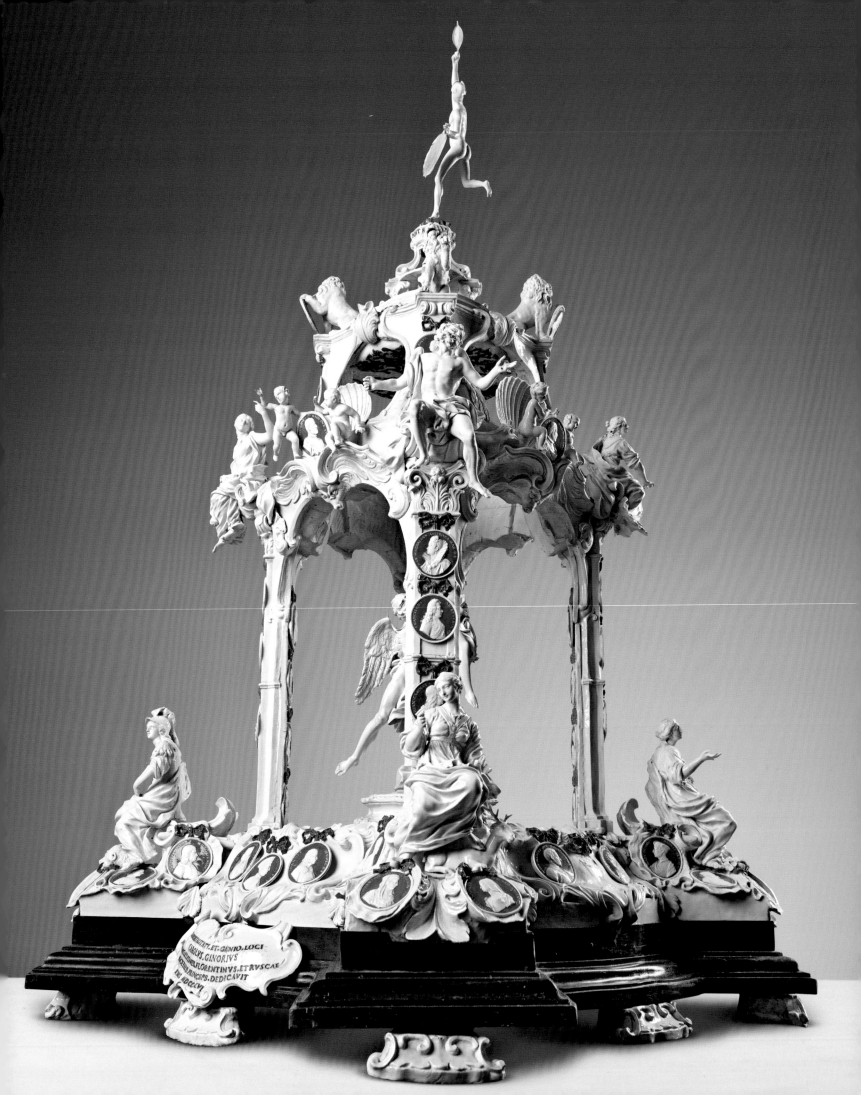

The "superb porcelain Machine" of Marquis Carlo Ginori*

CRISTIANO GIOMETTI

The year 1758 saw solemn celebrations being held in Cortona for the fifteenth anniversary of the foundation of the Accademia Etrusca, with a detailed *Relazione* (report) being printed that same year giving an idea of its sober atmosphere and the scholarly and laudatory content of the decorations. The drawing room of the Palazzo Pretorio, where the institution had its traditional meeting place thanks to a concession from the Grand Dukes of Tuscany, was dominated by the portrait of the Emperor and Regent Francis I of Lorraine, flanked on the side walls by four life-size busts of distinguished academics of the recent past: "that is, senator *Filippo Buonarroti*, formerly our first President, Abbot *Onofrio Baldelli*, who founded the Museum and the Academic Library, Marquis *Niccolò Marcello Venuti*, head of the Academy's founders, and the above-mentioned *Ant. Francesco Gori*, the celebrated Antiquarian scholar and most meritorious of our group". To round off this small pantheon, there was a series of portraits of the later *Lucumones* – named after the king of the Etruscan cities – and among them was the effigy of the "Marchese Senatore Cavalier Carlo Ginori, [who] was our Lucumone in the year 1756 and part of 1757".[1] The lengthy accompanying inscription mentions, in addition to the praise of his wise skills as administrator, the breadth of his cultural interests, ranging from antiquarianism to mathematics with a particular penchant for painting, sculpture and architecture, to the point of his being fully qualified to receive the title of "Rex Artium".[2] This definition was further reinforced by the gift that Ginori bequeathed to the Academy in his memory, "a superb porcelain Machine"[3] at the base of which an elegant scroll had been affixed with a significant dedication: IMMORTALITATI · ET · GENIO · LOCI | CAROLVS · GINORIVS | MARCHIO · ET · COMES · FLORENTINVS · ETRVSCAE | SOCIETATIS · PRINCEPS · DEDICAVIT | ANNO · MDCC.LVI. The continuation of the *Relazione* offers a succinct illustration, perhaps for the first time in a printed text, of the appearance of this admirable object, described as "a superb Temple more than two *braccia* in height, adorned with statues, groups, and trophies in the interior, and the exterior of which are loosely distributed the same number of porcelain medallions in the shape of Cameos, offering portraits of the Medici Royal Family, crowned by those of our most Illustrious Spouses",[4] the Grand Duke Francis of Lorraine and Maria Theresa of Austria (fig. 1).

Born from an idea of Marquis Carlo Ginori and recognised as being one of the masterpieces of the first phase of the manufactory he founded, the Cortona work is a culmination of Florentine sculpture from Giambologna to Foggini. At the same time, the medals that cover it completely, offer a condensed history of the Medici dynasty from its beginnings until the epilogue of Gian Gastone, whose death opened the way for the Lorraine regency. A tour de force of art and history, and a reflection of the refined taste of the time, it is perhaps first and foremost an almost moral portrait of its promoter, a lively political character of those years and a tireless investigator of the most varied fields of knowledge, from botany to zoology, chemistry to mineralogy and thence to the production of porcelain. Production in those years focused on the life-size reproduction of ancient sculptures, focusing on the monumentality of artefacts. The copies were made of a precious and fragile material, just like the original works, the unusual size of which is reflected in the terms used to define them. We can note a certain semantic ambiguity between the words 'machine' and 'temple', which are used interchangeably in the 1758 *Relazione*, although in the first documentary references, the former term was used exclusively. Carlo Ginori himself, in a letter dated 16 December 1750, referred to the "machine" to request a change to the apical inscription at the base of the Mercury,[5] and again on 21 April of the following year, the

1. Ginori manufactory, Gaspero Bruschi, *Tempietto Ginori* (cat. 4), porcelain, Cortona, Museo dell'Accademia Etrusca e della Città di Cortona

Marquis requested Gaspero Bruschi to inform him "whether the Machine has come out well, if it is accommodated in the base in such a way that it can turn it".[6] The latter part of the phrase suggests that the structure was originally intended to be set on a rotating support, superbly highlighting the multifaceted nature of the object, thanks to the wholly Baroque effect of the movement, as though to convey the idea of an ephemeral apparatus transforming itself before the eyes of the beholder and then crystallising into white porcelain.[7] While the reference to Bernini's *Baldachin* is evident, there is an equally strong reference to some magnificent buildings erected for the funeral obsequies of kings, as can be seen in the design for the *Catafalque for Cosimo III de' Medici* attributed to the workshop of Giuseppe Galli Bibiena, which is also similar in layout to our porcelain monument (figs. 2–3).[8]

The prevalence of the purely theatrical concept of 'machine' is found again at the turn of the 18th century in some inventory documents of the Accademia Etrusca.[9] But from the beginning of the nineteenth century, perhaps in the wake of a cultural climate more inclined to classical art, the term "temple" gained ground, with a significant shift of the semantic epicentre towards architecture. Thus in the *Inventario generale del Museo Etrusco* of 1838, there is mention of a "Porcelain temple from the Factory of Signor Carlo Ginori",[10] of a *tempietto*, which became a popular term in the twentieth century as of Mancini's 1909 text and was firmly established by Ginori Lisci in 1963 with the addenda of the dedication "to the glories of Tuscany".[11] This modern title fully grasps the historical and political significance of the decorative apparatus that focused on the triumph of the Medici dynasty, whose representatives are portrayed in medals with a blue background dotting the entire structure and which were adapted from the *Serie* of the same name by Antonio Selvi and Bartolomeo Vaggelli between 1740 and 1744.[12] To close the loop, at the top of the structure, we also see a double portrait of Maria Theresa of Austria and Francis I of Lorraine borne by *Mercury* who, significantly, raises a mirror, a characteristic attribute of prudence, with his right hand.[13]

The entirely Tuscan genesis of this work-manifesto, therefore, has its roots in the political events of the time, and primarily in the particular history of Carlo Ginori, who was more or less successfully involved in the government of the Grand Duke. This reading in a diplomatic key invites us to reflect on the problem of the chronology and function of the work, which arrived in Cortona only in August 1757, but had already been in existence in 1750, as evidenced by the aforementioned letter sent to Bruschi in December of that year. Ginori had thus begun work on this gigantic enterprise long before his presiding over the Accademia Etrusca; plausibly, in the opinion of this writer, he must have developed the idea after 1746, when the Marquis was appointed civil governor of Livorno. This astute move shifted him away from Florence and the Council of the Regency of which he was a member whilst apparently promoting him. This sort of enforced exile in Livorno seemed to have brought a long career in the ranks of court to an end; a career that began in 1718, when, at the age of just sixteen, he was appointed page to the Grand Duke Cosimo III and nominated knight of the Order of St. Stephen, before being named senator and secretary of the Riformagioni in 1734.[14] Meanwhile, the problem of the Tuscan succession seemed to be heading towards resolution with the arrival of the Bourbon dynasty, already established with the Congress of Cambrai of 1722, and sanctioned by a visit to Florence by Don Carlos on 9 March 1732. In its ranks, the pro-Bourbon Party boasted the likes of Carlo Rinuccini, Giovanni Antonio Tornaquinci and Prince Bartolomeo Corsini, whose daughter, Elisabetta, had married Ginori (1730), clearing the way for certain career advancements in the future. However, in the negotiations following the end of the War of Polish Succession (1733–8), the situation underwent a rapid development: through a series of diplomatic agreements, Tuscany was given to Francis, Duke of Lorraine, and his wife, Archduchess Maria Theresa, heir to the Habsburg domains. Even before the death of Gian Gastone (9 July 1737), the imperial army led by Prince Marc de Beauvau Craon arrived in Florence, followed closely by Emmanuel de Nay, Count of Richecourt, the faithful collaborator of the new grand duke, ready to dismantle the centuries-old system of Tuscan power. The prominent position he had gained over the years ensured that Ginori would be awarded the post of intimate adviser to the new sovereign and

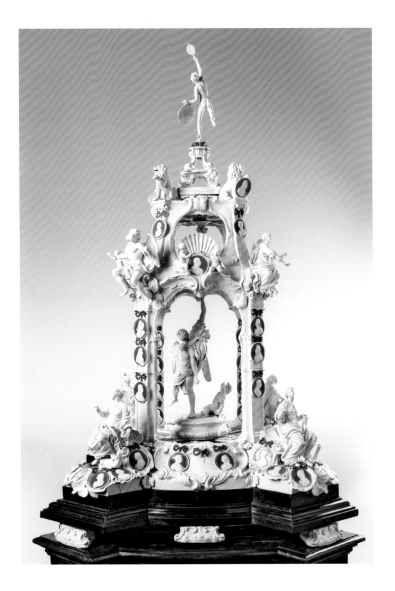

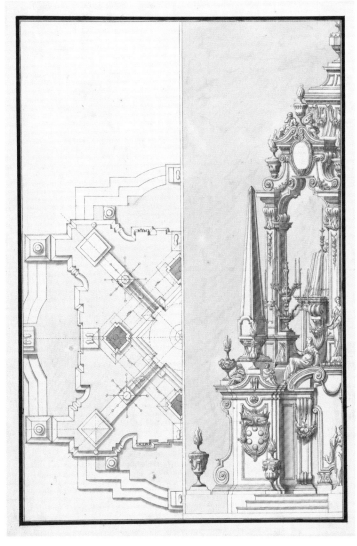

2. Ginori manufactory, Gaspero Bruschi, *Tempietto Ginori* (cat. 4), porcelain, Cortona, Museo dell'Accademia Etrusca e della Città di Cortona

3. Workshop of Giuseppe Galli Bibiena, *Half Ground Plan and Half Elevation of a Catafalque for Cosimo III dei Medici*, pen, brown ink and grey wash, New York, Metropolitan Museum of Art

called to be a member of the Regency (1739) and Finance Councils (1742). However, friction with Richecourt soon arose to such an extent that in 1742 the Marquis was invited to Vienna to be officially appointed Hofrat (court councillor) by Maria Theresa, but in reality was being removed from the Florentine government and subjected to a kind of loyalty test.[15] The divisions in the Regency Council were becoming increasingly bitter and the sharp opposition between the parties looked likely to lead to the burial of the important reforms enacted by Vienna, including reform of the Courts and the new legal code, as well as the revision of the delicate law on feudal rights. In order to ensure the work's rapid progress and to give Richecourt wider scope for action, Francis, who had since become Emperor, simultaneously began a reorganisation of the heads of the Florentine government that resulted in Ginori being given his new post as governor of Livorno, thereby evicting him from the seat of power. This minor institutional shift, clearly driven by Richecourt, is described with typical detachment by the British ambassador in Florence, Sir Horace Mann:

> We have had a strange revolution in our little government. The Count [Richecourt] … has removed everybody that can give him any trouble. Ginori was his great antagonist and he has been made governor of Leghorn without his consent or even participation. He is forced to submit, and is going. Madame Ginori is not tractable, and will not accompany him. It is a terrible *sconcerto* for their family.[16]

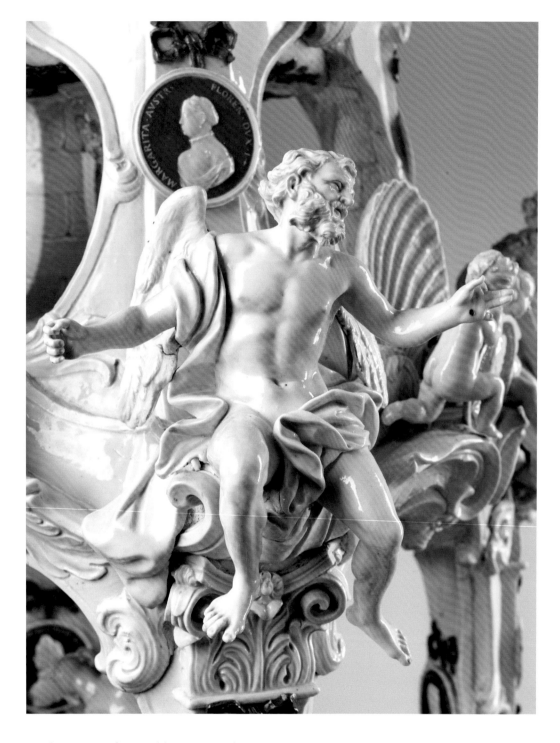

4. Ginori manufactory, Gaspero Bruschi, *Tempietto Ginori* (cat. 4; detail of *Time* after Giovan Battista Foggini), porcelain, Cortona, Museo dell'Accademia Etrusca e della Città di Cortona

The mirage of a possible ascent to the summit of power had by now vanished and the Marquis was paying a high price, but in Livorno too his unceasing industry continued apace. As governor, he pledged to support the commercial expansion of Livorno's port and promoted the construction of public housing for the poor. He also devoted himself to the administration of his family possessions, in particular of the Cecina estate, where he began the reclamation of marshy land and stimulated various manufacturing activities, including the production of coral. What is certain is that, after the bitter disappointment of being relegated to a peripheral position, Ginori must have embarked on a close reflection on his political career, at the same time meditating on ways to regain the trust of the Viennese court.[17] It was at this delicate juncture that the idea of the "superb porcelain Machine" perhaps first came to him; the making of a veritable monument

5. Ginori manufactory, Gaspero Bruschi, *Tempietto Ginori* (cat. 4; detail of the reverse of the medal with Gian Gastone after Lorenzo Maria Weber), porcelain, Cortona, Museo dell'Accademia Etrusca e della Città di Cortona

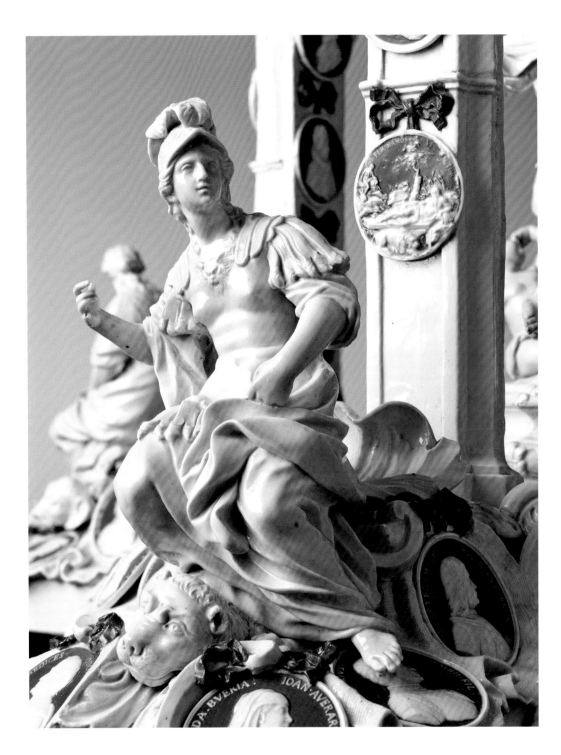

to the history of the Medici dynasty, to the golden age of Tuscany in the approximately three centuries of their governance until the moment in history dominated by the Lorraine dynasty, which in turn was to revive this felicitous season.

This 'concept' was very clear in the mind of the Marquis and it has been translated with great clarity in the iconography of the work, which is to be read from bottom to top, following a fairly rigorous chronological order. Close to the figure of *Fortitude*, the succession of the family's most significant members proceeds starting from the base, while the Grand Dukes from Cosimo I to Cosimo III are shown at the top of the structure, supported by the pairs of putti or by lions recalling the Marzocco, a symbol of Florence.[18] In this elevated seat, they underline the presence of a medallion dedicated to Grand Prince Ferdinand and of another to Joan of Austria, who is

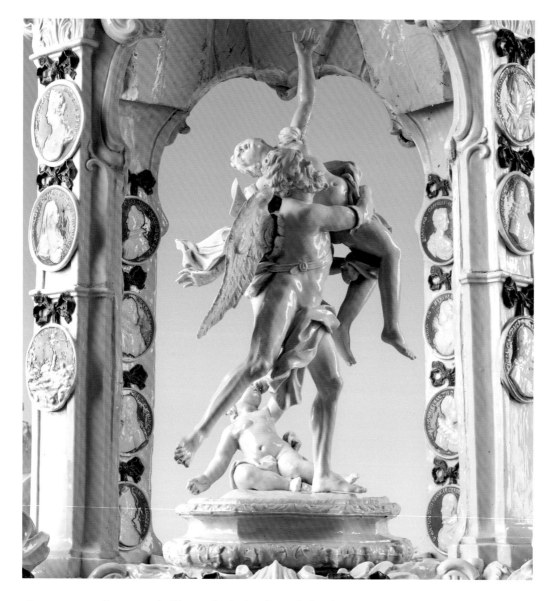

also present with a second effigy in the little pilaster behind *Prudence*, emphasising tthe Marquis' strongly Austrophile stance. The four *Cardinal Virtues*, sitting near the pilasters and accompanied by their respective symbolic animals, have protected and guided the good deeds of the Medici government, assuring prosperity and the revival of the arts but the inexorable passing of *Time* (fig. 4), sitting in precarious balance on the lantern's volute curl accompanied by the *Fates*, has led to the end of an epoch throwing the Grand Duchy into uncertainty over succession. Ginori even represents the brief digression of the hope for new direction under Don Carlos of Bourbon through a medallion located just behind the statuette of *Fortitude*, which is not part of the Medici series but was made by Lorenzo Maria Weber in 1732.[19] And while the recto is emblazoned with the portrait of Gian Gastone, the *verso*, the side reproduced in our case, depicts the reclining allegorical figure of the river Arno and, in the background, the Ibero and a tree-trunk with a graft to indicate the fruitful encounter between the two families (fig. 5).[20]

Once the Bourbon solution had failed and the hopes of their Florentine supporters, including Ginori himself, had faded, we arrive at the establishment of the Habsburg-Lorraine line, introduced to this great endeavour by *Mercury* who lightly lands atop the structure, placing his left foot on an elegant stand bearing the inscription in blue letters changed by the Marquis in 1750, which reads: POST FATA POTENTIOR SVRGIT ETRVRIA. An augur for a rebirth under the aegis of Francis I and Maria Theresa; the invitation to govern with prudence is addressed to them, as is

6. Ginori manufactory, Gaspero Bruschi, *Tempietto Ginori* (cat. 4; detail of *Time Abducting Beauty* after Giovan Battista Foggini), porcelain, Cortona, Museo dell'Accademia Etrusca e della Città di Cortona

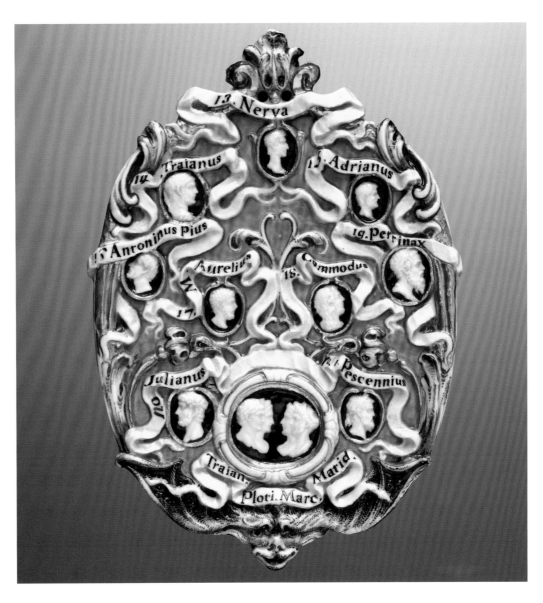

7. Ginori manufactory, *Small plaque with cameos of Roman emperors*, porcelain, London, Victoria and Albert Museum

indicated by the mirror raised by Mercury, their goal being the restored equilibrium in Tuscany of that now imperilled secular virtue, represented at the centre of the temple by the "magnificent elegiac group", with *Time Abducting Beauty* (fig. 6), borrowed from the Foggini bronze now conserved in the Los Angeles County Museum (see p. 94, fig. 5).[21]

If in April 1751, the Marquis was asking his trusted collaborator Jacopo Fanciullacci to inform him about the reactions to his 'machine' positioned on the "Base so that it may be turned",[22] we must assume that the work must have been completed by this date. As far as its structural parts were concerned, some of the medallions were fired, at the same time as the pilasters (as was clarified during the recent restoration[23]), using a tried technique, for example, the plaque with cameos of Roman emperors dated 1750, now preserved in the Victoria and Albert Museum (fig. 7).[24] However, Ginori's Livorno exile did not seem to be drawing to a close, thus also the potential possibility of sending his work to Vienna must have slowly evaporated. Indeed, it seems that the Marquis was considering transferring the porcelain factory to his Cecina estate, as pointed out by Salmon in the twenty-first volume of his encyclopaedic work: "It is also said that ... he has a mind to add other factories by moving the manufactures of Porcelains and Majolica, which, as already noted above, are presently worked on at his Doccia villa near Florence".[25]

But Filippo Venuti, who in 1751 was nominated provost of the Livorno collegiate church, was a key figure in this affair, having founded the Accademia Etrusca of Cortona together with his

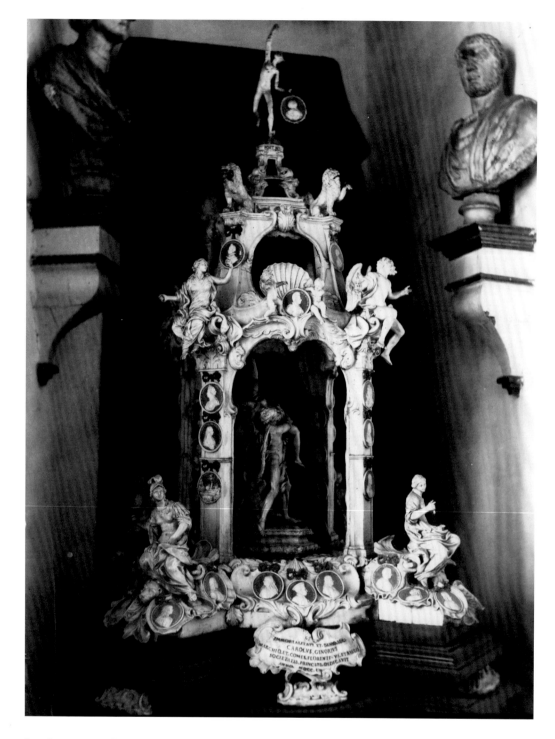

8. Early 20th-century period photograph with the *Tempietto Ginori* (cat. 4) at the entrance of the historical room of the Accademia Etrusca

brothers, Marcello and Ridolfino in 1726.[26] Already Canon of San Giovanni in Laterano, then procurator of the Dattiloteca Palatina, Venuti was the power behind an intense cultural activity that led to an attempt to found a Livorno branch of the Società Colombaria, of which Filippo had been a member since 1737. "The literary conversations in Livorno are becoming more colourful", wrote Anton Francesco Gori in July 1751; "they are rich in oriental matters".[27] The group was soon joined by Ginori who, in 1754, showed the members of the colony two coins of the Da Varano dynasty, the subject of dissertations at the thirteenth meeting.

The friendship and intellectual bonds between the governor and Venuti thus became ever closer and it is due to the protection provided by the Florentine Marquis that the collegiate was able to carry out freely its many cultural and publishing practises. As if to reciprocate so much

9. Ginori manufactory, Gaspero Bruschi, *Tempietto Ginori* (cat. 4; detail of *Time Abducting Beauty* after Giovan Battista Foggini), porcelain, Cortona, Museo dell'Accademia Etrusca e della Città di Cortona

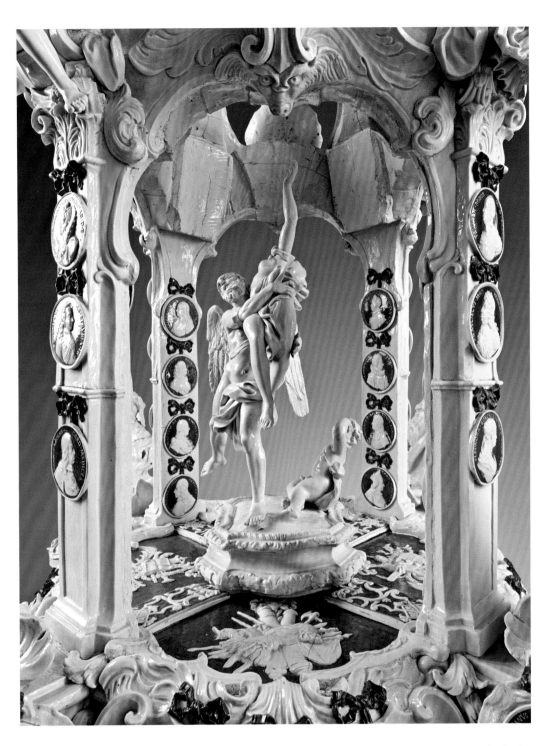

esteem, Venuti must have favoured Ginori's acceptance into the Accademia Etrusca, which the latter joined on 12 December 1754. Another result of their negotiations was the appointment of the Marquis as *lucumone*, which took place for the first time in 1756 and was renewed the following year. On the basis of the revision of the statutes that took place in 1753, each *lucumone* was called upon to honour the post by making a gift to the institution and it is at this juncture that the idea of sending the 'superb machine' to Cortona developed, thanks to the involvement of Venuti and the rising awareness on the part of the Marquis of the increasingly remote chance of an imminent end to his 'captivity' in Livorno. It seems clear that Ginori chose this work as a gift to the Accademia Etrusca because he considered that it supported the same political and ideological values as were expressed in the work of art, as is emphasised by the evocation of the

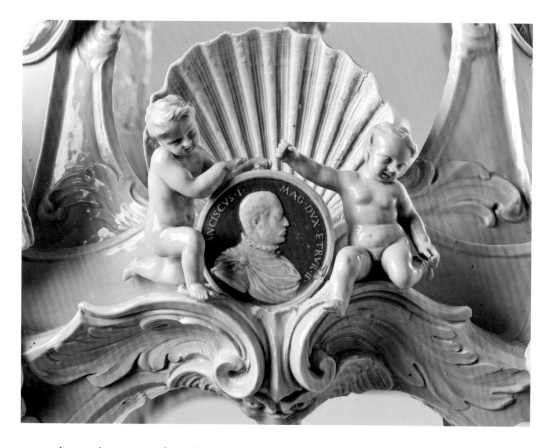

10. Ginori manufactory, Gaspero Bruschi, *Tempietto Ginori* (cat. 4; detail of putti bearing the medal with Grand Duke Francis I), porcelain, Cortona, Museo dell'Accademia Etrusca e della Città di Cortona

genius loci in the *incipit* of the dedicatory inscription in the beautiful rocaille porcelain scroll made specially for the occasion.

In actual fact, a possible change in the political situation appeared towards the end of 1756, when the deterioration of Count Richecourt's health effectively left Tuscany without a head, and among the possible candidates for his succession, Ginori appeared to be the most credible. The possible removal of the Marquis from Livorno dismayed Filippo Venuti who saw the possibility as resulting in the loss of an indispensable ally. In a letter sent on 4 February 1757 to Gaston Leparelli in Cortona, the collegiate's provost confirmed the renewed acceptance by Ginori of the title of *lucumone* for the current year and ended with a disconsolate consideration of the impending fate of his friend: "As for the fate of Ginori, much is being said, and it seems that he expects to depart, but it all depends on the return of Corrier Bindi. I shall be very sorry if he goes. He is my only resource".[28]

However, very soon after, on 6 April, the Marquis was afflicted by the stroke that killed him in the space of just five days, with the entire city of Livorno at the bedside of the governor,[29] but in a matter of only a few weeks, Richecourt too was obliged to leave Florence, weighed down by illness. "Jesus is dead and Pilate has left" was the murmur heard through the streets of the city, recorded by ambassador Mann who, with his usual sarcasm, gives a clear description of the climate of uncertainty caused by the prolonged power vacuum: "We not only expect orders, but even people to execute them, from Vienna."[30]

The agreement between Carlo Ginori and the Accademia Etrusca was nevertheless fulfilled by Carlo's eldest son, Marquis Lorenzo, who inherited the Doccia manufactory with his brothers Bartolomeo and Giuseppe and handled the work's shipment to Cortona. Reassurance that the transport had not damaged the precious cargo arrived with a letter of 18 August of that year, written by Filippo Venuti: "The machine has arrived in good condition, and was at once located in the Rooms of our Residence in a worthy and conspicuous place, as You will be able to ascertain from the man from your Doccia Factory".[31] The person in question assigned to escort the work to its permanent location can be identified as Jacopo Fanciullacci, who was paid for this

task in April 1758.[32] We do not know precisely where the "worthy and conspicuous place" Venuti spoke of may be, although we may assume that it was a location in the so-called Biblioteca Alta ('Upper Library'), on the second floor of Palazzo Casali, the oldest nucleus of the academic centre established by the Grand Ducal grant of 1727. As evidence of the work having been placed on this floor of the building, although probably in a different place to the original position, there is a photograph from the early 20th century in which the work is immortalised in a sort of square niche in the small passage leading to the library (fig. 8).

*The quotation is taken from the *Relazione de' Tricennali celebrati dall'Accademia Etrusca di Cortona* (Lucca 1758). The author wishes to thank Bruno Gialluca and Patrizia Rocchini, director of the Biblioteca di Cortona.

1 *Relazione* 1758, p. V.

2 Ibid., p. VII.

3 Ibid., p. VIII.

4 Ibid.

5 "Let Sir Bruschi change the machine's inscription, and it would be better said: Post Fata, potentior, surgit Etruria" (AGL, Manifattura di Doccia. Documenti vari, Filza 137, 1, fol. 718v, quoted in Biancalana 2009, pp. 50–1).

6 AGL, Manifattura di Doccia. Documenti vari, Filza 137, 1, fol. 938v, quoted in Ginori Lisci 1963, p. 141.

7 Regarding this subject, see Fagiolo dell'Arco 1997, in particular the chapter with the title *Dalla festa alla struttura stabile*, pp. 69–80.

8 New York, Metropolitan Museum of Art, inv. 1972.713.8.

9 BCAEC, ms. cod. cart. 732 bis, fol. 28v ("donated the porcelain 'Machine' with the Casa dei Medici Series to the Accademia"); ms. cod. cart. 610, Catalogo dei Lucumoni o principi della Nobile Accademia Etrusca di Cortona ("donated the beautiful porcelain 'Machine' made in his renowed manufactory"), both published in Balleri 2009, p. 15.

10 Quoted in Balleri 2009, p. 15.

11 Mancini 1909, p. 127; Ginori Lisci 1963, p. 141.

12 See Toderi, Vannel 1987, pp. 191–2. For a chronological hypothesis concerning the purchase of the casts of the medallions by Carlo Ginori, see Balleri 2009, p. 14.

13 The medallions – a total of 76, of which 3 are missing – are distributed as follows: 36 decorate the base (one missing), 28 the pilasters (3 on the outside and 4 on the inside of each pilaster), 4 the upright sections of the lantern, 3 are held by putti (one missing) and another 3 by lions (one missing). The medallions of Joanna of Austria, Christina of Lorraine and Ferdinando III are repeated twice, unlike the one of Giuliano de' Medici, as was indicated previously (Balleri 2009, p. 19), since these are of two different figures: Giuliano de' Medici (1453–78) and Giuliano II de' Medici Duke of Nemours (1479–1516). There is also a third of Giuliano, archbishop of Pisa († 1636).

14 For further insights into the political carreer of Marquis Carlo Ginori, see Verga 1990, *ad indicem*; Gori Pasta 2000; Contini 2002, *ad indicem*; Sesto Fiorentino 2006.

15 See Verga 1999, p. 39.

16 Horace Walpole (1717–97), *Correspondence*, ed. 1954–71, III, pp. 322–3 (25 October 1746).

17 For a political reading of the *Tempietto*, see also Gialluca 1993–4, pp. 295–7.

18 See Balleri 2009, pp. 18–19.

19 See Toderi, Vannel 1987, p. 243.

20 An interesting piece in *Memorie di Lorenzo Maria Weber per la storia degli intagliatori* (BU, Bencivenni Pelli, MS 463, ins. 35, fol. 27r, quoted in Balleri 2009, p. 19), shows that on the reverse side of the medallion, "there was the River Arno with a Lion and the River Ibero with a rabbit, and in the Middle, a Tree with a graft blowing in a light breeze, with the motto 'per ramos victor'".

21 J. Winter, in Florence 2003, p. 90.

22 AGL, Manifattura di Doccia. Documenti vari, Filza 137, 1, fol. 938v, quoted in Ginori Lisci 1963, p. 141.

23 Also during the last restoration, a crumpled sheet of paper was found in a cavity under the removable crown close to the left-hand front lion, which reads (in translation): "Let Poggetti smooth and clean this Stone on either side; but to take note that once smoothed he should leave all that white mark, that can remain, and once made clean he should return it". The Poggetti mentioned is Francesco, who was active in the manufactory from 1744 and specialised in the working of semi-precious stones but also in making bases in pear and rowan for the most important porcelain groups (see Biancalana 2009, p. 37). The 'stone' referred to may be the multi-faceted and bumpy blue-coloured base simulating a boulder, on which the figure of Mercury stands.

24 Inv. C.128-1924. The same technique is found in the *Vase* with 32 medallions of the Lorraine family, dated 1757, and conserved at the Museo Nazionale di Capodimonte (Inv. N.D.C. 296), which makes reference to Ginori Lisci 1963, pl. XVIII; A. d'Agliano, in Vienna 2005, p. 211, cat. II.

25 Salmon 1757, p. 206. Significantly, volume XXI of Salmon's text is dedicated to "sua Eccell. il Sig. Marchese Carlo Ginori Conte di Urbech, Consigliere di Stato intimo attuale delle L.L.M.M. Imperiali, e Consigliere di Stato, e di Reggenza in Toscana, Senatore, e Patrizio Fiorentino, Cavaliere dell'Ord. Milit. di S. Stefano, Governatore di Livorno, e Presidente del Consiglio di Commercio ec.".

26 Concerning Filippo Venuti and his intense activity as erudite scholar and intellectual, see Cagianelli 2009; Gialluca 2011 with extensive previous bibliography. Regarding the Accademia Etrusca of Cortona and its history, see Barocchi, Gallo 1985.

27 Letter sent from Livorno on 25 July 1751, BMF, MS B VIII 7, fol. 391v, quoted in Cagianelli 2009, p. 212.

28 Letter by Filippo Venuti in Livorno to Gastone Laparelli in Cortona, 4 February 1757, BNCF, Nuove accessioni 449, Ins. A.

29 In the *Diario fiorentino* by Minerbetti (BNCF, Fondo Nazionale II, III, no. 457, fols. 290v–291r, quoted in Contini 2002, p. 233) we read: "Since he was greatly loved, in those five days following the accident many public and private devotions and prayers were made in that city, the Venerable figure was displayed in a number of churches, processions held, to the point that no more could have been done for the sovereign himself".

30 Horace Walpole (1717–97), *Correspondence*, ed. 1954–71, V, p. 85 (30 April 1757).

31 AGL, Lorenzo Ginori. Lettere diverse dirette al medesimo 1757-1761, Filza 1, XIII, 1, fol. 640r, quoted in Ginori Lisci 1963, p. 141.

32 The payment, although not the the actual sum, is mentioned in Casciu 1992, p. 175.

LIST OF MEDALS ON THE TEMPIETTO
(from the base to the lantern, left to right in a clockwise direction)

At the centre on the base, between Fortitude and Prudence

Contessina de' Bardi (1391/2–1473), wife of Cosimo di Giovanni de' Medici, called the Elder
D. ELECTA. CONTESSINA. BARDI. COSM. P. P. VXOR

Cosimo de' Medici the Elder (1389–1464)
D. MAGNVS. COSMVS. MEDICES. P. P. P.

Giovanni de' Medici (1421–63)
D. IOANNES. MEDICES. COSM. P. P. FILIVS

beneath Prudence

Piero de' Medici the Gouty (1416–69)
D. PETRVS. MEDICES. COSMI. P. P. FILIVS

Lucrezia Tornabuoni (1425–82), wife of Piero de' Medici the Gouty
D. LVCRETIA. TORNABONI. PETRI. MED. VXOR.

Lorenzo de' Medici the Elder (1395–1440)
D. LAVRENTIVS. MEDICES. IOANNIS. FIL

Ginevra Cavalcanti (?–after 1464), wife of Lorenzo de' Medici the Elder
D. GENEFRA. CAVALCANTI. VXOR. LAVR. MED. IOHAN. FIL.

Pierfrancesco de' Medici the Elder (1430–75)
D. PETRVS. FRANC. MEDICES.

Laudomia Acciaioli (15th century), wife of Pierfrancesco de' Medici the Elder
D. LAVDOMINI. ACCIAIVOLI. PETR. FRANC. MED. VXOR.

at the centre, between Prudence and Justice

Giovanni de' Medici il Popolano (1467–98)
D. IOANNES. MEDICI.

Missing **Lorenzo de' Medici il Popolano** (?; 1463–1503)
D. LAVRENT. MEDIC. PETR. FRAN. FILIVS

Semiramide D'Appiano (?–1523), wife of Lorenzo de' Medici il Popolano
D. SEMIRAMIS. D. APPIANO. LAVR. MED. PETRIFRAN. F. VXOR

beneath Justice

Giuliano de' Medici (1453–78)
D. MAGN. IVLIANVS. MEDICES. PET. FI

Lorenzo de' Medici the Magnificent (1449–92)
D. MAGNIF. LAVRENTIVS. MEDICES

Clarice Orsini (1450–87), wife of Lorenzo de' Medici the Magnificent
D. CLARICIA. VRSINIA. MAGNIF. LAVR. MED. VXOR.

Giovanni de' Medici (1475–1521), Pope **Leo X** (1513–21)
D. LEO. X. PONT. MAX.

Giuliano II de' Medici, Duke of Nemours (1479–1516)
D. IVLIANVS. MEDICES. DVX. NEMORII.

Filiberta di Savoia (1498–1524), wife of Giuliano II de' Medici, Duke of Nemours
D. FILIBERTA. A. SABAVDIA. IVLIANI. MED. NEMOVRS. D. VXOR.

At the centre, between Justice and Temperance

Lorenzo II de' Medici, Duke of Urbino (1492–1519)
D. LAVRENTIVS. MEDICES. VRBINI. DVX. CP.

Catherine de' Medici (1519–89), Queen of France (1547–59), wife of Henry II, King of France
D. CATHARINA. MEDICES. GAL. REGI.

Madeleine de La Tour d'Auvergne (1501–19), wife of Lorenzo II de' Medici, Duke of Urbino
D. MAGDALENA. DE. BONONIA. VXOR. LAVREN. MED. DUCIS. VRBINI.

beneath Temperance

Giulio de' Medici (c. 1478–1534), Pope **Clement VII** (1523–34)
D. CLEMENS. VII. PONTIFEX. MAX.

Ippolito de' Medici (1511–35), cardinal
D. HYPPOLITVS. CARD. MEDICES.

Pierfrancesco de' Medici the Younger (1487–1525)
D. PETRVS. FRAN. MED. LAVRENT. FIL.

Caterina Sforza Riario (1462–1509), wife of Giovanni de' Medici il Popolano
D. CATHARINA. SFORZA. MEDICES.

Lorenzino de' Medici (1514–48)
D. LAVRENTIVS. MED. PET. FRA. FI.

Maria Salviati (1499–1543), wife of Giovanni dalle Bande Nere
D. MARIA. SALVIATI. MEDICES.

At the centre, between Temperance and Fortitude

Giuliano de' Medici (?–1636), archbishop of Pisa
D. IVLIANVS. DE. MEDICIS. ARCHIEP. PISA

Alessandro de' Medici (1535–1605), Pope **Leo XI** (1605)
D. LEO. XI. PONT. OPT. MAX.

Filippo di Vieri (?–1474), archbishop of Pisa
D. PHILIPPVS. DE. MEDICIS. ARCHIEP.PISANVS.

beneath Fortitude

Chiarissimo de' Medici (or Salvestro Chiarissimo) (14th century)
D. CLARISS. DE. AVERAR. MED. FIL. ALTERIVS. AVERAR. P.

Averardo di Bicci de' Medici (14th century)
D. AVERARDVS. MEDIC. COGNOM. BICCIVS.

Giovanni di Bicci de' Medici (1360–1429)
D. IOANNES. MEDICES. ODOARDI. FIL.

Piccarda Bueri, known as Nannina (c. 1368–1433), wife of Giovanni di Bicci de' Medici
D. PICCARDA. BVERIA. IOAN. AVERARDI. FILII. VXOR

Vieri di Cambio (1323–95)
D. EQVES. VERIVS. MEDIC. CAMBII. FIL.

Salvestro di Alamanno de' Medici (1331–88)
D. SILVESTER. MEDIC. AEQV. R. PVB. FLOR.

Pilasters, interior, behind Prudence

Camilla Martelli (1545–90), second wife of Cosimo I de' Medici
D. CAMILLA. MARTELLIA. DE. MEDICIS

Lucrezia de' Medici (1545–61), Duchess of Ferrara, wife of Alfonso d'Este, son of Ercole II, Duke of Ferrara
D. LVCRETIA. AB. ETR. FERRAR. D.

Pietro de' Medici (1554–1604)
D. D. PETRVS. AB. ETRVR. PRIN.

Joanna of Austria (1547–78), wife of Francesco I de' Medici, Grand Duke of Tuscany
D. IOANNA. AVSTRIACA. MAG. DVX. ETRVRIAE.

behind Justice

Bianca Cappello (1548–87), wife of Francesco I de' Medici, Grand Duke of Tuscany
D. BIANCHA. CAPPELLI. FRANCISCI. I. M. D. VXOR.

Maria de' Medici (1573–1642), wife of Henry IV, King of France
D. MARIA. AB. ETRVRIA. GAL. REGI.

Eleonora de' Medici (1567–1611), wife of Vincenzo I Gonzaga, Duke of Mantua
D. ELEONORA. MED. FRAN. I. M. D. ETR. FILIA. MANT. DVX.

Antonio de' Medici (1576–1621)
D. D. ANTON. MED. FRANC. I. F. CLASSIS. HIEROS. PRAEF.

behind Temperance

Christina of Lorraine (1565–1637), wife of Ferdinando I de' Medici, Grand Duke of Tuscany
D. CHRISTINA. PR. LOTHARINGIE. MAG. DVX. ETR.

Claudia de' Medici (1604–48), Archduchess of Tyrol
D. CLAVDIA. AB. ETR. ARCHID. AVST

Lorenzo de' Medici (1599–1648)
D. LAVRENTIVS. AB. ETRVR. PRINCE.

Carlo de' Medici (1596–1666), cardinal
D. CAROLVS. CARD. MEDICES

behind Fortitude

Margherita de' Medici (1612–79), Duchess of Parma and Piacenza, wife of Odoardo Farnese, Duke of Parma
D. MARGAR. AB. ETR. PARM. ET. PL. D.

Anna de' Medici (1616–76), Archduchess of Austria, wife of Ferdinand Charles, Archduke of Austria and Count of the Tyrol
D. ANNA. AB. ETRVR. ARCHID. AVSTRIAE.

Mattia de' Medici (1613–67)
D. MATTIAS. AB ETRVRIA. PRIN.

Leopoldo de' Medici (1617–75), cardinal
D. LEOPOLDVS. CARD. MEDICES.

Pilasters, exterior, behind Prudence

Maria Maddalena d'Austria (1589–1631),
wife of Cosimo II de' Medici
D. MAR. MAGDALENAE. AVSTRIACA. MAG. D. ETR.

Francesco de' Medici (1614–34)
D. FRANCVSCVS. AB. ETRVRIA. PR.

Giovanni Carlo de' Medici (1611–63)
D. IOAN. CAROLVS. CARD. MEDICES.

behind Justice

Marguerite Louise d'Orleans (1645–1721),
wife of Cosimo III de' Medici
D. MARGARITA. ALOYSA. AVRELIAN. M. DVX. ETR.

Ferdinando de' Medici (1663–1713), Grand Prince
of Tuscany
D. FERDINANDVS. III. MAG. PRINC. ETR.

Violante Beatrice of Baviera (1673–1731), wife
of the Grand Prince Ferdinando de' Medici
D. VIOLANTES. BEATR. MAG. ETR. PRIN.

behind Temperance

Vittoria della Rovere (1622–94),
wife of Ferdinando II de' Medici
D. VICTORIA. ROBOR. M. D. ETRVR.

Francesco Maria de' Medici (1660–1711)
D. FRANCVSCVS. M. PRINCEPS. AB. ETR.

Eleonora Gonzaga (1685–1741),
wife of Francesco Maria de' Medici
D. ELEONORA. GONZAGA. ETRVR. PRINCEPS.

behind Fortitude

Anna Maria Franziska of Saxe-Lauenburg
(1672–1741), wife of Gian Gastone de' Medici
D. ANNA. M. F. SAXELAW. MAG. DVX. ETRVR.

Anna Maria Luisa de' Medici (1667–1743),
Electress of the Palatinate, wife of Johann Wilhelm,
Elector Palatine
D. ANNA. M. ALOYS. COM. P. RH. ELECTR. NATA.
M. PR. ETR.

Gian Gastone de' Medici (1671–1737),
Grand Duke of Tuscany (1723–37), reverse
R. PER RAMOS VICTOR.

Lantern

Medals held up by Putti

at the centre, between Fortitude and Prudence

Cosimo I de' Medici (1519–74), Duke of Florence
(1537), Grand Duke of Tuscany (1569–74)
D. COSMVS. I. D. G. MAGN. DVX. ETRVR.

at the centre, between Prudence and Justice

Francesco I de' Medici (1541–87),
Grand Duke of Tuscany (1574–87)
D. FRANCISCVS. I. MAG. DVX. ETRVR. II.

at the centre, between Justice and Temperance

Missing **Ferdinando I de' Medici** (?; 1549–1609)
Grand Duke of Tuscany (1587–1609)
D. FERDINANDVS I. MAGN. DVX. ETR. III.

at the centre, between Temperance and Fortitude

Cosimo II de' Medici (1590–1621),
Grand Duke of Tuscany (1609–21)
D. COSMVS. II. MAGN. DVX. ETRVRIAE. IIII.

Medals on the supports of the lantern

above Prudence

Margaret of Parma (1522–86), wife first of Alessandro
de' Medici, Duke of Florence, and then of Ottavio
Farnese, Duke of Parma and Piacenza
D. MARGARITA. AVSTR. FLOREN. DVX. I

above Justice

Eleonora di Toledo (1522–62), wife of Cosimo I
de' Medici, Grand Duke of Tuscany
D. ELEONORA. TOLETANA FLOR. DVCISSA.

above Temperance

Joanna of Austria (1547–78), wife of Francesco I
de' Medici, Grand Duke of Tuscany
D. IOANNA. AVSTRIACA. MAG. DVX. ETRVRIAE.

above Fortitude

Christina of Lorraine (1565–1637), wife
of Ferdinando I de' Medici, Grand Duke of Tuscany
D. CHRISTINA. PR. LOTHARINGIE. MAG. DVX. ETR.

Medals held by the Lions

above Prudence

Missing **Gian Gastone de' Medici**
(?; 1671–1737) Grand Duke of Tuscany (1723–37)
D. IOANNES. GASTO. D. G. MAGN. DVX. ETRVR VII

above Justice

Ferdinando de' Medici (1663–1713), Grand Prince
D. FERDINANDVS. III. MAG. PRINC. ETR.

above Temperance

Cosimo III de' Medici (1642–1723), Grand Duke
of Tuscany (1670–1723)
D. COSMVS. III. D. G. MAG. DVX. ETR. VI

above Fortitude

Ferdinando II de' Medici (1610–70), Grand Duke
of Tuscany (1621–70)
D. FERDINANDVS. II. MAG. DVX. ETR. V

Foggini and Doccia

ALVAR GONZÁLEZ-PALACIOS

In 1983, I happened to organise an exhibition for the Colnaghi Gallery in London of outstanding, mostly Italian, objects that attracted the interest of the British press. For the occasion, *The Adjectives of History* catalogue was published.[1] The work that, in my opinion, was particularly appreciated at the time was a white porcelain *Calvary* from the Ginori Manufactory in Doccia, which was of a considerable size (74 × 83 × 43 cm; fig. 1). The three crosses stood on a tall base of rocks from which skulls and fragments of skeletons emerged, made with remarkable perfection. The skeleton on the left is complete and looks towards the Redeemer (fig. 3). Mary Magdalene can be seen at the foot of the cross.

In *La Porcellana di Doccia*, the pioneering study that launched the archival research into Florentine porcelain, Leonardo Ginori Lisci recalled "a large Mount Calvary" made in 1744 in that manufactory, which has not yet been found.[2] Later, Klaus Lankheit published his volume on the Doccia manufactory in which some papers refer to the *Calvary* still believed lost: "A group depicting Mount Calvary, the wax made by Giambatista Foggini with a cast". The phrase is drawn from the old *Inventario dei Modelli*, while the casts for a "Crucified Christ … and two thieves and the cast of Mary Magdalene" are listed in the *Inventario delle Forme* of the same period. Finally, the author mentions two payments on 27 and 29 August 1744 to Anton Filippo Maria Weber "for three casts of Our Lord on Calvary… for a cast of St. Mary Magdalene".[3] If we read this note 3, it becomes clear that Foggini's son Vincenzo not only sold his father's original waxes to the Manifattura Ginori but also provided some entirely new models. We also know that Lorenzo Weber and his brother Filippo were employed in Doccia for the creation of "many models and casts".[4] It might seem strange that the wax models of such an important work as the great *Calvary* by Foggini should have disappeared from the collections of Doccia. But this is not the only case where this has occurred.

The vivacity and the peculiar asperity of the modelling of the Calvary studied here are typical of Foggini's manner, while the almost violent pathos of the scene embodied by the four figures' different poses – poses ranging from the sublime resignation of Christ to the despair of the unrepentant thief with his tongue hanging in a grimace of horror (fig. 2) – has nothing in common with Vincenzo's weaker style or with the subtle world of Massimiliano Soldani and the other sculptors active under the last Medici. Foggini's style, as is made clear here, derives from the virile *pietas* of the Bernini. In relation to this work, it is useful to recall the relief of skeletons leaving their tombs depicted on the left sarcophagus designed by Bernini just before 1640, which can be found in the Cappella Raymondi in the Church of San Pietro in Montorio in Rome. The stylistic comparisons between the Calvary and Foggini's work are quite evident.

I must note that the figure of Christ is particularly close to the one by Alessandro Algardi. In Florence, moreover, the *Crucifixion* with the ivory Christ and the Magdalene, conserved in the ground-floor Chapel of Palazzo Pitti, may be compared to our porcelain Christ. This is also true of at least another work by Balthasar Permoser, a *Crucifixion* dating from around 1683 in the Museum der bildenden Künste in Leipzig. To make a comparison of Foggini's own works, see the bronze bas-relief with the *Crucifixion*, datable to 1675–7, in the Museo degli Argenti in Florence.[5]

1. Ginori manufactory, *Calvary* (after Giovan Battista Foggini), porcelain, formerly London, Colnaghi Gallery

2. Ginori manufactory, Calvary (after Giovan Battista Foggini; detail of the unrepentant thief), porcelain, formerly London, Colnaghi Gallery

3. Ginori manufactory, Calvary (after Giovan Battista Foggini; detail of the skeleton), porcelain, formerly London, Colnaghi Gallery

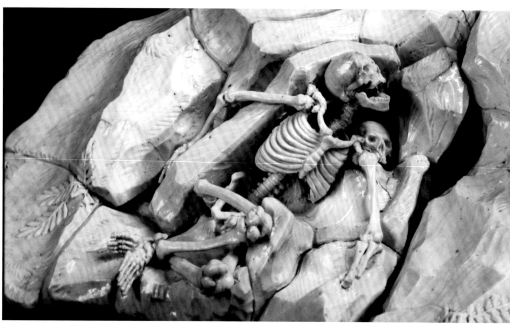

*

The iconographic research of the *Calvary* indicates that it was conceived by an artist strongly influenced by the profound religiosity of the 17th century and not by the more conventional piety of the following century. The figures chosen for the sacred scene are the thieves and Mary Magdalene instead of the Virgin and St John. The presence of Mary Magdalene in the garments usually associated with her later hermitic life serves to emphasise the meaning of redemption of Christ's Passion. The tradition that depicts Mary Magdalene as the only figure at the foot of the Cross has illustrious precedents in Tuscany. In the period considered here, we encounter this form in sculptural groups such as the Soldani statue in the convent of Santa Maria degli Angeli in Pistoia, in the ivory *Crucifixion* (attributed to Permoser), in the bronze *Mary Magdalene* by Antonio Raggi – mentioned above – in the ground-floor chapel of Palazzo Pitti, and in another masterpiece again by Permoser in Bamberg. However, in these examples, the Magdalene is wrapped in ordinary garments, albeit sometimes disordered. The unusual iconographic element of skeletons emerging from the opened tombs, which replaces the traditional skull of

4. The porcelain *Calvary* in Palazzo Corsini, Rome, about 1880. Fondo Cugnoni, Rome, ICCD

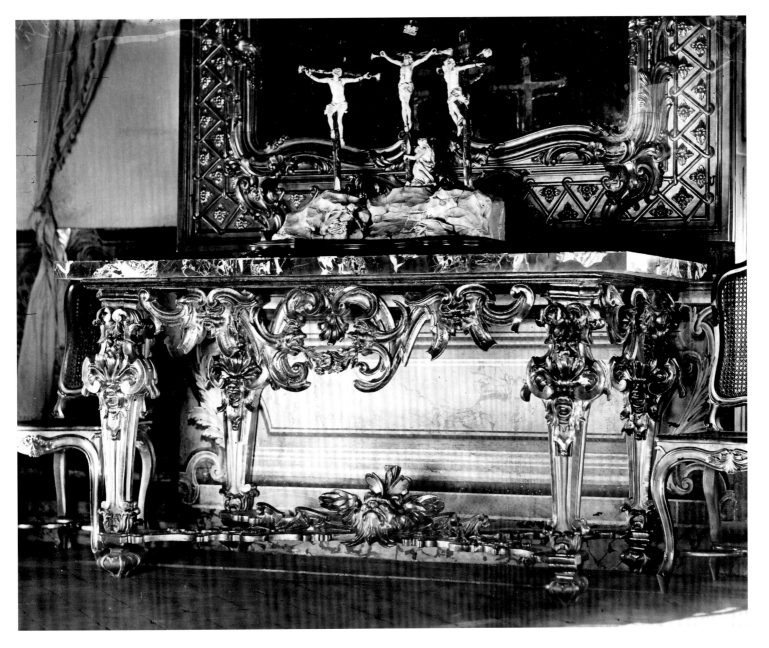

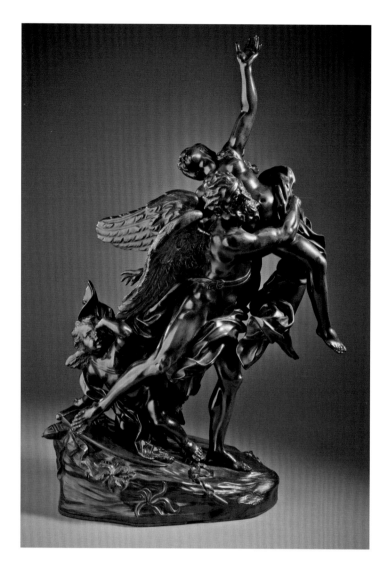

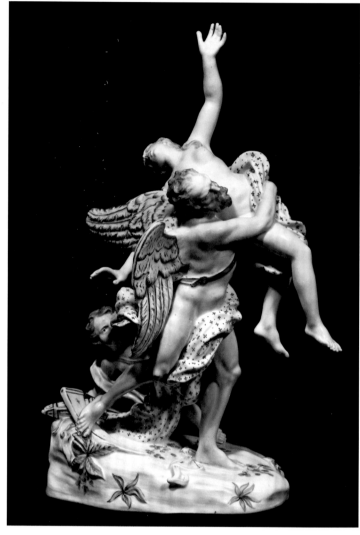

Adam at the foot of the Cross, refers to the culmination of the Passion according to Matthew: when Christ rendered his spirit, the veil of the temple broke into two parts and the sepulchres burst open. The dead, however, did not appear in Jerusalem until after the Resurrection, which explains why, since the cycle of redemption is still not complete, they take the form of skeletons here.

Contrary to what I had supposed in 1983, no bronze, even partial, version of this Foggini composition has appeared. Instead, purely by chance, while undertaking some research on furniture once at Palazzo Corsini in Rome, I found the porcelain *Calvary* depicted in an old photograph of the late 19th century from the Fondo Cugnoni. It appears on a luxurious console in Palazzo Corsini as if it were regarded as an elegant object of ornament and not as a religious symbol (fig. 4).[6]

5. Giovan Battista Foggini, *Time Abducting Beauty*, bronze, Los Angeles, County Museum of Art

6. Ginori manufactory, *Time Abducting Beauty* (after Giovan Battista Foggini), polychrome porcelain, unknown whereabouts

*

In the above-mentioned catalogue *Gli Ultimi Medici* (1974), a magnificent Foggini bronze appears, *Time Abducting Beauty*, an example of which is in the Los Angeles County Museum of Art (fig. 5). In entry 30 of the volume, Jennifer Montagu specifies how there used to be a bronze of this model at Palazzo Pitti in 1761 (now unidentified).[7] This depiction, translated into porcelain at Doccia, was included in the 1756 Cortona *Tempietto* (cat. 4) devoted to the glory of Tuscany, which was derived mainly from Foggini's ideas. That work is considered the *tour de*

7. Ginori manufactory, *Prudence* (after
Giovan Battista Foggini), polychrome
porcelain, unknown whereabouts

8. Giovan Battista Foggini, *Prudence*,
drawing, Rome, Istituto Nazionale per la
Grafica

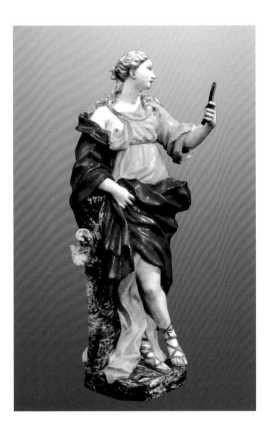

force of the Ginori manufactory. At the time, a special wax cast was prepared, which may be the
same cast that had served for a painted porcelain group I purchased in the mid-eighties from a
dealer in Turin (fig. 6). That porcelain group was to be a gift from me to an old friend who was
then celebrating his sixty-fifth birthday. This was Mario Tazzoli, a great art connoisseur who had
subsidised the magazine called *Antologia di Belle Arti*, of which I was then the editor along with
Federico Zeri. Tazzoli appreciated the gift somewhat wryly as it reminded him of the implacable
passage of Time.

In the catalogue, Montagu noted how the idea of Time abducting Beauty, breaking Cupid's
bow in the process, was a strange iconographic choice for the *Tempietto*. However, its signifi-
cance may also be the triumph of Virtue over Time and Fate. Tazzoli's Time came to an end
early, in 1990, before he had reached the age of seventy. Since then, I do not know what became
of the porcelain group I gave him. I should add that that porcelain came from the collection of
Emanuele Restelli in Como and had been published by Morazzoni as being produced by the Ca-
podimonte manufactory around 1758. Elena Romano, in 1959, instead had shown another simi-
lar group belonging to the Pinacoteca Ambrosiana claiming that it bore the brand of a stamped
lily typical of Capodimonte.[8] Thirty years after my purchase, I am in doubt as to whether the
porcelain group with Time and Beauty was made in Doccia or Capodimonte. I did not even
note the size (which is not specified in either of the two publications just mentioned) and nor
do I even remember if the Tazzoli group had the maker's mark of an impressed lily. In the latter
case there would be some doubts as to when the group was made. Angela Carola Perrotti[9] has
perceptively been dealing with this problem and explains that these striking marks are examples
of *supercherie*, not to say fraud.

*

In his *Le Statue del Marchese Ginori*, John Winter noted how despite the fact that Ginori's
white porcelain is in modern times very "fashionable ... at the time of production, just out of
the factory (and here we are talking about circa 1760) the porcelain groups '... being painted

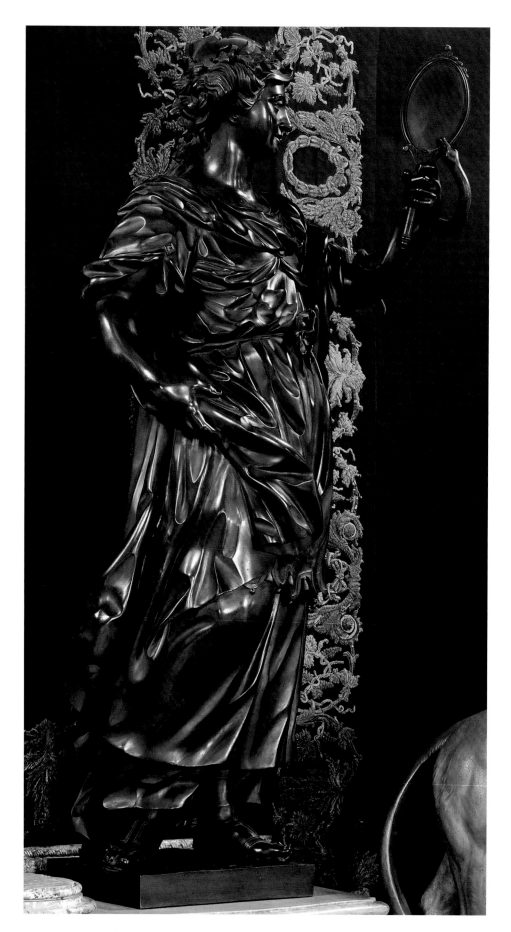

9. Workshop of Giovan Battista Foggini,
Prudence, bronze, Madrid, Palacio Real

sell at double the price', and indeed, until recently, collectors were more eager to seek out the colourful specimens".[10] Personally, I am among those who do not have a particular admiration for the polychrome Doccia works. The colours, in my opinion, are not always very harmonious and the contrasts between them are to my eye a little strident, but maybe it is all a matter of the times, of fashion – nothing is more ephemeral and more uncertain.

I had already described the polychrome image of Prudence published here.[11] This porcelain figure (fig. 7) painted in bold colours – yellow, blue and red above all – is inspired by a drawing and a figure by Giovan Battista Foggini. The drawing is part of a group of sheets kept in the Gabinetto Nazionale delle Stampe in Rome, and is linked to a wax model from the Museo di Doccia and with one of the four great bronzes in the Royal Palace of Madrid. The small wax work is listed in the manufactory's *Inventario dei Modelli* dating back to 1760, where it appears on page 29 under number 32: "Prudence resting against a trunk with mirror in the left hand, of wax with mould". This statuette has been not entirely convincingly attributed to Giovan Battista Foggini. However, the relationship between the wax and Foggini's drawing is undeniable.[12]

I have always advanced the idea that the drawings in the Gabinetto delle Stampe in Rome are to be associated with the four bronzes preserved in Madrid, about which we know little. Those bronzes appear for the first time in the inventory compiled in Madrid after the death of Philip V in 1746 but neither these papers nor other documents mention the author of those statues. On a couple of occasions, I have proposed attributing these works to the circle of Foggini, but I have never been able to unequivocally prove my proposal and apparently no one has hitherto either rejected or supported it. We can see at least one these with Prudence, in a picture published for the first time thanks to the courtesy of the Patrimonio Nacional.

1 London 1983.

2 Ginori Lisci 1963, p. 62.

3 Lankheit 1982, p. 101. On that same page there is mention of pieces for another *Mount Calvary*, which appears to be linked to a payment to Vincenzo Foggini, son of Giovan Battista: "for casting a wax group depicting Jesus on the cross with the Madonna, St. John and St. Mary Magdalene" – this is a different *Calvary* because in ours there are neither the Virgin nor St John. See fig. 100 of the same volume and Maritano 2012[b], p. 102, 106.

4 Lankheit 1962, p. 244.

5 The ivory *Crucifix* is examined by K. Aschengreen Piacenti, in Detroit/Florence 1974, pp. 384–5; for Permoser's other works, see Lankheit 1962, fig. 165 and for Foggini's bronze one in the Museo degli Argenti, ibid., pl. 88.

6 The *Mount Calvary* is mentioned in Medici 1880. It is impossible to tell on what date the photograph was taken of the Fondo Cugnoni illustrated here: we do not know either Valeriano Cugnoni's biographical information or the dates

when he took his photographs. We do not even know if he was a professional photographer, but he certainly had a photography studio in the Prati district in Rome and it is to be assumed that many of the photographs purchased by the state in 1913 date back to before 1860, while others date to decades later; they may also have been taken by several photographers. We cannot therefore know with absolute certainty whether the Cugnoni photograph was taken in Florence or Rome. Certainly, at least since 1955 when I went to live in Florence, Foggini's *Calvary* has not been on display in the Florentine gallery. I do not know how it arrived at Colnaghi's in London or where it went to thereafter.

7 J. Montagu, in Detroit/Florence 1974, cat. 30.

8 Morazzoni, Levy 1960, II, pl. 333; Romano 1959, p. 73, fig. 36.

9 Caròla-Perrotti 2008.

10 Winter 2003, p. 21.

11 González-Palacios 2010, fig.11.

12 Lankheit 1982, p. 129, fig. 154; González-Palacios 1996.

Fig. 6.

Fig. 8.

Fig. 7.

Fig. 3.

Porcelain sculpture, a "very difficult process"

CRISTINA MARITANO

That the enterprise of making porcelain statues was as difficult as it was unprecedented was evident to every visitor to the Doccia manufactory and its gallery during the years of Carlo Ginori.[1] Vasari's observation concerning the sculptures of Luca della Robbia ("reflecting that clay could be worked easily and with little labour, and that it was only necessary to find a method whereby works made with it might be preserved for a long time, he set about investigating to such purpose that he found a way to defend them from the injuries of time; for, after having made many experiments, he found that by covering them with a coating of glaze … in a special furnace, he could produce this effect very well and make works in clay almost eternal"[2]) seemed to have found a new manifestation at Doccia, where the "beautiful and white" porcelain contended with bronze in the reproduction of the most famous ancient and modern statues, and having exceeded the example of Meissen, was now following a road marked by antiquarian culture.[3]

From China to Europe
"For money they employ the white porcelain shell, found in the sea." "Let me tell you also that in this province … they make vessels of porcelain of all sizes, the finest that can be imagined. They make it nowhere but in that city, and thence it is exported all over the world."[4] First made in China in the eighth century AD, porcelain was known in the West only in the wake of Marco Polo's travels and writings. The undeniable affinity with the appearance and texture of shells led the Venetian to call this mysterious ceramic material by the same name used for the *Cypraea moneta*, which some Chinese provinces used as coins for trade. This fact generated a long-lasting misunderstanding and in the mid-16th century some European scholars such as Giulio Scaligero maintained that porcelain was obtained from shells of marine gastropods, finely ground and mixed with water.[5] Contrasting with these hypotheses, there came reports from missionaries, who were eyewitnesses, not of the whole process of manufacture, which was kept secret, but at least of the use of a white clay unknown in Europe, kaolin (from the Gaoling region in China), and of a stone, petuntse, thereby steering discussion of its origin from the animal to the mineral world.[6] Its beauty, rarity, (erroneous) assimilation with the ancient *murrine* described by Pliny,[7] together with its supposed anti-toxic properties, gradually increased the fame of porcelain in the West, where it might be found in the *Wunderkammern* created by princes and men of science. In his *Musaeum metallicum*, published posthumously, building on the stories of the first Jesuit fathers, Ulisse Aldrovandi (1522–1605) rebuffed the theory of Scaligero and came to the gist of the question: "Haec vasa in nostris Regionibus deficiente tali Argilla, et aqua memorata, fabricari non possunt".[8] However, "nihilominus Magnus Hetruriae Dux aeternae memoriae Franciscus huiusmodi vasa Chinensibus non inferiora fieri curavit".[9] And indeed, around 1575, in Florence, at the court of Francesco I de' Medici, one of the earliest attempts to imitate Oriental porcelain in Europe took place, which saw the involvement of majolica-makers from Urbino (Flaminio Fontana) and Faenza, as well as a mysterious 'Levantine'. The recipe, preserved in a codex from the Fondo Magliabechiano in the Biblioteca Nazionale di Firenze, reveals a composition based on a crystalline frit with a little kaolin clay from Vicenza, white sand and rock crystal.[10] This was a so-called 'soft porcelain', so called because compared to the hard Chinese porcelain, it scratches easily, has a greater expansion coefficient and thus reduced resistance to sudden heat changes, and melts at low temperatures.[11]

1. *The preparation of raw materials in a porcelain manufactory*, in de Milly 1772, pl. 1

After the Florentine experiments, more than a century passed before European manufactories again began to explore the production of porcelain. This occurred in France, first in Rouen, in the manufactory of Edmé Poterat, and then on the outskirts of Paris, in Saint-Cloud. Here the experiments were conducted by Pierre Chicaneau, a painter and maker of majolica from 1674, and continued with his sons until they obtained patents to produce porcelain in 1697. Again, this was a soft porcelain, made up mostly of an alkaline frit, composed of sand, saltpetre, rock salt, Alicante soda, gypsum and rock alum, mixed with limestone clay.

It was only between 1708 and 1710, in Dresden, Saxony, thanks to the findings of the scientist Ehrenfried Walther von Tschirnhaus and the chemist and alchemist Johann Friedrich Böttger, that the process for obtaining a hard porcelain able to rival the Chinese one was invented. In 1710, Augustus II, King of Poland and Prince of Saxony, established the first European hard porcelain factory, the Meissen factory. The secret (the 'arcanum') was, however, soon exported by workers who left Meissen for other cities. This led to the founding of the first 'subsidiaries', the manufactories of Vienna (1718) and Venice (1720), which in turn spawned other factories in Germany and Italy.[12] In France, instead, soft porcelain dominated for a long time, and was developed to a very high level of quality by the Sèvres manufactory, which began producing hard clays only in the 1770s after the discovery of a kaolin deposit on French soil.[13] The same happened in England, where the discovery of the precious clay took place in Cornwall in 1746.

Materials and techniques

Hard porcelain stands out from other ceramic compounds for a number of special characteristics: it is white, resonant to the touch, translucent and waterproof, resistant to scratches, acids and thermal shocks. In order to create porcelain, it is necessary to first have available special white clays that remain white when fired. Only primary clays satisfy this requirement because they are deposits that have not shifted but have remained in the same place as where they were formed on the mother rock; they have therefore not accumulated minerals, such as iron, that can alter their colour. These clays are the result of alteration of the mother rock composed of feldspars, an effect of weathering or leaching. These clays include the kaolins.

The clay is what gives the final mixture plasticity, or cohesion to the mix for moulding. The composition for porcelain has kaolin clay as the main ingredient, comprising about 50% and constitutes the infusible part; another 25% consists of a fluxing agent, the feldspar, essential for vitrification; and another 25% of quartz, an inert, siliceous material which, thanks to its high melting point, can raise the refractory level of the mixture.

The most important 18th-century published source for our knowledge concerning the processes used in porcelain factories is Nicolas-Christiern de Thy de Milly's text,[14] dated 1771 and illustrated with plates that re-appeared in the *Encyclopédie* (fig. 1). It shows the spaces and structures of porcelain manufactories, from decanting tanks to furnaces and workshops, and the main operations carried out. The first stage involves the preparation of the raw materials. The kaolin being used must be purified of organic residues by washing in water, and separated by sedimentation from the residues of the mother rock, such as quartz, mica or feldspar. It is then dried and reduced to powder. The quartz and the feldspar, also cleaned, are crushed into small pieces that are then calcined thrown into cold water to make them more friable, and subsequently reduced to very fine dust. Calcined talc and gypsum are sometimes added to these three elements, beaten and passed through a sieve, together with fragments of ground fired porcelain. The ingredients are then blended together in the proportions required by the various recipes and kneaded with water to create a malleable material. The resulting paste is macerated for a long time before being used and is constantly kept moist to facilitate its fermentation.

Once ready, the paste can go to the workshop, where it is transferred into the hands of turners for the manufacture of crockery or into those of modellers for making sculptures. Porcelain sculpture is an *ex negativo* sculpture and requires the use of plaster moulds in which to press the clay. In the eighteenth century, these moulds were of the 'dowel' type consisting of several

elements, to allow the reproduction of the undercuts (fig. 2), and were made from a terracotta, wax or plaster model. In the case of a human figure, there were usually several moulds: one for the head, one for the bust, one for each of the limbs, and for each added element. Each mould had two parts and in each of them the moulder would press the clay with his fingers, then secure the two halves together with liquid clay after removing any excess clay within. Since the plaster absorbs part of the moisture of the clay, after a few hours it shrinks and becomes easier to detach from the mould. The porcelain parts, now in the 'green' stage, are gently extracted from the moulds after removing the dowels, cleaned and then welded together by the craftsman using liquid clay to copy the reference model. The modelling of the figure is now completed and holes are made to enable air to escape. The figure is then dried for a period that may last several weeks, depending on the size of the work and the seasonal conditions. Perfect drying is a necessary condition, though not the only one, for an effective firing of the piece. The

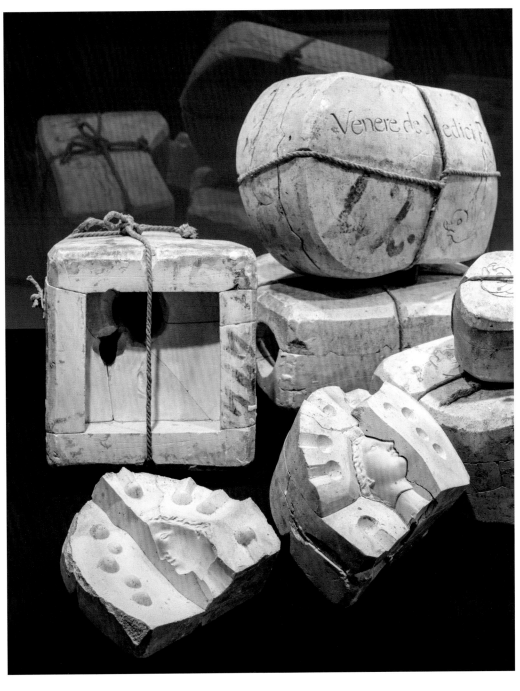

2. Dowel moulds for the miniature of *Venus de' Medici* (h. 44 cm), second half of the 18th century, plaster, Sesto Fiorentino, Museo Richard Ginori of the Doccia manufactory

first firing – biscuit-firing or *dégourd*, *glühbrand* or *lowfiring* – takes place at low temperatures of around 800–900° C, and eliminates all the carbon and organic scraps contained in the clay and ensures the stability of the work. The solid and porous 'biscuit' is now ready to be glazed, using a mixture dissolved in water, consisting of quartz and feldspar powder, and which may also include ground fired porcelain and kaolin. The glazing is applied by immersing the piece, if it is small, or by brush. The composition of the glaze must 'agree' with that of the clay and have the same degree of fusion and dilation.

When the glaze has dried, the work being fired is placed in a refractory container, called a box or crucible, which protects it from direct flames and from the oven's ashes and offsets sudden changes of temperature, allowing for a more gradual heating and cooling. The base of the box is sprinkled with a refractory powder, such as a quartz sand, which, acting as an insulator, prevents the porcelain from sticking to the bottom and allows for the slight movement caused by shrinkage during firing. In order for vitrification to occur, or in other words to enable the ceramic material to become porcelain, the furnace temperature must reach a maximum of 1400° C in a reducing atmosphere, that is, in the absence of oxygen. When the pieces are brought to melting point, the clay and vitrifying agents interpenetrate and vitrify, turning into porcelain. The furnaces in which the firing takes place have the fuel feed located at the front of the furnace: the flames cross the horizontal tunnel, licking around the boxes containing the porcelain and leave via the chimney at the back of the furnace. This causes strong temperature differences inside the firing chamber, which must be taken into account when stacking the pieces. Meissen developed three different clay mixtures with varying levels of refraction for three different areas of the furnace. Once the melting point is reached, the figure undergoes a softening and tends to deform under its own weight, with the risk of damaging the lower parts. For this reason, each work is held up by porcelain supports, and great care is taken over the shape and size of the bases, which must be fairly wide. At this stage, the pieces can be irreversibly damaged through excessive softening, breakage or distortion, resulting in a high rate of rejects. The furnace cooling phase is also extremely delicate and takes several days. At the end of the firing, the porcelain will have lost 14–16% of its volume compared to its 'green' stage.

At this point, the object can be painted with metallic oxide colours and then subjected to a third, glaze-firing at about 600–850° C. This further phase in the oven is not without risk for large sculptures: so much so that Meissen preferred to use colours applied cold to paint the large animals it produced.[15]

At Doccia

In November 1741, a doctor and naturalist called Antonio Cocchi went to visit the factory of Marquis Ginori in the company of some illustrious British friends, including Horace Mann and John Chute:

> A' La fabrique de Porcelaines de Ginori. Elles [le porcellane] sont audessous de la mediocrité. La fayence est un peu meilleure en son genre … La Porcelaine demande tre cotture. The first is light of pure clay without glaze. The second with glaze is strong so that it vitrifies and then it is painted with colours diluted with oil of *spicum*. The third is fair and it dries the painting on top like polish and that one is mediocre. They fire it in clay cylinders. The major difficulty and cost lies in these cylinders for which clay is required from near M. Carlo, or from elsewhere. The porcelain paste is kept secret by Ginori. As well as the glaze, I believe, and even some of the colours are kept secret. There are a sculptor that directs the manufactoring and the design of all the vessels, and a painter that directs the colouring. I do not know who supervises the composition of the clays or the furnaces or firing.[16]

The rather unflattering judgment of the porcelain would seem to contradict what Ginori himself wrote just a year earlier, in a letter of 13 December 1740, addressed to Ferdinando

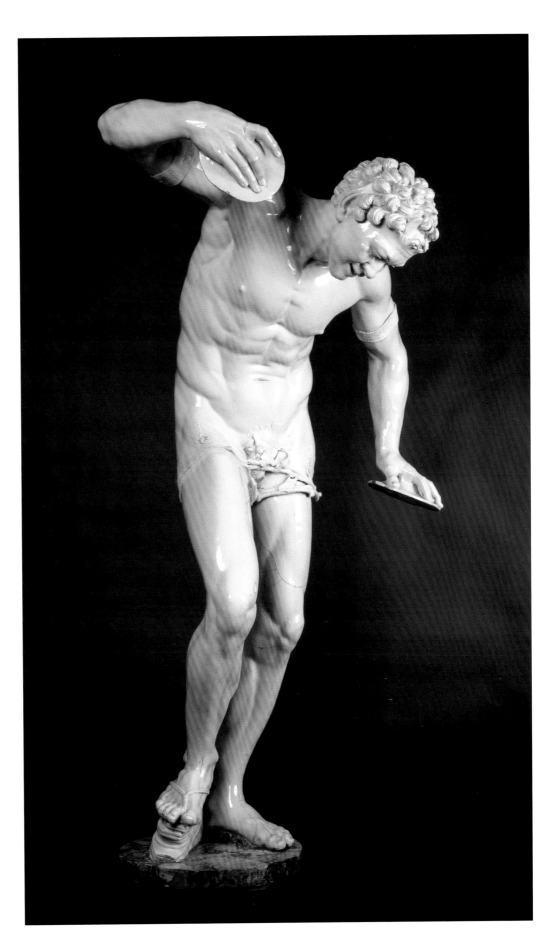

3. Ginori manufactory, Gaspero Bruschi, *Dancing Faun* (after the Antique), porcelain, Turin, Palazzo Madama, Museo Civico d'Arte Antica

4. Ginori manufactory, Gaspero Bruschi, *Dancing Faun* (after the Antique; detail), porcelain, Turin, Palazzo Madama, Museo Civico d'Arte Antica. The detail shows the inconsistencies of the glaze between the arm and forearm and the "link" that masks the junction between the segments

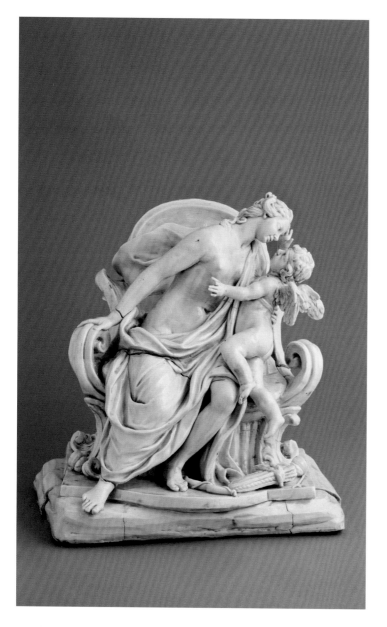

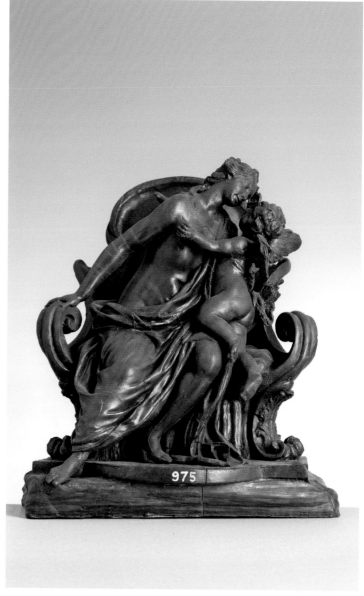

5. Ginori manufactory, *Cupid and Psyche* (after Massimiliano Soldani Benzi), porcelain, Turin, Palazzo Madama, Museo Civico d'Arte Antica

6. After Massimiliano Soldani Benzi, *Cupid and Psyche*, wax, Sesto Fiorentino, Museo Richard Ginori of the Doccia manufactory

7. Ginori manufactory, *Cupid and Psyche* (after Massimiliano Soldani Benzi; detail), porcelain, Turin, Palazzo Madama, Museo Civico d'Arte Antica.
View of the partially open base with a central small crossbeam to stabilize the unit. Note the cracking due to firing and the remnants of sand adhered to the base

Bartolomei, representative of the Grand Duchy of Tuscany in Vienna, in which he claimed that his porcelain articles were "few in number in order to have little cause to envy those of Saxony".[17] Some examples attributable to Karl Wendelin Anreiter confirm Ginori's claim with regard to the high quality achieved, but perhaps this was not yet the usual standard.

As has been repeatedly pointed out, Carlo Ginori was the first arcanist in his factory,[18] and we know that he conducted experiments on the melting point of the various clays, a research to which he was greatly dedicated, gathering a large set of samples, a few years before the founding of the manufactory itself.[19] The secret of porcelain lay, however, not only in the ingredients, but in a body of knowledge concerning the construction of the furnaces and the firing phases, as well as the modelling of the clay. Ginori therefore made use of the Viennese Johann Georg Deledori and Anreiter, who moved to Doccia to instruct the factory workers, including Jacopo Fanciullacci and Gaspero Bruschi.

There are hundreds of 'masses' or mixtures for porcelain documented in the first twenty years. In the aforementioned letter of 13 December 1740, Ginori mentioned the three types of kaolin used: "from the Venetian [territories]"; "from the island of Elba" and "from Montecarlo".[20] These were soon joined by another, "Vienna clay", although the factory always tried to limit expensive imports of raw materials "from alien states".

The making of large statues began in 1744, a year that saw the production of the *Pietà* (cat. 8), an extremely complex work, followed shortly by the *Knife Grinder*. Just over a decade separated these large sculptures from the large animals produced at Meissen by Johann Jakob Kirchner and Johann Joachim Kändler for the Japanese Palace in Dresden, the first large sculptures in European porcelain, the production of which halted in 1736, however.[21]

The main ingredient for the Doccia statues was the 'clay from Montecarlo' near Lucca, which was a non-perfectly white kaolin clay high in silica, and therefore very refractory. Cleaned, washed, and decanted, it was used to make the 'mass' or mixture, with the addition of 'sand' – a rock made of quartz and feldspar. Due to its high level of refraction, Montecarlo clay was also used in Doccia to make the "crucibles", or boxes, and the lining of the furnaces.[22] To counteract the grey tone of the mixture, an attempt was made to use a whiter glaze, probably containing porcelain scrap and gypsum, but this did not always give optimal results, as Le Condamine's testimony recalls.[23]

In a few years Carlo Ginori endowed the manufactory with an extraordinary wealth of moulds and models of wax, terracotta or plaster (figs. 6, 12), either commissioned from sculptors or bought from them, or in some cases made by the factory workers.[24] If the moulds, or 'negatives', were purchased (whether the original ones by Massimiliano Soldani Benzi or those made *ad hoc* by Vincenzo Foggini), a 'positive' would be made with a 'cast' of wax or plaster. From this, other moulds (the 'hollows') were made to be used for the actual production of porcelain articles. The same was true if waxes, plaster casts, or terracotta articles were purchased or commissioned: these were used as templates and were subjected to a 'moulding' operation; that is, the making of moulds. To do this, it was not necessary to dissect the model in several parts, and so it could remain intact. There was also the case of moulds obtained directly from statues, which needed to be finished by the modeller.[25] The plaster moulds of this period, as we have seen, were of the 'dowels' type (fig. 2), enclosed within a shell called *madreforma* which held together the various elements with the aid of a rope.[26] After a number of uses the moulds had to be renewed, either because the plaster's water absorption of the plaster decreased or because there was a loss of definition in the details of the modelling.

As mentioned above regarding assemblage, the various "green", unfired pieces were extracted from the moulds using slip, or liquid clay. These parts were then cleaned and later modified with respect to the model, before subsequent bisque firing. In Doccia, however, as occurred three hundred years before with the sculptures of Luca della Robbia and his pupils, in the case of large sculptures, the assembly was usually done after the firing of the individual pieces: head, arms, legs, were fired separately and then assembled with plaster stuccoes or iron pins and resins (fig. 9).[27] It was thus possible to reproduce "full size" statues, achieving heights that were unthinkable in Meissen. The points of contact between the parts were covered by *rapporti*

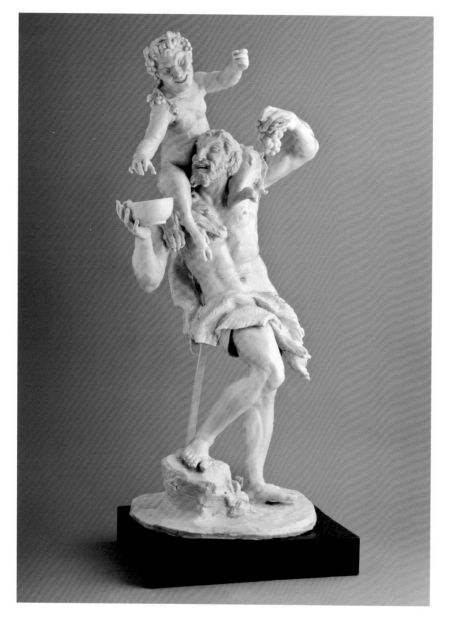

8. Ginori manufactory, *Faun Bearing a Satyr on His Shoulders* (after Giuseppe Piamontini), porcelain, Turin, Palazzo Madama, Museo Civico d'Arte Antica

9. Ginori manufactory, *Faun Bearing a Satyr on His Shoulders* (after Giuseppe Piamontini), porcelain, Turin, Palazzo Madama, Museo Civico d'Arte Antica. The Faun was disassembled during the 1991 restoration. The segments were assembled with iron pins and adhesive grout after firing

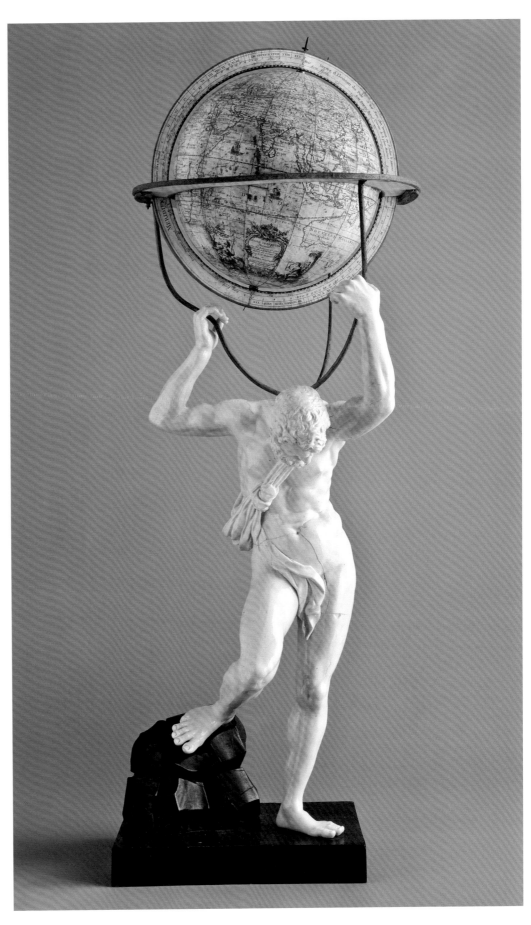

10. Ginori manufactory, *Atlas Carrying the Globe* (after Pietro Tacca), porcelain, Turin, Palazzo Madama, Museo Civico d'Arte Antica. Compared to the Pietro Tacca model, the arms and hands were bent before firing to enable the figure to bear the globe

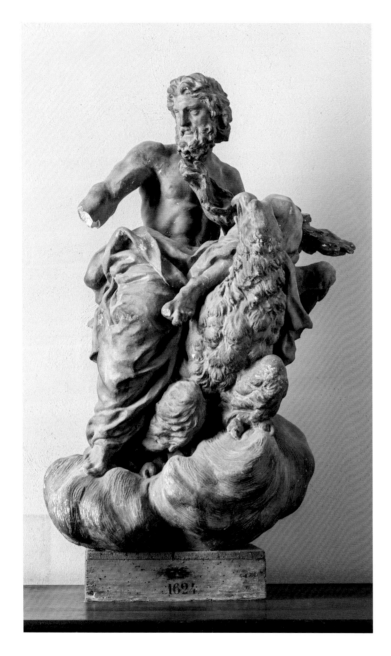

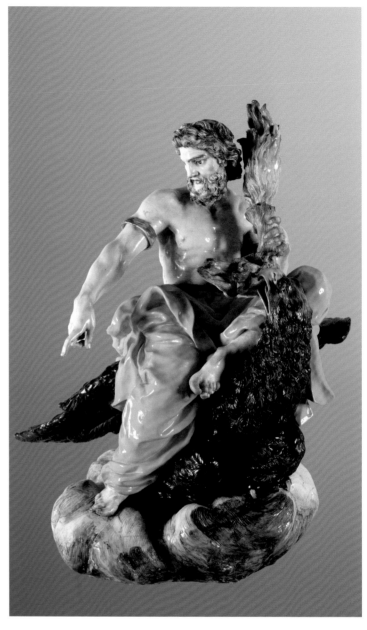

('linkages'; figs. 3–4) in the form of decorative elements, such as bracelets or foliage, not present on the original model. They were introduced by the modeller to conceal the gaps between pieces caused by the varying shrinkage, the result of firing at different times.[28] Despite these devices, cracks and firing defects were frequent (figs. 5, 7).

Exceptionally, some large porcelain items were decorated in a glaze-firing. The largest polychrome specimen is the *Jupiter Sitting on an Eagle* at Palazzo Madama in Turin, which is 64 centimetres high. In this case too, Doccia marked an improvement over Meissen and other European factories, demonstrating the notably original and extraordinary nature of Carlo Ginori's "quest for Estimable Porcelain".[29]

11. After Giuseppe Piamontini, *Jupiter Sitting on an Eagle*, plaster, Museo Richard Ginori of the Doccia manufactory

12. Ginori manufactory, *Jupiter Sitting on an Eagle*, (after Giuseppe Piamontini), polychrome porcelain, Turin, Palazzo Madama, Museo Civico d'Arte Antica

1 "The Marquis Ginori, unsatisfied with having exactly emulated with his works those of foreign factories, tasked with the extremely difficult and very doubtfully successful work of Statues" (Salmon 1757, p. 92). "Dans la manufacture de porcelaine, établie et entretenue à ses frais à *Florence*, on exécute des morceaux d'un très-grand volume. J'y ai vû des statues et des groupes grands comme demi nature, modelés d'après les plus belles antiques" (La Condamine 1757, p. 345). Both passages are reproduced in Ginori Lisci 1963, p. 230.

2 Vasari 1568 – De Vere 1996, I, p. 275.

3 See the noted passage by Francesco Algarotti in a letter dated 30 August 1739: "Would it not be so lovely to have in beautiful and white porcelain some fine pieces of bas-relief, a series of medallions, of emperors, of philosophers, the most beautiful statues, such as The Venus, The Faun, The Antinous, The Laocoön, moulded on a miniature scale" (1823, III, p. 109).

4 Marco Polo, *The Travels* [XIV century], book II, chapters XXXIX, LXXXII.

5 Scaligero 1557, pp. 313–14.

6 See Lightbown 1969; Spallanzani 1978/97, pp. 25–9.

7 Pliny the Elder, *Naturalis historia*, book 37, 18–21.

8 Aldrovandi ed. 1648, p. 231

9 Ibid.

10 BNCF, Fondo Magliabechiano, Cl. XV, n. 142.

11 In the composition, the preponderant part – about 75% – comprised a frit, a vitrified product obtained by the semi-fusion of a colourless compound. After cooling, the frit was finely ground and mixed with a little clay, the infusible part of the compound. The objects, once formed and dried, were painted with cobalt or manganese oxide, placed in a box and fired at a temperature of about 1200° C, then covered with an alkaline-lead glaze and again baked at 900–50° C. Regarding the Medici porcelain, see Alinari 2009; Darr, Wilson 2013 (with previous bibliography).

12 For a survey of European porcelain factories, see Berlin 2010.

13 See D'Albis 1999.

14 De Milly 1772.

15 See Wittwer 2004, pp. 93–9; concerning the technical aspects of production, ibid. pp. 75–107.

16 Florence, Biblioteca Biomedica dell'Università di Firenze, Antonio Cocchi, *Effemeridi* [3 August 1741–12 November 1741], fols. 61r–62v (9 November 1741), available on the website of the Università di Firenze. Cited partially in Biancalana 2009, p. 184, where reference is made to an overall survey of the factory's production and associated documentation.

17 Ginori Lisci 1963, p. 231.

18 For an overall view of Carlo Ginori, see Sesto Fiorentino 2006.

19 See Biancalana 2006; Biancalana 2009, pp. 205–23.

20 Ginori Lisci 1963, p. 231.

21 See Wittwer 2004.

22 See *La manifattura* 1970.

23 Le Condamine 1757, p. 345: "On desireroit … un vernis plus blanc pour la couverte; et cette perfection ne lui manqueroit vraisemblablement pas, si le marquis *Ginori* ne s'étoit fait une loi de n'employer d'autres matières que celles qu'il tire de péis même". Concerning the numerous recipes for glazes used at Doccia, see Biancalana 2009, pp. 239–45, in particular with regard to the use of porcelain scrap and gypsum and for the distinction between 'soft' and 'hard' glazes see p. 241. Also, D'Albis, Biancalana 2008. Non-invasive chemical analyses using x-ray fluorescence planned for the Doccia porcelain collection in Palazzo Madama in Turin may provide further elements for evaluation.

24 See Lankheit 1982; Zikos 2011; Balleri 2014[b], where reference is made to a study of the plaster, terracotta and wax models.

25 Letter from Bruschi to Ginori, 1754, cited in Biancalana 2009, pp. 54–5: "you requested that I make great statues from Rome, but currently these cannot be done, being that the cast of the marble is no longer serviceable for the undercuts, and for the links of the arms, and shadowed areas, such as under the arms and in other areas where plaster may not reach, here dowel moulds are done in wax, so that they may bind to the cast, and fill the plaster, and this you can saw, and form in quadrature. Squarcione has sent these well made plasters; he has even sent some casts, however if I do it in porcelain I will waste them, and we will the casts".

26 See Carradori 1802 – Sciolla 1979, p. X.

27 In this regard, see some restoration reports: Ravanelli Guidotti 2006; Lauricella 2011; Balleri 2012.

28 See the letter from Bruschi to Jacopo Rendelli, undated, included in the 1745 correspondence (cit. in Biancalana 2009, p. 45): "We have learnt of the intention of the Sig. Senator and master to join parts of the statue of the Knife Grinder before they are fired using linkages. It must also, however, be remembered that when such a large object is removed from the kiln it is difficult to support and so it must immediately be cut into pieces; in addition, being thin and fragile, despite their size, there is no longer the possibility of any further intervention; for this reason, the linkages would end up by being made without true awareness of the facts". The second copy of the *Knife Grinder* "senza cigne" would only be made in 1754 and assembled before firing. (ibid., p. 53).

29 Carlo Ginori, *Teoria degli ingredienti atti a fare la porcellana*, AGL, Manifattura di Doccia, Documenti vari, Filza no. 137, II, doss. no. 11, fols. 513–714, quoted in Biancalana 2009, p. 16.

Catalogue

1. Massimiliano Soldani Benzi (1656–1740)
Venus de' Medici (after the Antique)

1702
bronze; h. 157.5 cm

Vaduz-Vienna, Liechtenstein. The Princely Collections, inv. SK 537

PROVENANCE. Commissioned by Johann Adam Andreas I, Prince of Liechtenstein, from the artist, and since then in the family collections

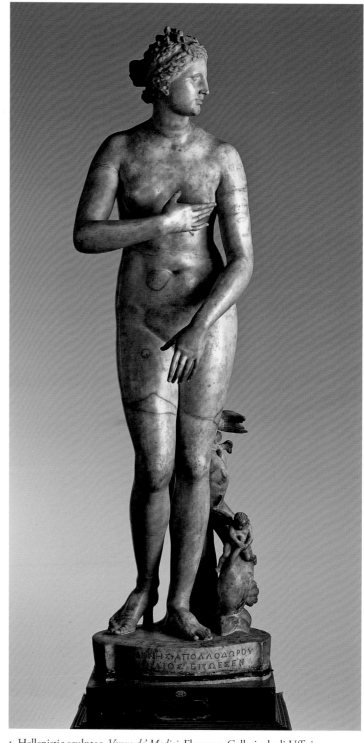

The bronze *Venus*, a full-size replica of the *Venus de' Medici* in the Tribuna at the Uffizi (fig. 1; Mansuelli 1958–61, I, pp. 69–74, cat. 45), is one of the statues cast by Massimiliano Soldani Benzi, commissioned by Prince Johann Adam Andreas I of Liechtenstein (Zikos 2005ª). In a letter dated 18 June 1695 Johann Adam expressed a desire to possess copies in bronze of three famous works from the Medici collection, to be made from casts of the originals: the *Dancing Faun* (D. Zikos, in Vienna 2005, p. 395, cat. 251), the *Venus de' Medici* and the *Bacchus* by Michelangelo (O. Raggio, in Frankfurt 1986, p. 226, cat. 46). In July of the same year, Soldani accepted the assignment without, however, concealing his preoccupation regarding obtaining permission to take casts of the statues from the Grand Duke Cosimo III. But given the importance of the client, permission was accorded shortly after, towards the end of August. On 29 September 1696 Soldani began work on the *Faun*, and on 18 February 1698 he wrote that he had received orders from Marquis Alessandro Vitelli not to continue work on the *Venus* (Lankheit 1962, pp. 328–32, docs. 643–8, 653, 658). The work in question is mentioned again only after the arrival in Vienna of its pendant, in a letter from the prince (27 May 1699) in which he asks for the bronze of the *Bacchus*. However, the artist wrote (on 23 June) that he would have preferred to work first on the *Venus*, having already prepared the moulds (ibid., p. 332, docs. 659–61). Soldani cast both statues without receiving any explicit order (30 August) and declared that he was still working on them in November 1699 and in August of 1701 (ibid., pp. 332–3, doc. 662; D. Zikos, in Wien 2005, p. 392, cat. 249). The *Bacchus* arrived in Vienna in April 1703 while the *Venus*, already completed in 1702, entered the collections of Johann Adam only in January 1707 (Lankheit 1962, pp. 335, 337, docs. 673, 685). Perhaps this is the Doccia porcelain version of a similar size made using the original moulds by Soldani and purchased by Carlo Ginori in 1744, now preserved in the Sesto Fiorentino Museum (cat. 2).

DANIELE LAURI

BIBLIOGRAPHY. Tietze-Conrat 1917, p. 101, n. 98; Hallo 1927, pp. 213–16; Lankheit 1958ª, p. 190; Lankheit 1962, pp. 143–5; Bregenz 1967, pp. 76–7, cat. 131; O. Raggio, in Frankfurt 1986, pp. 230–1, cat. 48; Zikos 1996, pp. 132–4; D. Zikos, in Vienna 2005, pp. 392–3, cat. 249.

1. Hellenistic sculptor, *Venus de' Medici*, Florence, Galleria degli Uffizi

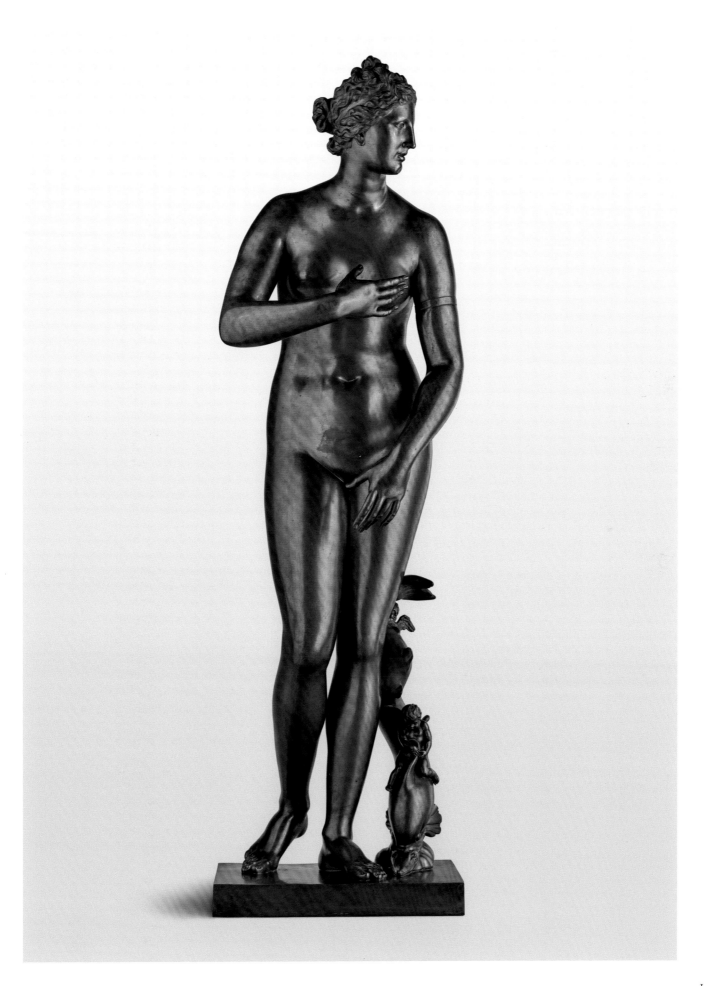

2. Ginori manufactory, Gaspero Bruschi (1710–80)
Venus de' Medici (after the Antique)

c. 1747–8
porcelain; h. 132 cm

Sesto Fiorentino, Museo Richard Ginori of the Doccia manufactory, inv. 17

The largest porcelain version of the *Venus de' Medici* made by the Doccia manufactory is in all likelihood the one by Gaspero Bruschi, an attribution that would seem to be confirmed by an autograph document (15 January 1748), in which the sculptor attests to having finished it (A. D'Agliano, in Rome 2008, p. 194, cat. 67). The statue consists of six portions (Mottola Molfino 1976–7, I, cat. 467), assembled using plaster (Ginori Lisci 1963, p. 61), with the joints dissimulated by the presence of a drape on the lower limbs and by jewellery on the neck and arms (G. Cefariello Grosso, in *La manifattura* 1988, p. 173, cat. 18). The dating, however, is still subject to debate: having established the *terminus ante quem* of 15 January 1748, the main hypotheses oscillate between 1745 (Liverani 1967, p. 63; Mottola Molfino 1976–7, I, cat. 467; L. Melegati, in Vienna 2005, p. 394, cat. 250) and 1747 (A. D'Agliano, in Rome 2008, p. 194, cat. 67; Biancalana 2009, p. 49; Balleri 2014[b], pp. 274–5). Based on the marble prototype preserved in the Tribuna at the Uffizi since 1688 (Haskell, Penny 1981, cat. 89), the porcelain version differs from it, however, in a number of details: the omission of the irregularly-shaped base (replaced by one of black pear wood; Biancalana 2009, p. 92), the dolphin with the two Erotes, and the trunk placed to support the goddess's left leg. It has yet to be firmly established from which moulds it was made, but it was most probably from "the four moulds of the large Gallery Statues" (Lankheit 1962, p. 284, doc. 351) present in the home of Massimiliano Soldani Benzi in Borgo Santa Croce and purchased by Marquis Ginori on 17 December 1744 through Giovan Battista Vannetti, who allegedly undertook the actual negotiations (Zikos 2005[a], p. 176, note 10; Biancalana 2009, pp. 69–74). It is also conceivable that they may be the same moulds that Soldani made to cast the bronze version of the *Venus de' Medici* (cat. 1) for the Prince of Liechtenstein (D. Zikos,

in Wien 2005, p. 392, cat. 249), the height of which is consistent with that of the Doccia figure, if we take into account the inevitable reduction of volume of the porcelain clay by about 16% as a result of firing (Balleri 2014[b], p. 275). Confirming the success of the classical prototype in the 18th century, are not only the six copies of the *Venus de' Medici* mentioned in the *Inventario dei Modelli* of the manufactory (Lankheit 1982 5:37, 7:66.1, 29:37, 48:14, 76:1.5, 81:17) but also the other four porcelain versions known today: two in private collections, measuring 67 cm (Caròla Perrotti, Melegati 2000, p. 38) and 49 cm (A. D'Agliano, in Florence 2003, p. 40, cat. 4), and two conserved at the Museo of the Doccia manufactory, measuring 44 cm (L. Melegati, in Vienna 2005, p. 394, cat. 250) and 42 cm (A. D'Agliano, in Rome 2008, p. 194, cat. 67), with their respective plaster models.

MARIA PERSONA

BIBLIOGRAPHY. Liverani 1967, p. 63; Mottola Molfino 1976–7, I, cat. 467; Lankheit 1982, pp. 105, 109, 144; G. Cefariello Grosso, in *La manifattura* 1988, p. 173, cat. 18; L. Melegati, in Vienna 2005, p. 394, cat. 250; A. D'Agliano, in Rome 2008, p. 194, cat. 67; Biancalana 2009, pp. 49–50, 69–74; R. Spinelli, in Florence 2009, p. 174, cat. 52; Balleri 2014[b], pp. 274–5

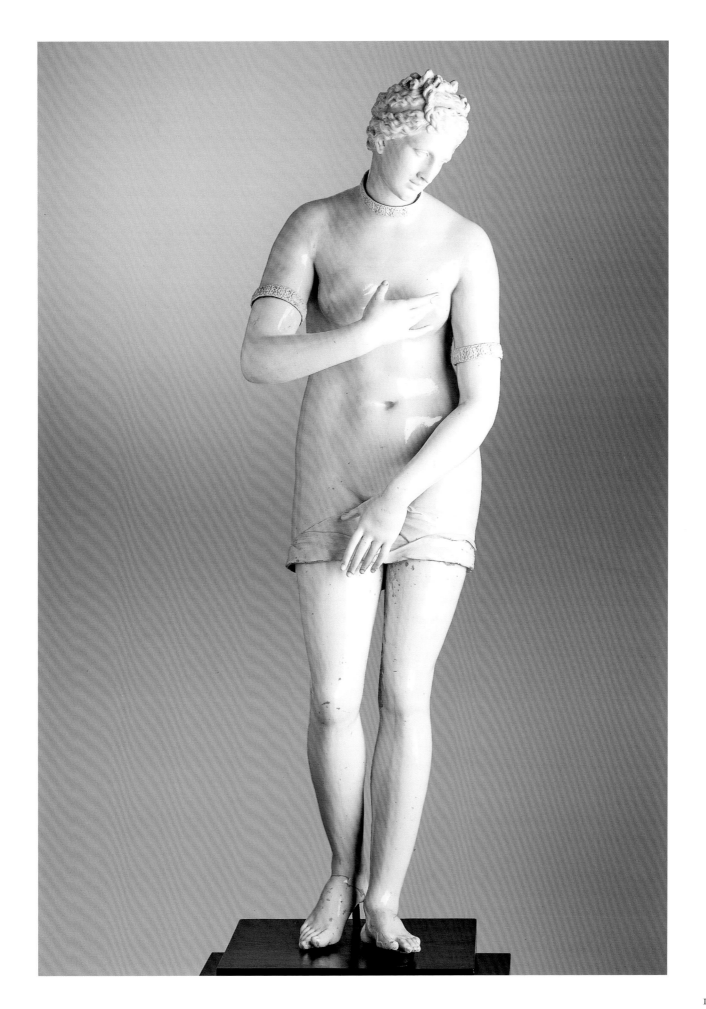

3. Ginori manufactory, Gaspero Bruschi (1710–80)
Mercury (after the Antique)

c. 1744–5
porcelain; h. 143 cm

Florence, Ginori collection

The only known life-size statue of the *Mercury*, now in private hands and on public display for the first time since the division of the old Museo di Doccia's holdings (see, in this volume, the text by Cristina Gnoni, on p. 24), where it used to be on show, is one of the masterpieces of the manufactory's early period of activity. It is made up of portions measuring about 60 cm (Ginori Lisci 1963, p. 61), joined by a natural resin coated with a light-coloured stucco, as revealed in the restoration conducted by Francesca Rossi on the occasion of the exhibition. The production of scale porcelain copies of ancient sculptures is a response to the precise wish of Marquis Carlo Ginori (ibid., p. 58): the prototype of the work in question is the *Mercury* in Parian marble which has been in the Uffizi Gallery since at least 1734 (Mansuelli 1958–61, I, p. 50, cat. 27; Haskell, Penny 1981, cat. 61). There are many similarities that may be observed: the height, which is almost the same if we take into account the shrinkage of the porcelain clay during firing; the pose of the figure, which recalls the type of the *Resting Satyr*; the slope of the shoulders with the head tilting towards the right, with an echo of Polyclitus also reflected in the physiognomy of the face, and the reference to the *Pothos* of Scopas in the crossed posture of the legs (J.L. Martinez, Paris 2007, p. 342, cat. 88).

However, the porcelain version differs from the original in the shape and material of the base, here of black pear wood (Biancalana 2009, p. 92), in the absence of attributes in the god's hands and in the only partial nudity of the body. Since in the current state of research, no data have emerged to confirm that a cast was taken from the ancient statue at the behest of Marquis Ginori, it is possible to hypothesise that of the sculptors active in the Florence of the last Medici, Massimiliano Soldani Benzi was the most likely to possess casts taken directly from Antique marbles. Indeed, together with other copies after the Antique, he made a life-size bronze version of the *Mercury* for the Genoese patrician Stefano da Passano, today conserved in the Museumslandschaft Hessen Kassel (Ciechanowiecki 1973, p. 184; Zikos 1996, p. 133). It is therefore reasonable to assume that the casts Soldani Benzi made from the Uffizi prototype were purchased after his death by his pupil Lorenzo Maria Weber (who in turn sold them to Carlo Ginori), or directly by the Marquis himself (Lankheit 1962 pp. 243–4; Melegati 2000, p. 136; Zikos 2011, pp. 21–2). Biancalana (2009, p. 67) instead links the porcelain work to a payment for "making casts of Mercury" invoiced by Anton Filippo Maria Weber ("per fattura di forme di Mercurio", 23 May 1744), brother of the aforementioned Lorenzo. The Doccia manufactory still possesses a full-size plaster cast of the statue of *Mercury* and a reduced terracotta version. Nothing is known of the provenance of the first, but Rita Balleri (2014[b], p. 276, cat. 162) suggests it belongs to a group of similar plaster works, drawn from Antique marbles in the Uffizi Gallery between 1746 and 1747 by Gaetano Traballesi and Niccolò Kindermann. The second (ibid., p. 359, cat. 267) has been instead attributed by Lankheit (1982, 76:1,1) to Soldani Benzi. Another bronze life-size *Mercury* was cast in Florence by Zanobi di Bernardo Lastricati in 1551 (Spallanzani 1978, p. 17; Haskell, Penny 1981, cat. 61), commissioned by Cardinal Ridolfi de' Medici and his brother Lorenzo di Piero for the courtyard of their *palazzo* in via Tornabuoni (now at the Walters Art Gallery in Baltimore).

MARIA PERSONA

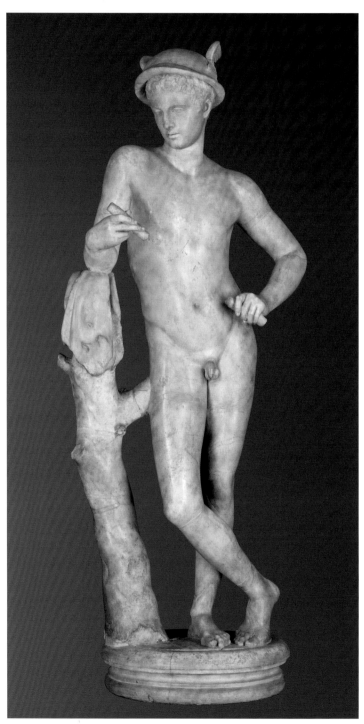

1. Greek sculpture, 4th century BC, *Mercury*, Florence, Galleria degli Uffizi

BIBLIOGRAPHY. Unpublished.

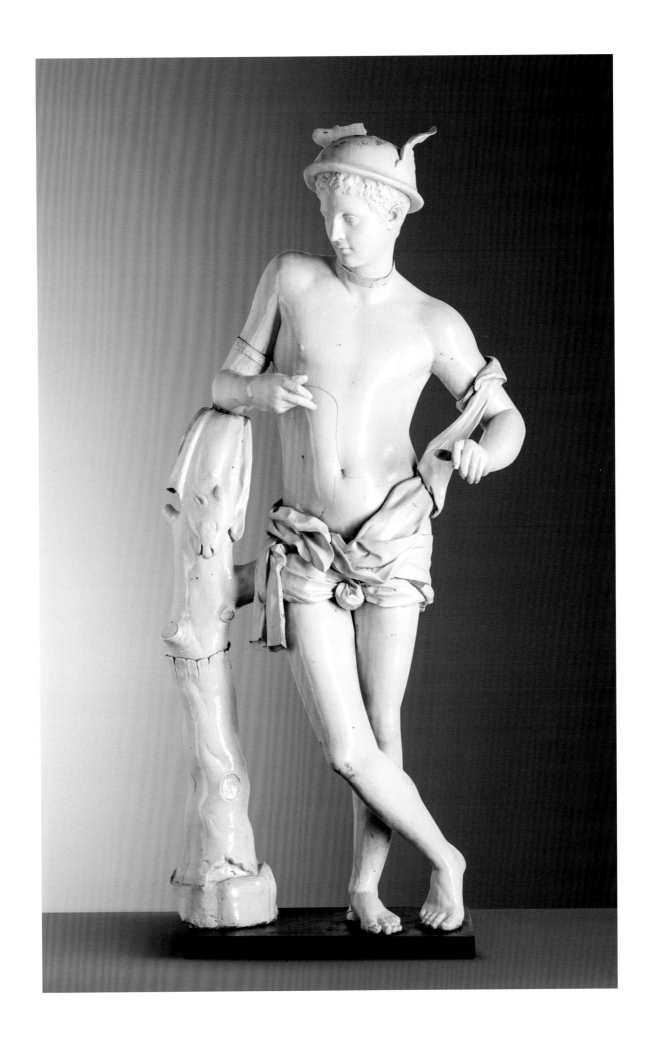

4. Ginori manufactory, Gaspero Bruschi (1710–80)
Tempietto Ginori

1750–1
porcelain; h. 167 cm (with the base)

INSCRIPTIONS. On the scroll: IMMORTALITATI · ET · GENIO · LOCI | CAROLVS · GINORIVS | MARCHIO · ET · COMES · FLORENTINVS · ETRVSCAE | SOCIETATIS · PRINCEPS · DEDICAVIT | ANNO · MDCC.LVI.
On the base of *Mercury* base: POST FATA POTENTIOR SVRGIT ETRVRIA

Cortona, Museo dell'Accademia Etrusca e della Città di Cortona, inv. AE 492 + AE 491 (base)

RESTORED. 2017, Francesca Rossi

The masterpiece of the early period of the Doccia manufactory's activity, the *Tempietto Ginori* leaves its historic home in Palazzo Casali (Cortona), where it has been located since 1757, for the first time for this exhibition. Its arrival at the Accademia Etrusca was noted in a missive (18 August 1757), in which Filippo Venuti confirms to Carlo Ginori's son, Lorenzo, that "the machine has arrived in good condition" (AGL, Lorenzo Ginori. Lettere diverse dirette al medesimo 1757-1761, Filza I, XIII, 1, fol. 640r, in Ginori Lisci 1963, p. 141). The work was already being completed by 16 December 1750 when the Marquis Carlo Ginori instructed the factory's chief modeller, Gaspero Bruschi, to change the inscription at the base of the *Mercury* (AGL, Manifattura di Doccia. Documenti vari, Filza 137, 1, fol. 718v, cited in Biancalana 2009, pp. 50–1). It can be considered almost finished on 21 April of the following year: in a letter, the Marquis calls on Jacopo Fanciullacci to ask Gaspero Bruschi "whether the Machine has come out well, whether it is accommodated on the Base so that it may be turned, and what do people who have seen the piece say?"(AGL, Manifattura di Doccia. Documenti vari, Filza 137, 1, fol. 938v, quoted in Ginori Lisci 1963, p. 141).

Made entirely of many pieces of porcelain, it appears as a light-looking architectural structure, incorporating a rich decorative apparatus. At the four corners of the original polylobed base of black wood sit the four cardinal virtues with their respective symbols and attributes, designed by Giovan Battista Foggini. At the top of the pillars, in precarious equilibrium, we see the three figures of the *Parcae* and the personification of *Time*, also by Foggini. The manufactory possessed wax models for all these figures, made by the son, Vincenzo Foggini, from his father's moulds (Lankheit 1982, 8:69, 87:2,1, 87:2,2). The crowning of the piece is embellished with four lions, which are also mentioned in the *Inventario dei Modelli* (ibid., 89:13), together with a porcelain version of the *Mercury* derived from a Giambologna model for a bronze known in several versions, including one today at the Museo Nazionale del Bargello (cat. 5). Of the latter, the Museo di Doccia preserves a red wax model (cat. 6) and

one in terracotta, joined by a third specimen, also of terracotta (ibid., 80:10,2), which John Winter (in Florence 2003, p. 91, cat. 17) suggests be the reference for the version in Cortona, but which was actually a copy of the large *Mercury* in Villa Medici by Giambologna (today in the Museo Nazionale del Bargello). Finally, the central part of the *Tempietto* is dominated by a group of *Time Abducting Beauty*, again by Giovan Battista Foggini, the wax model for which was paid to his son Vincenzo on 13 July 1744 (Lankheit 1982, 22:13).

The *Tempietto*'s architectural structure is entirely covered with 73 white porcelain medals on a blue ground, reproducing the bronze *Medici series* by Antonio Selvi and Bartolomeo Vaggelli (1740–4). Of the 76 originals, three medals are missing (Gian Gastone, Ferdinand I and Lorenzo di Pierfrancesco de' Medici, il Popolano), while three subjects are cast twice (Joanna of Austria, Christina of Lorraine and Ferdinand III or Ferdinand di Cosimo III). One medal instead (the one bearing the image of Gian Gastone on the *recto*) shows just the *verso*, with allegories of the Arno and Ibero rivers, probably an allusion to the failed nomination of Don Carlos of Bourbon as Grand Duke of Tuscany (Balleri 2009, pp. 18–19). The celebration of the Medicean dynasty leads to the exaltation of the new sovereigns, Francis I, Holy Roman Emperor, and Maria Theresa of Austria, immortalised in a joint portrait medallion supported in the left hand of the *Mercury*.

MARIA PERSONA

BIBLIOGRAPHY. Morazzoni, Levy 1960, pl. 244; Ginori Lisci 1963, pl. XXXVIII; Liverani 1967, pl. XLIV–XLVII; Mottola Molfino 1976–7, I, cat. 477; Lankheit 1982, pp. 109, 120, 129, 156, 160, 162; *La manifattura* 1988, pp. 176–8, cat. 23; Casciu 1992, p. 175; J. Winter, in Florence 2003, pp. 88–105, cat. 17–22; Balleri 2009, pp. 18–19; Biancalana 2009, pp. 50–1, 57.

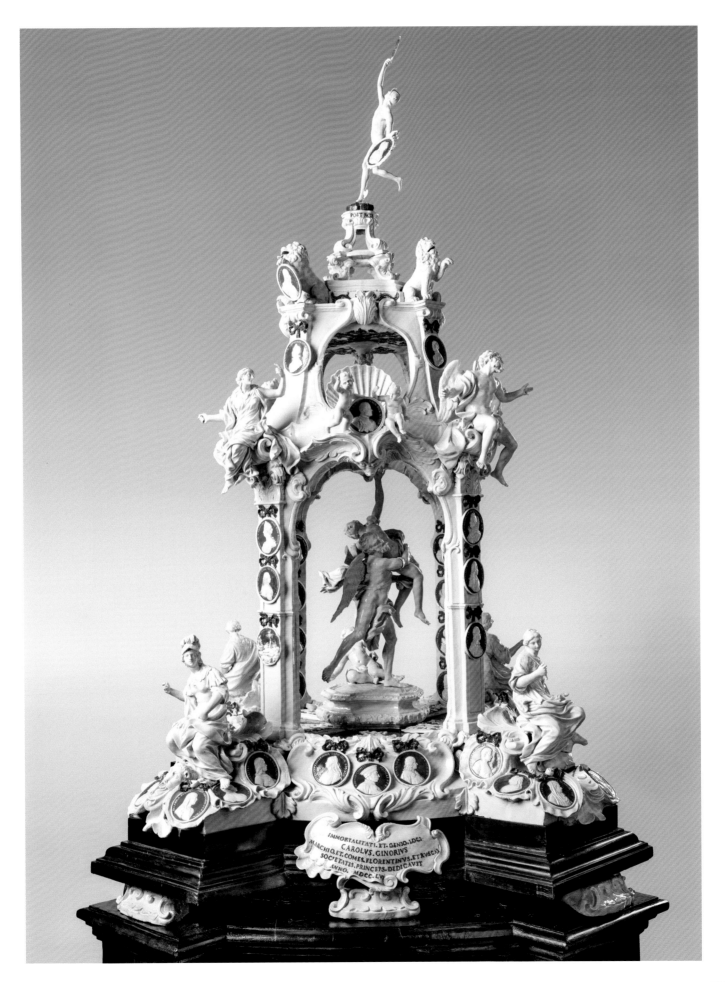

5. Giambologna (1529–1608)
Mercury

before 1589
bronze; h. 62 cm (72 with the base)

Florence, Museo Nazionale del Bargello, inv. Bronzi 210

Recorded as being in the Bargello collection by Igino Benvenuto Supino (1898, p. 398, cat. 54), but included in art historical literature only with Herbert Keutner in 1978, the bronze statue of *Flying Mercury* by Giambologna in the Museo Nazionale del Bargello was compared by the German scholar with the work mentioned in the *Inventario della Tribuna* of 1589, drawn up in the reign of Ferdinand I. Here, indeed, there is mention of "a bronze Mercury, 7/8 *braccia* high, standing on one foot, by Giovanni Bologna, with its black wood base, no. 1" (fol. 26; Gaeta Bertelà 1997, p. 35). According to the specifications, therefore, the height should be approximately 50 cm and the incongruence with regard to the base, which today consists of a bronze pedestal with semi-precious stones, is probably due to a replacement effected in the 16th century (D. Zikos, in Vienna 2006, p. 256, cat. 24). Traceable in the inventories of the Gallery since 1784, where it is mentioned as "… a copy of the Mercury by Gian Bologna with some changes. b.1 high with bronze base formed of mixed marble" (*Inventario* 1784, II, p. 4, no. 2352), the Bargello bronze is similar to the other versions of the small model, such as the example sent before 1579 by Giambologna to the Duke of Parma, Ottavio Farnese (now Naples, Museo di Capodimonte; F. Capobianco, in Vienna 2006, pp. 253–4, cat. 23), or the one donated by the Grand Duke Francis I to the Elector of Saxony, Christian I by 1587 (today Dresden, Staatliche Kunstammlungen; D. Zikos, in Munich 2015, pp. 150–2, cat. 4). The figure of the Florentine *Mercury* appears slimmer than the Farnese version, while the shape of the petasus and attachment of the wings is different to the bronzes of Dresden and Vienna (C. Kryza-Gersch, in Vienna 2006, pp. 259–61, cat. 26). At all events, in terms of the similarity of the pose and size, it is plausible that the wax in the Museo Richard Ginori (cat. 6) is a derivation from the same moulds used for the Medici version and other autograph versions, naturally modified in terms of the modelling and then updated in its porcelain transformation (cat. 4).

DANIELE LAURI

BIBLIOGRAPHY. Supino 1898, p. 398, cat. 54; H. Keutner, in Vienna 1978, p. 117; M. Collareta, in Florence 1980, p. 332, cat. 676; Keutner 1984; Gaeta Bertelà 1997, p. 35; Gasparotto 2005, pp. 72–5; B. Bertelli, in Florence 2006ᵇ, p. 266, cat. 56; D. Zikos, in Vienna 2006, p. 256, cat. 24; D. Ekserdjian, in London 2012, p. 271, cat. 107; D. Zikos, in Munich 2015, pp. 150–2, cat. 4.

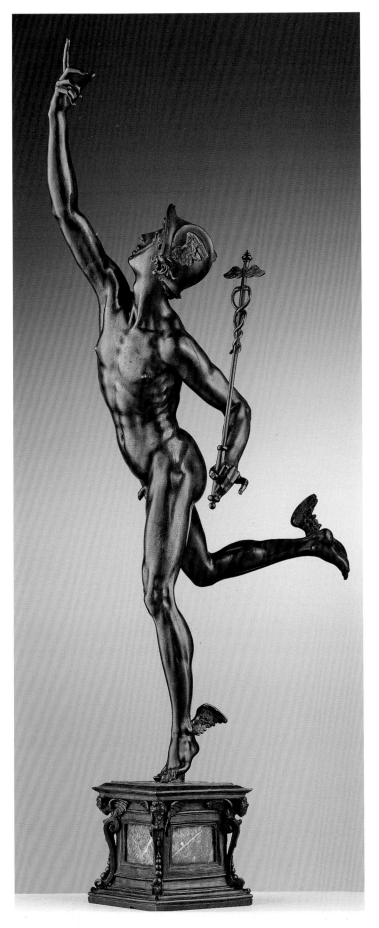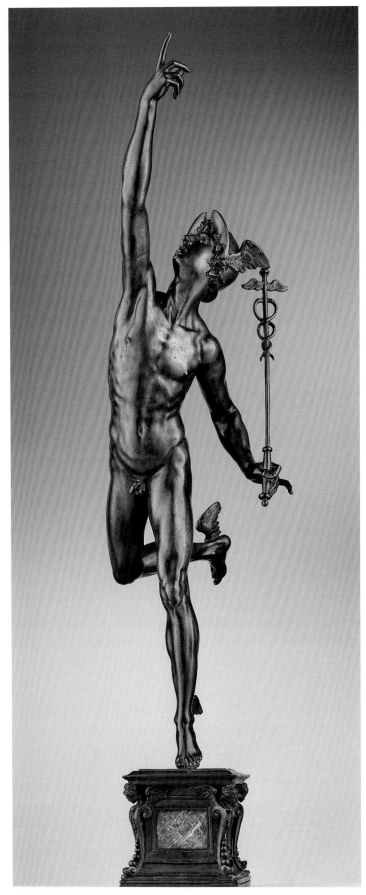

6. *Mercury* (after Giambologna)
before 1751
red wax; h. 62 cm

Sesto Fiorentino, Museo Richard Ginori of the Doccia manufactory,
inv. 88 (hist. inv. 315)

RESTORED. 2017, Francesca Rossi

Published for the first time by Gino Campana (1966, p. 40, fig. 17), the wax *Mercury*, probably derived from the same moulds used for a small bronze of the same size by Giambologna – like the example in the Museo Nazionale del Bargello (cat. 5) – was compared by Klaus Lankheit (1982, fig. 235) with the terracotta (mistakenly referred to as wax) that is still conserved in the Museo Richard Ginori of the Doccia manufactory (fig. 1) which, however, does not appear in the *Inventario dei Modelli*. The latter, smaller in size than the wax (53.5 cm in height), seems to have been a preparatory work for the realisation of a porcelain version, with the addition of a tree trunk to ensure stability (Balleri 2006, p. 344). Indeed, a porcelain *Mercury* similar to the two versions of this prototype after Giambologna appears at the top of the *Tempietto Ginori* (cat. 4) made between 1750 and 1751 commissioned by Carlo Ginori. Payments to Vincenzo Foggini attributable to this enterprise are recorded for the production of red wax and moulds of the works by his father Giovan Battista, which would add to the complex iconographic programme of the "machine": *Time Abducting Beauty* (July 1744) and the three *Fates* (June 1750; Biancalana 2009, pp. 63, 66). The making of the waxwork in question, however, has not yet been documented, but must go back to this period and in any case before its definitive translation into porcelain.

The Doccia *Inventario dei Modelli* mentions a "Hermes known as the Mercury of Villa Medici. By Gio. Bologna of wax from a mould" and a "Second Mercury from Villa Medici", of which the material is not specified, while from the *Inventario delle Forme* we learn that they were respectively composed of 10 and 4 parts (Lankheit 1982, 29:34, 80:10.2). Lankheit identifies the first with the work in question, but does not link the second to an example preserved in the Museo in Sesto Fiorentino. The waxwork's reference to the model of the large *Mercury* of Villa Medici, now in the Museo Nazionale del Bargello (D. Zikos, in Munich 2015, pp. 146–8, cat. 3), would suggest that this is either a large statue, or a reduction from the bronze. However, neither the one nor the other are documented in Doccia. It is therefore likely that whoever wrote up the inventory erroneously suggested the larger and more famous bronze as the iconographic model for our wax, and that this is therefore 29:34 in the *Inventario dei Modelli*. The large porcelain *Mercury* mentioned by Ginori Lisci (1963, p. 61) is probably not a version of the Medici bronze, as is asserted by John Winter (Florence 2003, p. 91, note 7), but a translation of the example in the Galleria (cat. 3).

DANIELE LAURI

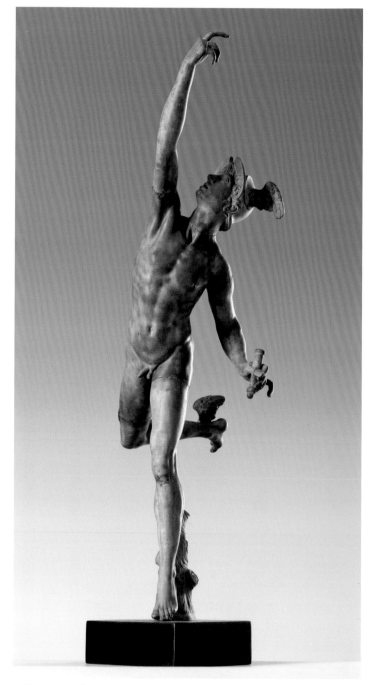

1. Ginori manufactory, *Mercury*, terracotta, Sesto Fiorentino, Museo Richard Ginori of the Doccia manufactory

BIBLIOGRAPHY. Campana 1966, pp. 30, 40, fig. 17; Lankheit 1982, 29:34, fig. 236.

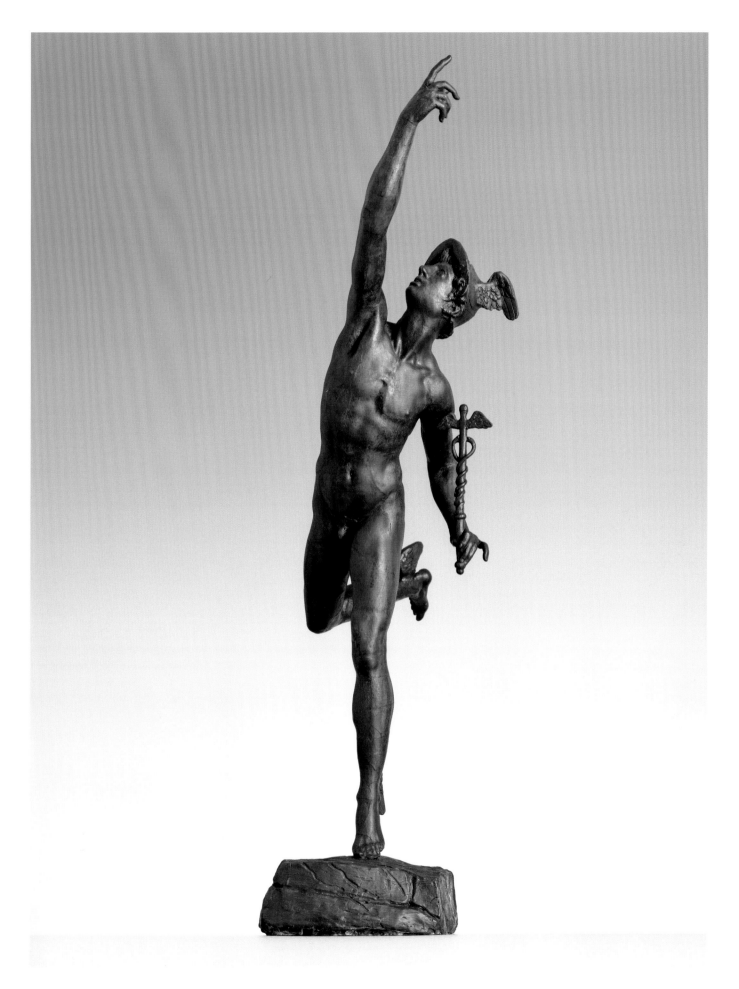

7. Massimiliano Soldani Benzi (1656–1740)
Lamentation over the Dead Christ, or *Pietà*

1713–14
bronze; 74.9 × 75 × 50.9 cm

Seattle, Art Museum, inv. 61.178, Samuel H. Kress Collection

PROVENANCE. Milan, Baslini Collection

In February 1714, Anton Maria Salviati bought a "bronze group depicting a dead Christ with the Holy Virgin, and some Angels" from Massimiliano Soldani Benzi (in Keutner 1976, pp. 150, 162, doc. 20). The *Pietà* was also mentioned in the Duke's will of 1719, bequeathed on his death in 1723 to his brother Alamanno, Cardinal Salviati. In two inventories of the furniture in the *palazzo* in via del Palagio (now via Ghibellina), the work is recorded as being on a "base of black pear wood with four bronze balls beneath, with two Protectors, one with a black veil and the other of dyed green silk" (1723), while more than twenty years later, it is described as "all golden" (ibid., pp. 162–3, docs. 23–4). The *Pietà* in question, attributed by Leo Planiscig to Alessandro Algardi in 1940, but correctly reattributed to Soldani by Ulrich Middeldorf (see Suida, Fuller 1954, p. 82), is the only known bronze model of the successful composition (a version without the tomb and flying cherubs is conserved in the Walters Art Museum in Baltimore; Lankheit 1958[b], pp. 9–15).

It does not show any traces of gilding and it is likely that those who described it thus misinterpreted the reddish-gold paint typical of Florentine bronzes from the mature Giambologna onwards, which in part still survives to this day. Derived from the same moulds used for the wax *Pietà* in Villa La Quiete (cat. 9; D. Zikos, in Vienna 2005, p. 466), the group is one of the first to have been translated into porcelain (cat. 8) immediately after the purchase of the original moulds from Massimiliano Soldani by Carlo Ginori in 1744 (Zikos 2011, p. 21). A wax model, made by using these moulds, which is still preserved in the Museo Richard Ginori, appears in the *Inventario dei Modelli* of the Doccia manufactory, in which it is specified that "The original is to be found in the house of the Conti Bardi" (Lankheit 1982 2:3). John Winter (in Florence 2003, p. 67, note 5) has suggested that if the bronze was in the Salviati house, the Bardi example, the material of which is not specified, could be the wax *Pietà* from the Villa La Quiete (cat. 9), but this suggestion should be rejected given the provenance of the latter from the Gondi collection, but also because the *Pietà* in the Bardi house was of terracotta (see the essay by Zikos in this volume, on pp. 64–5, note 10).

DANIELE LAURI

BIBLIOGRAPHY. Sambon, Milan, 26 November 1888, *Catalogo della collezione Baslini di Milano*, lot 448, fig. XVI; Suida, Fuller 1954, p. 82; Lankheit 1962, pp. 137–8; Pope-Hennessy 1965, pp. 134–5, cat. 494; K. Lankheit, in Detroit/Florence 1974, p. 102, cat. 65; Keutner 1976, pp. 149–2, 162–3, s 20–4; D. Zikos, in Vienna 2005, pp. 465–6, cat. 315; R. Spinelli, in Florence 2009, pp. 198–9, cat. 64.

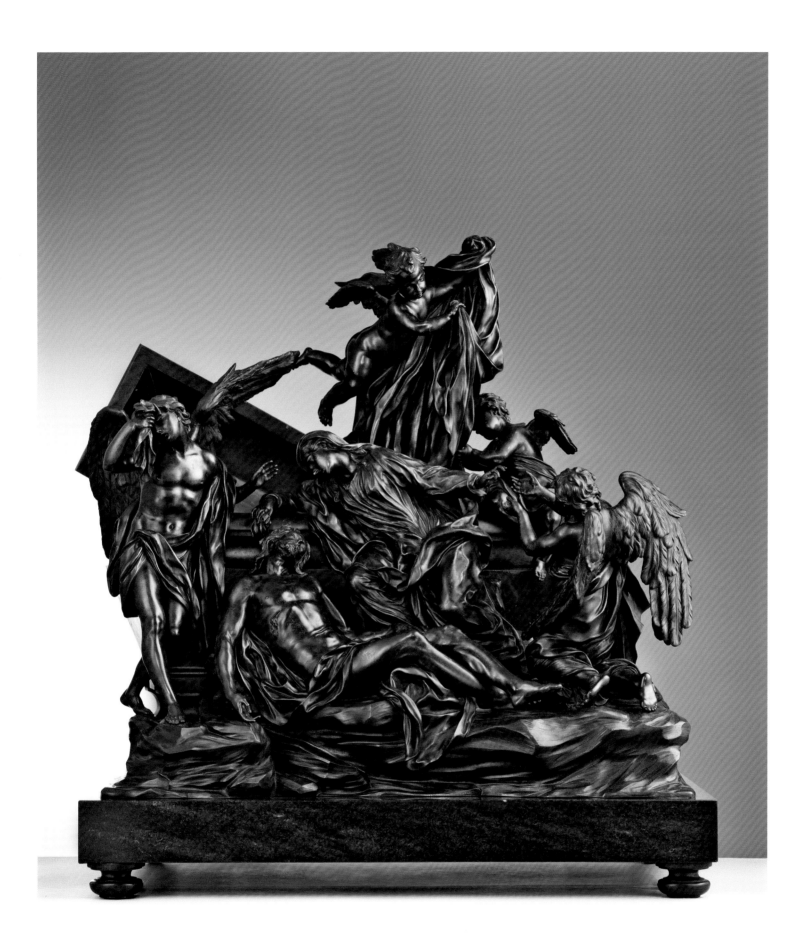

8. Ginori manufactory, Gaspero Bruschi (1710–80)
Lamentation over the Dead Christ, or *Pietà* (after Massimiliano Soldani Benzi)

1744–5
porcelain; 71.5 (92.5 with the base) × 92.5 × 73 cm

Florence, Galleria Corsini

PROVENANCE. Rome, Palazzo Corsini alla Lungara
RESTORED. 2009, Antonia Lauricella

The *Lamentation over the Dead Christ*, also known as *Pietà*, is one of the first white porcelain groups to be modelled by Gaspero Bruschi in 1744 (Ginori Lisci 1963, p. 62) from the original moulds of Massimiliano Soldani Benzi, purchased by Marquis Carlo Ginori on 25 July of the same year (Lankheit 1962, p. 284, doc. 352). By 1 March 1745 the work was already nearing completion, as evidenced by a letter from Francesco Poggetti who, in his role as 'assembler' of the *Pietà* group (González-Palacios 2006, p. 29), had already "put together the Base, with the Sepulchre, except for the figures" (in Biancalana 2009, p. 42). The sculpture still has its original base "of cut-out rowan" (ibid.; formerly in Ginori Lisci 1963, p. 62), that John Winter (in Florence 2003, p. 64, cat. 11) believed to be a replica of the wooden black pear wood base with bronze feet (Keutner 1976, p. 163, docs. 23–4) planned by Soldani Benzi for the *Pietà* preserved today at the Art Museum in Seattle (cat. 7). Recorded as being among the works in the collection of Cardinal Neri Corsini in the audience chamber of his Palazzo alla Lungara in Rome, the group was apparently a gift from the Marquis Ginori to the uncle of his wife (Elisabetta Corsini), aimed at promoting his manufactory in one of the city's most influential circles (J. Winter, Florence 2003, p. 64, cat. 11). This does not exclude the possible devotional function of the work, which was returned by descent to the family in Florence after 1771 (J. Winter, in Vienna 2005, p. 466, cat. 316). The restoration, carried out on the porcelain in 2009, has revealed that it is not composed of 54 parts as previously thought (Lankheit 1982 2/3:3), but rather 59, and that the disposition of the figures presented obvious differences compared to the Soldani prototype and the waxwork preserved in Doccia (Lauricella 2011, p. 179). The complete disassembly of the sculptural group has made it possible to restore the original composition. Another two versions in polychrome porcelain of the 'large *Pietà*' by Soldani Benzi are known, now in the County Museum of Art in Los Angeles and at the Nationalmuseum in Stockholm. In 2009, a third example was made (Sesto Fiorentino, Museo Richard Ginori of the Doccia manufactory) in biscuit, taken from the original Soldani moulds preserved in the manufactory Voltone, through which it was possible to ascertain the dating of the model (1708) by means of the discovery of two inscriptions that had so far remained illegible (Zikos 2011, p. 23).
MARIA PERSONA

BIBLIOGRAPHY. Lankheit 1962, p. 284, doc. 352; Ginori Lisci 1963, p. 62; Mottola Molfino 1976–7, I, cat. 463; Lankheit 1982, p. 100; J. Winter, in Florence 2003, p. 64, cat. 11; J. Winter, in Vienna 2005, p. 466, cat. 316; González-Palacios 2006, p. 29; Biancalana 2009, p. 42; R. Spinelli, in Florence 2009, p. 202, cat. 66; Lauricella 2011, p. 179; Zikos 2011, p. 23.

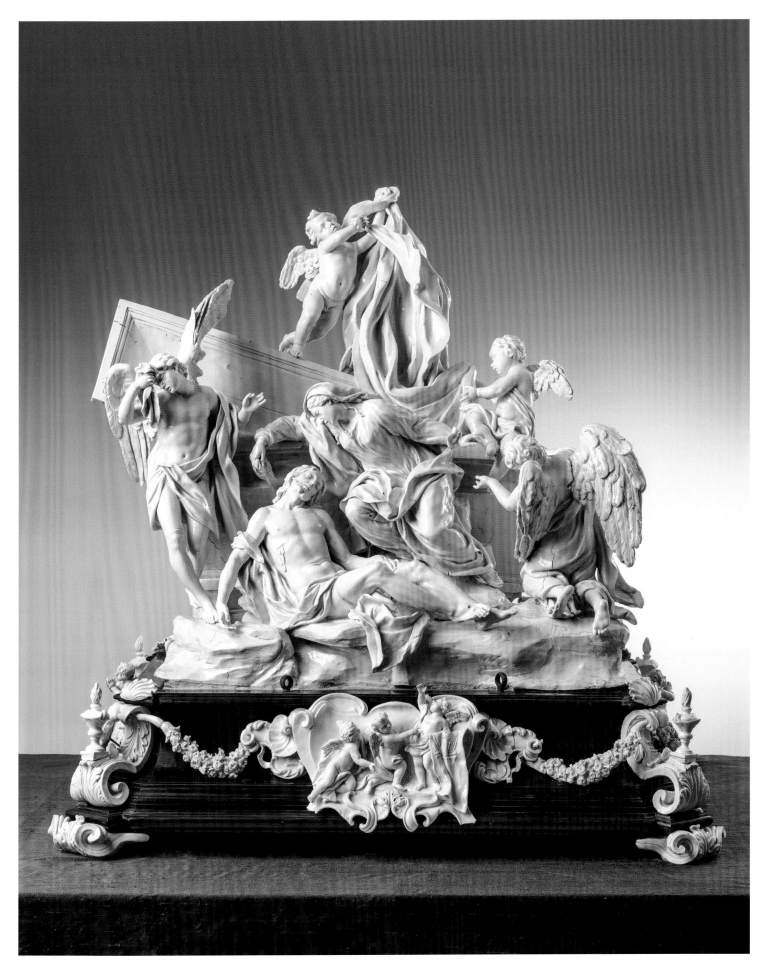

9. Massimiliano Soldani Benzi (1656–1740)
Lamentation over the Dead Christ, or *Pietà*

after 1708-before 1740
wax, cast and modelled; 59 × 70 × 46 cm

Florence, Villa La Quiete alle Montalve
(on loan to Palazzo Pitti, Tesoro dei Granduchi [formerly Museo degli Argenti])

PROVENANCE. Giovan Battista Gondi, Florence
RESTORED. 2009, Chiara Gabbriellini, Francesca Rossi

not on display

Unknown to literature before Lankheit (1962, p. 215, note 74), and immediately afterwards only referred to by Ginori Lisci (1963, p. 141) and by Pope-Hennessy (1965, p. 135), this wax was first published and illustrated by Paolucci (1978, pp. 68–9) who praised its superior quality with regard to another wax version in the Museo di Doccia, which is of a darker colour typical of the waxes made in the Ginori manufactory as models for porcelain and less finished than the present cast (Lankheit 1982, 2/3:3). Nevertheless, both were made with the same moulds Soldani had used for the only known bronze version of this composition (cat. 7) and were acquired – as was discovered by Lankheit (1962, p. 284, doc. 352) – from his son and heir Ferdinando by the factory's founder Carlo Ginori on 25 September 1744 to be employed soon afterwards to produce the splendid Corsini porcelain (cat. 8). Although the appreciation of the La Quiete wax has continued to the present day (Lankheit 1982, pp. 17–18; R. Spinelli, in Firenze 2009, pp. 200–1, cat. 65), it has not been recognized as a work made in the artist's workshop. Soldani is, however, known to have had such waxes made by his assistants and to have encouraged their acquisition because – notwithstanding the lesser value of the material and the infinitely minor cost compared to that of a bronze – they were still, in Soldani's proud statement, "things moulded on my originals made with some study" (Oxford, Bodleian Library, Mss. Rawlinson, Letters, 132, fol. 243v; see my essay in this volume, on p. 48). It is certainly not a "mould prepared for bronze casting" (Balleri 2014[b], p. 12), as such a wax casting model would have had a core, whereas according to a recent restoration by the Opificio delle Pietre Dure (GR 12710) the stability of the Montalve *Pietà* is secured by a system of wooden beams and the group is otherwise empty inside.

The evident devotional character of this wax received an unexpected confirmation when the original moulds were rediscovered in the Richard Ginori factory and an inscription was noted under Christ, indicating that the artist had made the model in 1708 "for his devotion" (Zikos 2011, p. 23). Herein lies perhaps the explanation for two varying accounts of an old label on the Museo di Doccia wax. According to Morazzoni (1935, p. 44, pl. XXXI), the latter (which he considered an original model by Soldani thus being the first in print to refer to the model as the invention of this artist) was signed ("firmata") "in atonement for my sins 1742". In 1954 Suida reported that Ulrich Middeldorf considered the Doccia museum wax as the model for cat. 7 and that according to the German scholar "it bears the following inscription by the artist: 'All'età di 82 anni in espiazione dei miei peccati'" (p. 82).

If the rediscovery of the original moulds has helped ascertain the date of the model, the history of the present wax appears more complex. In 1978 Paolucci suggested it could have entered the Villa La Quiete as a gift of Anna Maria Luisa de' Medici, Dowager Electress Palatine, who spent periods of spiritual retreat in that Conservatory. The suggestion was taken up by Lankheit in 1982 and later by Roani Villani and Spinelli. The group did not, however, belong to the works of art left to the Conservatory by the Electress Palatine as it is not included either in an unpublished list of the 'Donativi' (ASM, 5026, Libro di memorie "M", pp. 63 ff.) nor in the Annals of the monastery (ASM, 5024).

Its earliest presence in the Villa La Quiete can now be attested to 1808 according to newly discovered document (ASM, 674, ins. 3). How the sculpture arrived there remains a riddle. But in 1982, Gino Corti (p. 502, note 2) published a reference to the 1750 posthumous inventory of Giovan Battista Gaetano Gondi (1689–1750) of a "Pietà in bas-relief, the work of Massimiliano Soldani, in a glass case, first base of red velvet with gold trim and lower base of black pear wood", which prompted Mara Visonà to identify this work with our wax (oral communication). This is indeed possible and we have tried to reconstruct the history of the work in the Gondi collection. Its earliest mention is included in a 1741 inventory where it is described in the same way as the one discovered by Corti (ASM, 4159, unpaginated) and is located in a 'long room' of a house on Via Maggio. It appears to have still been there ten years later, though at that time it was found in Gondi's bedroom where it could have been moved shortly before his death. The use of this house was granted to Gondi by Grand Duke Cosimo III on 10 April 1718 (ASM, 4149, ins. 12), a likely *terminus post quem* for the acquisition or commission of the wax. The wax was therefore never in the Palazzo Gondi as is claimed by De Vuono (2005, p. 116).

Visonà's proposal that the Gondi documents refer to a bas-relief could be contested. In fact Soldani also made a bas-relief of the *Lamentation*, today in Munich (D. Zikos, in Firenze 2006[c], p. 194, cat. 46). But the two bases of the Gondi *Pietà* are an unequivocal reference to a group. It is in fact not uncommon for the term bas-relief to be used in Renaissance and Baroque texts for the designation of a group.

By 1741, when the wax is first mentioned, Giovan Battista Gondi had inherited the estates of his father Ferdinando (1639–1717) and his paternal uncle Carlo Antonio Gondi (1642–1720). The latter was an old acquaintance of Soldani's who had stayed in Paris in the last months of Gondi's tenureship as a Grand Ducal ambassador to the court of France (Zikos 2014[b]). Soldani is paid by Carlo Antonio (ASM, 4137) twice in 1714 for the restoration of two bronze equestrian statuettes. He is therefore the Gondi who most likely commissioned this work. But it is also possible that it had been given to Giovan Battista by his mother Ottavia di Federigo Gondi (1667–1747) during her lifetime. It is interesting that she owned a small set of devotional waxes (according to her post mortem inventory of 28 March 1747; ASM, 4159).

After Giovan Battista's death on 24 January 1750 the wax was inherited by Maria Ottavia, his daughter by his second wife, Teresa Mendez Vigo. As Maria Ottavia had not yet come of age, her patrimony was administered by two trustees who decided to put some works on sale already in June of that year before obtaining a proper permit to do so by the Magistrato Supremo, which was granted on 29 September. Sometime between 5 June and 19 September the wax *Pietà* was sold for 12 scudi – two scudi more than it was valued at Giovan Battista's death – to a certain Senator Rossi (as stated in an leaflet found in ASM, 4159): who must be the only

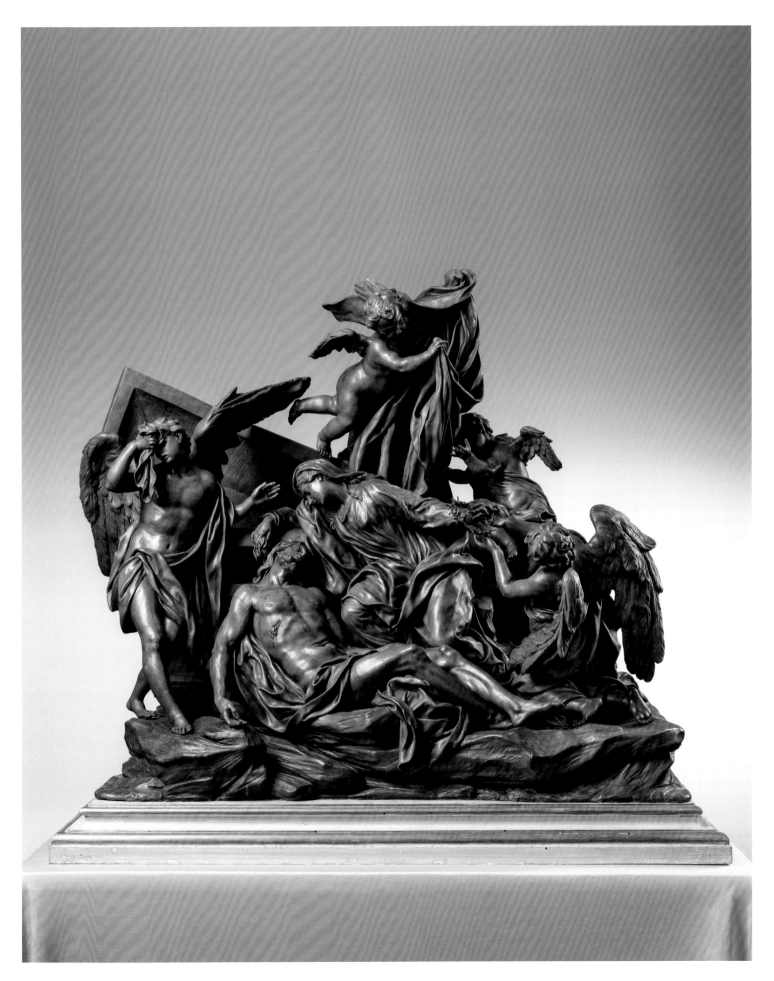

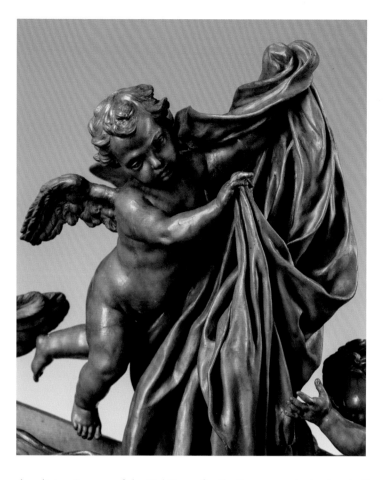

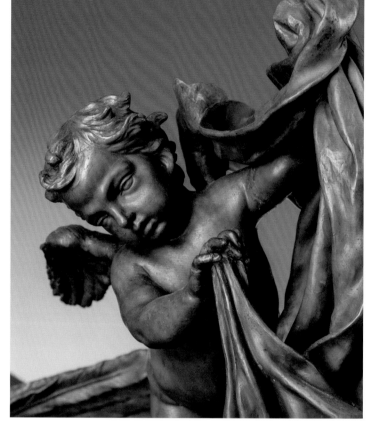

then living Senator of the Del Rosso family, Francesco, the husband of Maria Ottavia's aunt, Maria Maddalena Gondi. It is therefore likely that Francesco Del Rosso bought the *Pietà* for the price of 12 scudi, precisely the same amount of money bequeathed to Maria Ottavia by her grandmother as a life annuity to cover part of her fees while staying at the Conservatory (ASM, 4253). Hence, Del Rosso may have done so in order to relieve Ottavia Gondi's guardians of that obligation, subsequently giving the *Pietà* to the Montalve in lieu of the annuity, although this remains a hypothesis.

DIMITRIOS ZIKOS

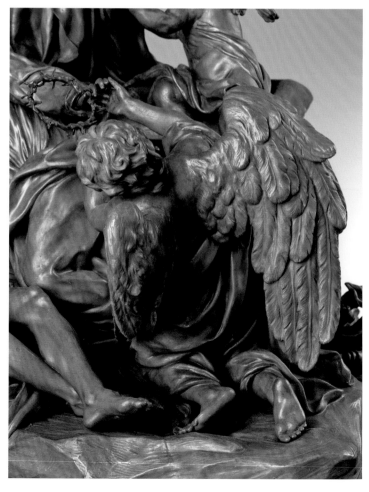

BIBLIOGRAPHY. Lankheit 1962, p. 215, note 74; Ginori Lisci 1963, p. 141; Pope-Hennessy 1965, p. 135; Paolucci 1978, pp. 68–9; Lankheit 1982, pp. 17–18; R. Roani Villani, in *Villa La Quiete* 1997, pp. 119–20; R. Spinelli, in Florence 2009, pp. 200–1, cat. 65; Balleri 2014[b], p. 12.

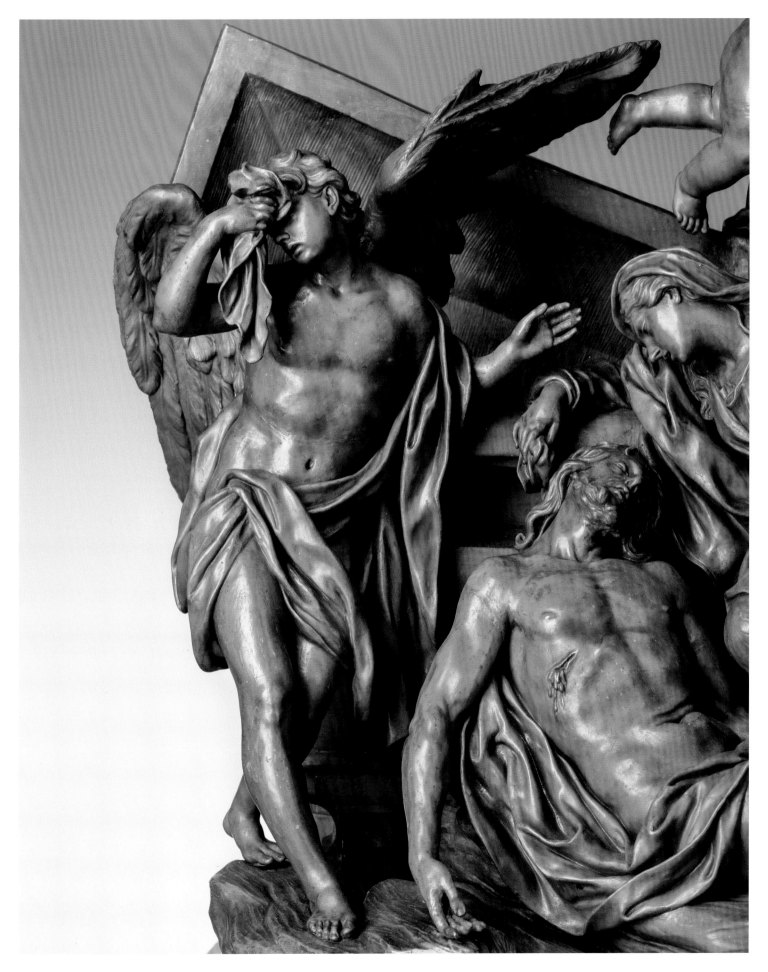

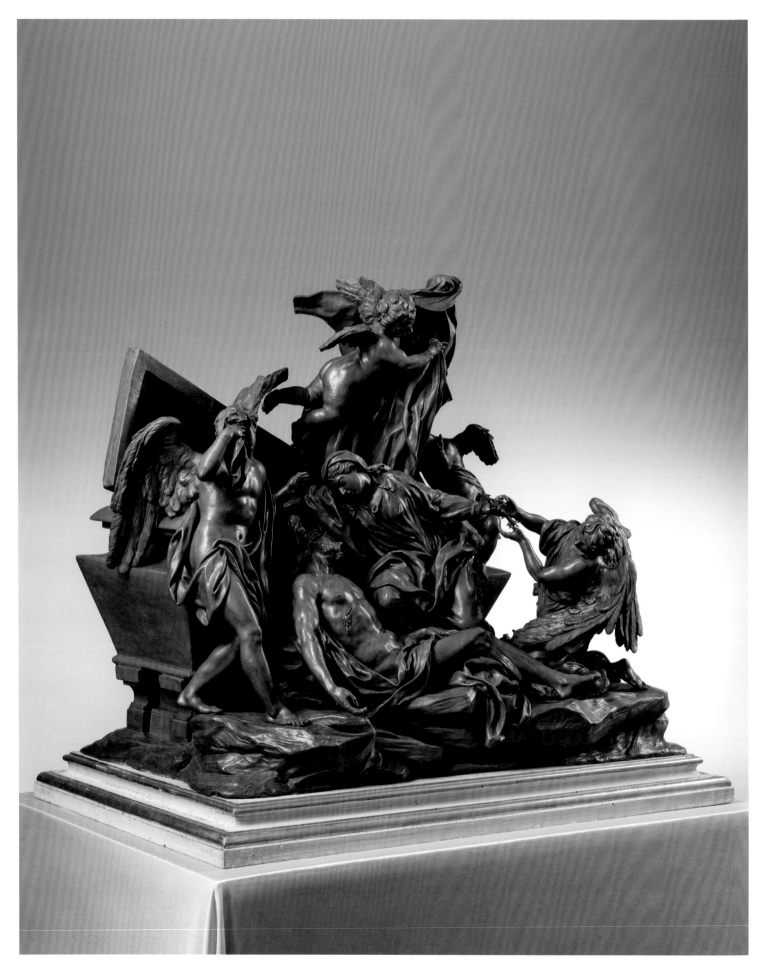

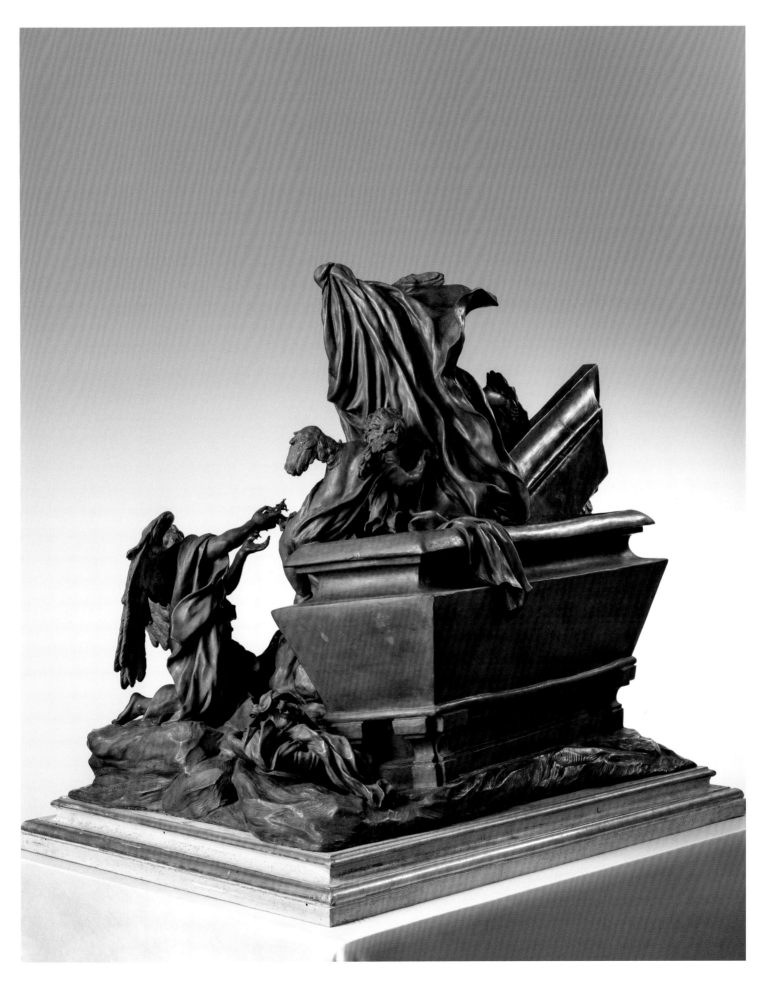

10. Agostino Cornacchini (1686–1754)
Judith with the Head of Holofernes

1722
terracotta; 45.5 × 42.5 × 24.5 cm

Private collection

In the inventory of the assets of the Sienese poet Ludovico Sergardi, dated 1727, there is mention of a terracotta model depicting "Judith with the head of Holofernes", as well as "a bust of Cicero of white marble by Cornacchini" (B. Granata, in Siena 2005, p. 578). Though only remembered for the bust, Andrea Bacchi (2010) also reattributed the terracotta *Judith with the Head of Holofernes*, today in a private collection, to the Tuscan sculptor. The work must be linked to the commission by Anna Maria Luisa de' Medici for twelve bronze groups showing *Biblical stories* (1722–5), made by nine of the greatest Florentine sculptors of the 18th century (Bacchi 2010, p. 37, note 10). The *Judith with the Head of Holofernes* (Birmingham, Museum and Art Gallery), made in Rome by Cornacchini – as evidenced by the sending of 272 pounds of bronze from Florence in June of 1722, and the model of a base from Rome (Zikos 2005[b], pp. 22, 59–60, doc 2) – belongs to the first group of bronzes delivered to the Electress in December of the same year, consisting of a *David and Goliath* by Giovan Battista Foggini, the *Sacrifice of Isaac* by Giuseppe Piamontini and the *Sacrifice of Jephthah* by Massimiliano Soldani Benzi. These were placed opposite each other according to theme on silver tables with mirrors of the same material in Palazzo Pitti (S. Casciu, in Florence 2006[c], pp. 302–3, cat. 166). The presence of the preparatory study for the *Judith* in the Sergardi collection confirms the role he must have played in the commission, as testified by two letters between Sergardi himself and the Electress in May 1723 (Montagu 1976, p. 129). The group in question varies in some details with respect to the bronze version, which instead has a closer relationship with the version in porcelain. From a document dated 1744, we learn that two sculptural groups were transferred to Palazzo Ginori on 12 October "from Casa Guadagni" and on 2 November "from Casa Rinuccini". These must have been the *Sacrifice of Jephthah* by Massimiliano Soldani Benzi and the *Judith Cutting the Head of Holofernes* by Cornacchini (Zikos 2005[a], 177, note 9), intended for the Florentine marquis in the Electress's will of 1739 (S. Casciu, Florence 2006[c], pp. 302–3, cat. 166). This circumstance must necessarily be attributed to the desire to take casts directly from the original, from which derived the porcelain version made by Gaspero Bruschi (cat. 11).

DANIELE LAURI

BIBLIOGRAPHY. Bacchi 2010.

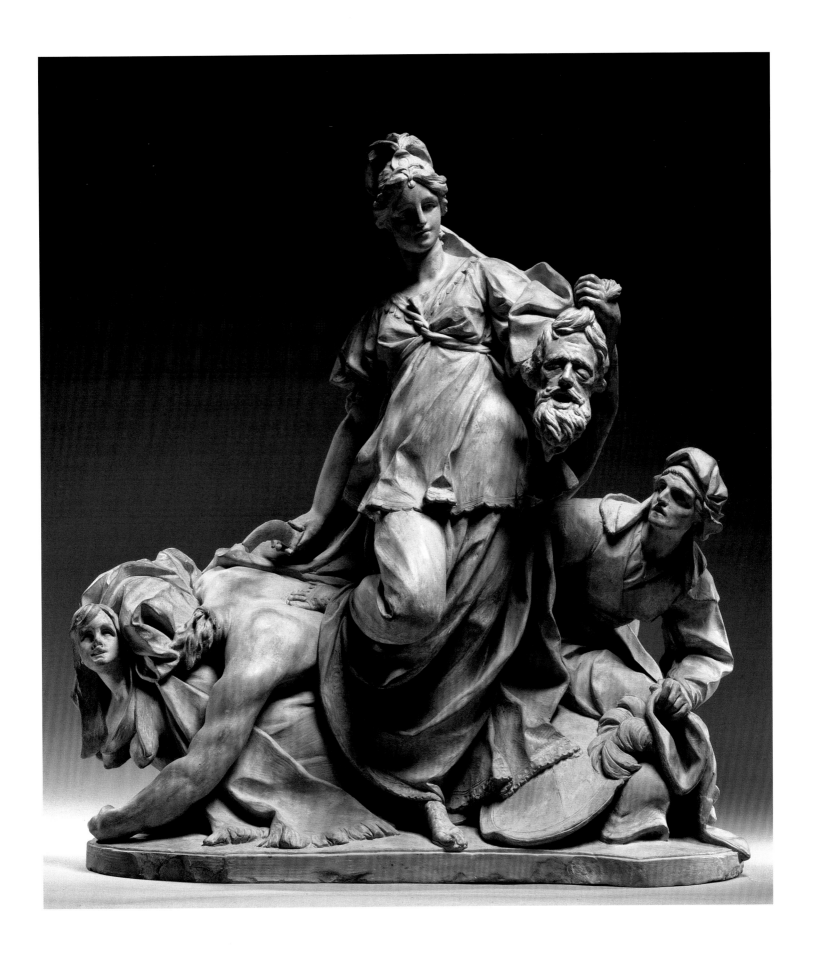

11. Ginory manufactory, Gaspero Bruschi (1710–80)
Judith with the Head of Holofernes (after Agostino Cornacchini)

c. 1746–50
porcelain, with original wooden base; 55.25 × 43.18 × 30.48 cm

Los Angeles, County Museum of Art, inv. M.2004.175

PROVENANCE. London, Trinity Fine Art
RESTORED. 2000, Rupert Harris

The group depicting *Judith with the Head of Holofernes* was in all probability made by Gaspero Bruschi around 1750, as demonstrated by the evidence of the clay and the sculptor's typical vigorous modelling (Melegati 2005, p. 54). The parallels with the bronze, cast in Rome by Agostino Cornacchini for Anna Maria Luisa de' Medici (1722–3), are such as to presuppose the existence of a cast taken directly from the original. This hypothesis is confirmed by a document dated 1744 testifying to the shipping of two sculptures to Palazzo Ginori: one on 12 October, "from Casa Guadagni" and one on 2 November, "from Casa Rinuccini" (Zikos 2005ᵃ, p. 177). The reference is to the *Sacrifice of Jephthah* by Massimiliano Soldani Benzi and to the *Judith with the Head of Holofernes* by Cornacchini, for the Florentine marquises, bequeathed by the Electress Palatine in 1739 (S. Casciu, Florence 2006, p. 302, cat. 166). According to Andrea Bacchi (2010, p. 34), the terracotta model conserved in the museum of the Doccia manufactory derives from the aforementioned casts (Lankheit 1982, 27:8; Balleri 2014ᵇ, p. 29, fig. 22), from which Anton Maria Selvi made the plaster moulds for which he was paid on 27 April 1746 (Lankheit 1982, 27:8; Biancalana 2009, p. 76). Indeed, there are very few differences between the bronze prototype and the porcelain version: the most striking is the presence of a shield beneath the left foot of Judith, introduced to conceal a defect in the rather long firing and to conceal the excessive reduction in size of the heroine, who would otherwise have been suspended above the surface (L. Melegati, in Florence 2003, p. 72, cat. 13). The group, now in the County Museum of Art in Los Angeles, still has its original base, a version in ebonised wood of the rich lapis lazuli and gilded bronze base probably designed by Giovan Battista Foggini for the work by Cornacchini (ibid.). An almost identical wooden base with volute supports and *rocailles* of white porcelain also appears in another group attributable to the Electress Palatine series: the *Judgment of Paris* (after Massimiliano Soldani Benzi), today at the Castello Sforzesco in Milan (L. Melegati, in Vienna 2005, p. 452, cat. 303).
MARIA PERSONA

BIBLIOGRAPHY. Lankheit 1982, p. 126; L. Melegati, in Florence 2003, p. 72, cat. 13; Melegati 2005, p. 54; Zikos 2005ᵃ, p. 177; S. Casciu, in Florence 2006, p. 302, cat. 166; Biancalana 2009, p. 76; Bacchi 2010, p. 34; Balleri 2014ᵇ, p. 29, fig. 22.

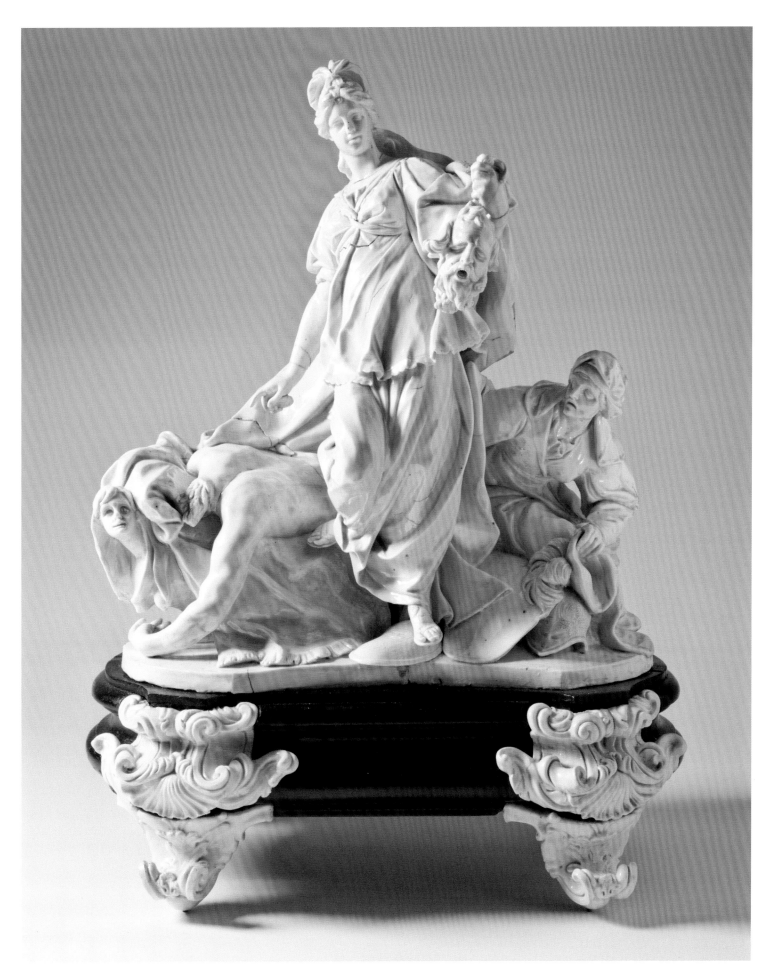

12. Massimiliano Soldani Benzi (1656–1740)
Death of Saint Joseph

before 1729
unfired clay; 58.3 × 40.7 cm

Private collection

Only recently discovered (2009), this unfired clay relief depicting the *Death of Saint Joseph* has been recognised by Dimitrios Zikos as a model for the bronze of the same subject in the Museo Nazionale del Bargello (cat. 13). The relationship between the two is very close, despite the differences appearing between the development phase and the final execution. In the model, apart from the Virgin, Saint Joseph and Christ, Soldani included angels and cherubim: most fly over the saint, while three of them sprinkle roses from above. The setting, which in the model can be deduced only from a frame shown in summary form at the top and from an open door through which a tent can be discerned, is completely different in the bronze version, where the plane of the ground on which the whole scene takes place contributes to a more convincing spatial construction. In the foreground of the relief in question, there are three angels in different postures: the first on the left kisses the hand of Saint Joseph, while the Virgin offers the arm of the dying saint; in similar manner, the other two on the right uncover and kiss the foot of the saint. These three characters in the bronze are replaced by the Archangels Michael and Gabriel, who frame the main scene on the right side of the plaque, with Mary appearing on the opposite side. Some details reflect a more mature evolution: the vase resting on the ground in the rough clay model is supported in the Bargello example by an archangel, while the other hand holds a burning candle. Likewise, the more prominent positions of the main characters and their consequent accentuated three-dimensionality; the crossing of the hands; the looks passing between father and son. This unfired clay relief cannot be the "Terracotta sketch depicting the Transition of Saint Joseph" appearing – according to a note to me from Zikos – in Soldani's posthumous inventory of 1740, conserved in the house in Borgo Santa Croce in Florence.
DANIELE LAURI

BIBLIOGRAPHY. Trinity Fine Art, New York, 23–31 January 2009, *A Selection of Works of Art*, p. 20–3, cat. 7; F. Berti, in Florence 2009, p. 208, cat. 69.

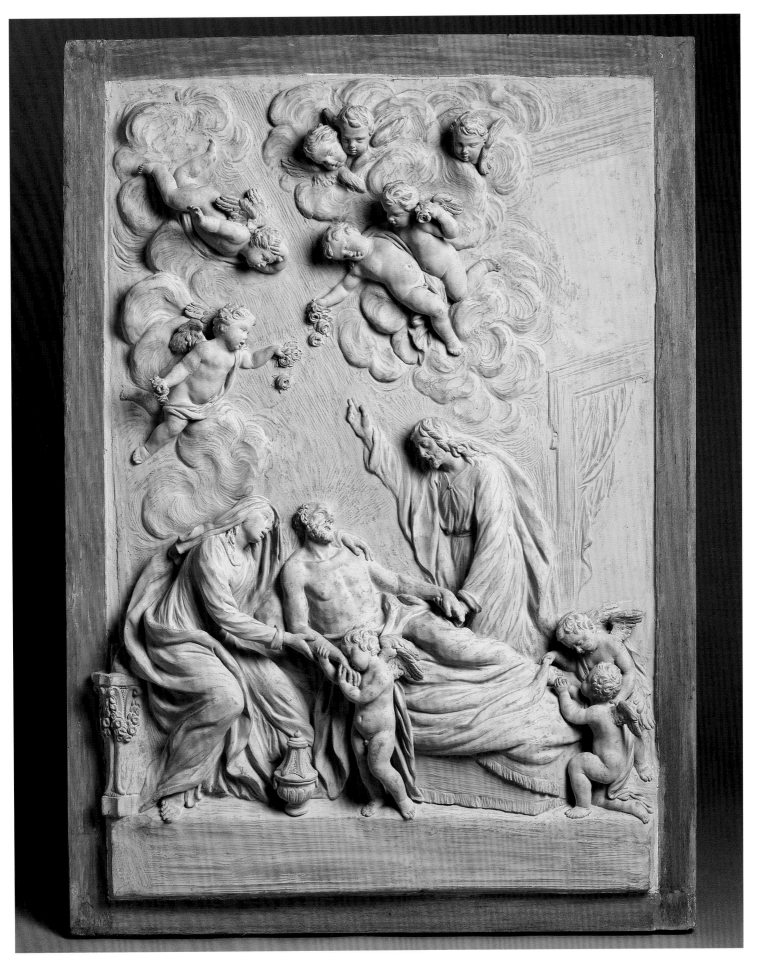

13. Massimiliano Soldani Benzi (1656–1740)
Death of Saint Joseph

c. 1729
bronze; 65 × 43.5 cm

Florence, Museo Nazionale del Bargello, inv. Bronzi 129

On 5 February 1729, Massimiliano Soldani Benzi wrote to the Florentine Gian Giacomo Zamboni, then in London, that he possessed a bas-relief depicting "the Transit of St Joseph with Jesus and the Madonna, and an angel, all more than half the size, with a glory of small angels raised and almost detached from the base with heads of seraphim … made for the viceroy of Palermo, commissioned from me by the *commendator* Sansedoni" (Oxford, Bodleian Library, Mss. Rawlinson, Letters, 132, fol. 278r). These few lines contain considerable information: Soldani received the commission from Fra Orazio Sansedoni, acting as go-between for the viceroy of Sicily, Joaquín Fernández de Portocarrero, in office from 1722 to 1728, a Knight of the Order of Malta. Mentioned for the first time in the Galleria by Luigi Lanzi in 1782, along with two other bas-reliefs by Soldani – *The Death of Saint Francis Xavier* and *Saint Catherine of Siena Receiving the Stigmata*, today in the Bargello (p. 53; D. Zikos, in Florence 2006ᶜ, pp. 198–9, cat. 49) – the *Death of Saint Joseph* re-appears in the *Inventario* of 1784 (II, p. 36, no. 2296): "A work depicting the Transit of Saint Joseph, b. 1.2 high and 15 s. broad Frame of Black Pear". On 20 May 1774, the bronze in question and two aforementioned bas-reliefs were named in a list of works from Palazzo Pitti which were transferred to the Galleria (AGF, Filza VII, 1774, ins. 22, nos. 171–3). At that date, therefore, the work was already in the Grand Duke's collection. Among the works handed to the Ginori manufactury in 1744 by the artist's son was – according to a version of the list published by Lankheit – "A bas-relief of the transit of Saint Joseph, from the bronze of the Most Ill. Sig. Martelli" (1962, p. 284, doc. 351; then in Biancalana 2009, p. 72, p. 70). Biancalana did not link this to our relief whose presence in the Martelli collection it has not been possible to verify.

Like the two companion pieces in the Bargello, the *Death of Saint Joseph* also accords with the tradition of a "relief in the guise of a painting" (Soldani's term in a letter to Zamboni of 15 October, 1717; Oxford, Bodleian Library, Mss. Rawlinson, Letters, 132, fol. 46r) required of students of the Accademia di Cosimo III in Rome, where Soldani studied and where he learned to base himself on painted prototypes, such as Maratti's picture of the same subject of 1679 (Vienna, Kunsthistorisches Museum; Garms 2003). Perhaps Soldani knew of this work through Nicolas Dorigny's print of 1688; at all events, the composition was used here as a prototype for the creation of the Bargello bronze.

DANIELE LAURI

DIMITRIOS ZIKOS

BIBLIOGRAPHY. Lanzi 1782, p. 53; Supino 1898, p. 399, cat. 64; Lankheit 1962, pp. 134–5, doc. 93; Lankheit 1982, p. 133, 33:64; Pratesi 1993, I, p. 102; F. Berti, in Florence 2009, p. 208, cat. 69.

14. *Death of Saint Joseph* (after Massimiliano Soldani Benzi)

after 1744

red wax; 66 × 43 cm

Florence, Museo Nazionale del Bargello, inv. Cere 467

PROVENANCE. London, Heim Gallery, 1978; Florence, art market, 1999

On 17 December 1744, Carlo Ginori purchased some plaster casts from Ferdinando Soldani of bas-reliefs, groups and other works by his father, Massimiliano. The sale was negotiated by the painter and sculptor Giovan Battista Vannetti. Among the casts sold to the Ginori manufactory there were not only the famous *Pietà* (cat. 7) and the bas-reliefs *Saint Catherine of Siena Receiving the Stigmata* and the *Death of Saint Francis Xavier* (Florence, Museo Nazionale del Bargello, D. Zikos, in Florence 2006ᶜ, pp. 198–9, cat. 49), but also "A bas-relief of the transit of Saint Joseph, from the bronze of the Most Ill. Sig. Martelli" (Lankheit 1962, p. 284, doc 351; Biancalana 2009, p. 70, 72 ff.). Whereas, in the manufactory's *Inventario dei Modelli*, there is mention of a "Bas-relief depicting the Transit of Saint Joseph, of wax. By Soldani, with its moulds" (Lankheit 1982, p. 133, 33:64). When it entered the collections of the Museo Nazionale del Bargello in 1999, the *Death of Saint Joseph* was considered to be the work of Soldani by all the recent scholars, who considered it a first draft for the bronze (cat. 13) or a version for translation into porcelain (Paolozzi Strozzi, Vaccari, Spallanzani 2003, p. 40). As noted by Zikos (2011, p. 24), there is no mention of original waxes by Soldani being sold to Ginori, but only casts, a fact also confirmed by the payments made by the manufactory to artists and modellers. Among these was Vannetti, who made wax models between 1744 and 1754 (Biancalana 2009, pp. 69–70). The work here presents some minor differences with regard to the bronze, such as the position of the upper cherubs, the detail of the closed door in the background, and the arm of Christ, here more folded. There is no known porcelain version of the *Death of Saint Joseph*, but it is clear that the changes mentioned are attributable to the work of a modeller who, after obtaining the wax form from the mould, could modify it and vary its details as he wished.

DANIELE LAURI

BIBLIOGRAPHY. Lankheit 1962, pp. 134–5; Ginori Lisci 1963, p. 229, doc. 7; London 1978, cat. 35; Lankheit 1982, p. 133, 33:64; Pratesi 1993, I, p. 102; G. Gaeta Bertelà, in *Acquisti e donazioni* 2002, p. 120; Paolozzi Strozzi, Vaccari, Spallanzani 2003, pp. 40, 63, cat. 48; F. Berti, in Florence 2009, p. 208, cat. 69.

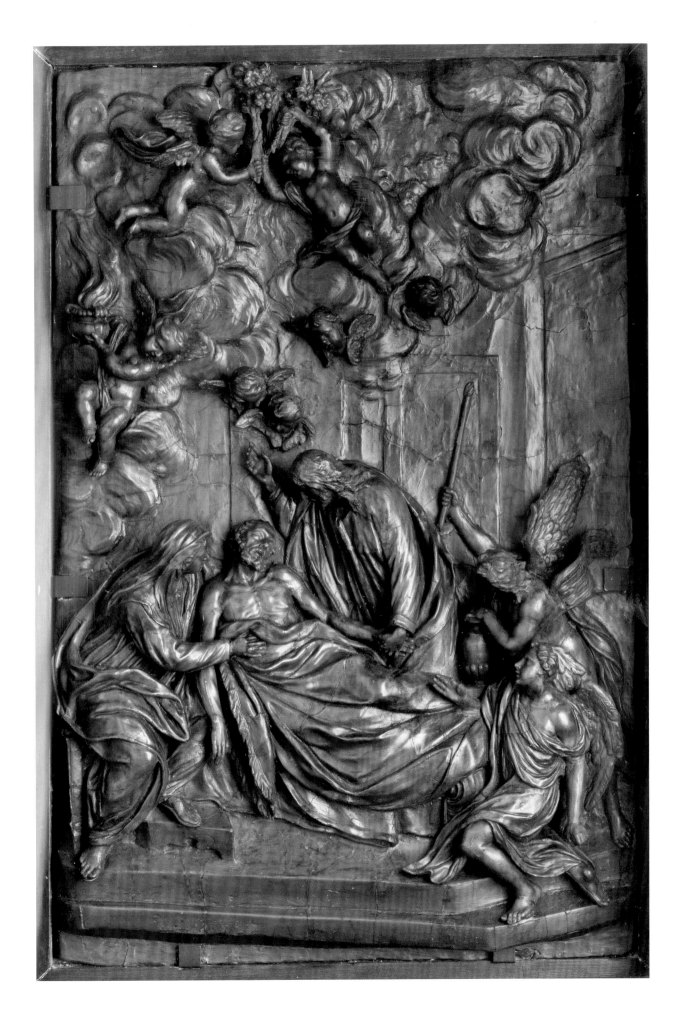

15. Ginory manufactory, Gaspero Bruschi (1710–80)
and Domenico Stagi (1712–83)
Fireplace

1754
porcelain; h. 310 cm

Sesto Fiorentino, Museo Richard Ginori of the Doccia manufactory, inv. 4437

RESTORED. 2017, Francesca Rossi

The monumental *Fireplace* in Doccia Porcelain was made by Gaspero Bruschi in 1754 to decorate the end wall of the gallery, built by the Marquis Ginori at the centre of his villa and frescoed with "architectures according to the taste of the time and with original scenes depicting the process of making porcelain" (Ginori Lisci 1963, p. 39), attributed to the capriccio painter Giuseppe del Moro and painter Vincenzo Meucci.

The structure of the work consists of three main elements: the hearth, walled into the end of the gallery on 10 March 1754 (AGL, Ginori Sen. Carlo. Lettere diverse dirette al medesimo dal 1755 al 1760, Filza 23, XII, 5, fol. 34, in Biancalana 2009, p. 53), a rectangular mirror framed by *rocaille* volutes, and an exuberant apex. The first is entirely lined in tiles from Holland (and in part by Ginori), which arrived at Doccia on 6 April 1754 (ibid., p. 53), depicting country scenes and views in the typical blue monochrome of Delft's manufactories. The second rests on an architrave with garlands and a female mask in the centre (Campana 1966, p. 30), supported by two vigorous telamons. The third bears two porcelain versions of Michelangelo's *Dusk* and *Dawn* and "a bas-relief oval of putti scattering flowers", derived from a wax model by Massimiliano Soldani Benzi (Lankheit 1982, 40:116), the bronze prototype of which is in the vestibule of the oratory of the Compagnia di San Niccolò in San Quirico di Vernio since 24 October, 1705 (Marchini 1982, P. 71, Bellesi 1999, pp. 273–4). Inserted inside the *Fireplace*, the medallion and the original inscription (DISPERSIT, DEDIT PAVPERIBVS), lose any allusion to the charitable nature of Ridolfo de' Bardi, the patron of the oratory's foundation, and only maintain its allegorical significance. However, the overall design of the top part of the *Fireplace* had not yet been defined by 18 May 1754, the day of the Marquis's notice of suspension of the work, pending Domenico Stagi's opinion regarding the project (AGL, Ginori

Sen. Carlo. Lettere diverse dirette al medesimo dal 1755 al 1760, Filza 23, XII, 5). As for Soldani's bas-relief, the Doccia manufactory retains the moulds of the Michelangelo sculptures, derived from models that came from Rome (L. Melegati, in Vienna 2005, p. 415, cat. 268), perhaps by Soldani Benzi (Lankheit 1982, 79:5), who in 1703 offered a bronze copy of the *Dusk* to the prince of Liechtenstein (Lankheit 1962, pp. 333–5). It is not impossible that these moulds are those made in Rome by one of the factory's modellers, Francesco Lici, sent for this purpose to the studio of the Florentine sculptor, Filippo della Valle, between 1753 and 1754 (L. Melegati, in Vienna 2005, p. 415, cat. 268). This hypothesis would seem to be confirmed in the correspondence of the Marquis (Filippo della Valle's letter to Carlo Ginori, 16 February 1753, in Biancalana 2009, p. 79). Two other versions in white porcelain are known of the *Dusk* and *Dawn*, today at the Castello Sforzesco in Milan (Melegati 1999, p. 74) and in the Museo Civico di Torino (Maritano 2009, p. 97).

MARIA PERSONA

BIBLIOGRAPHY. Morazzoni, Levy 1960, pl. 250; Lankheit 1962, pp. 333–5; Ginori Lisci 1963, p. 39; Campana 1966; Liverani 1967, p. 68; Lankheit 1982, 40:116, 79:5; Marchini 1982, p. 71; Bellesi 1999, pp. 273–4; Melegati 1999, p. 74; L. Melegati, in Vienna 2005, p. 415, cat. 268; Biancalana 2009, p. 53; Maritano 2009; Moore Valeri 2014.

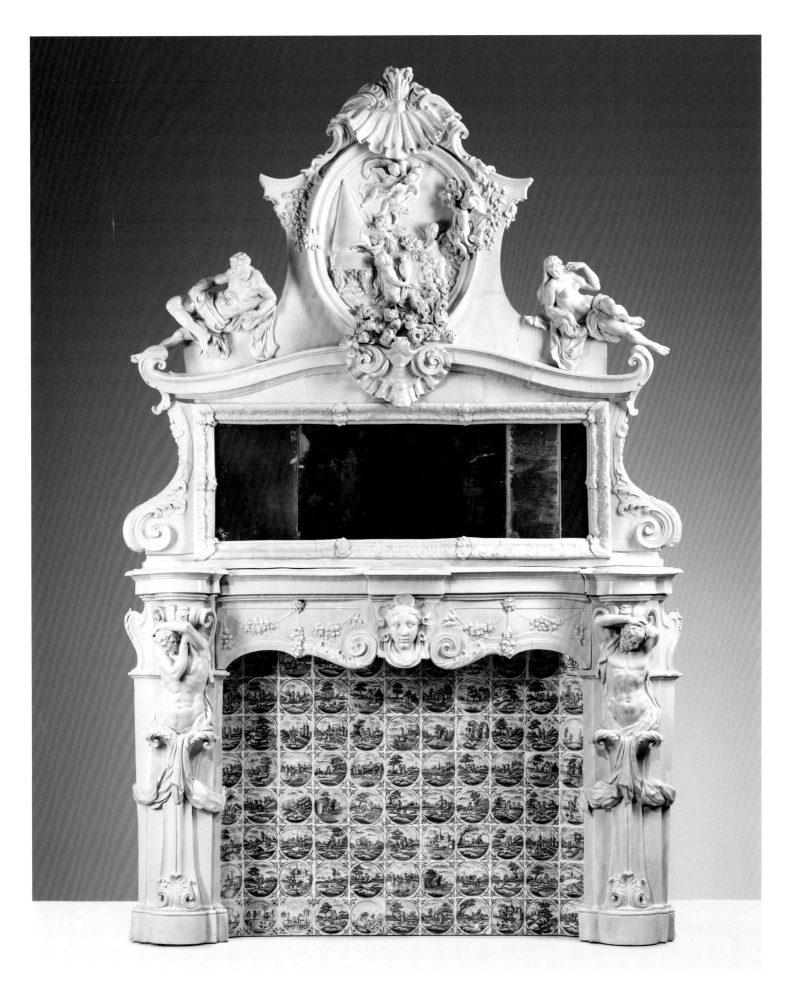

16. Niccolò Tribolo (1497–1550)
Dusk, Dawn

c. 1534–7
terracotta; h. 55 cm

Florence, Museo Nazionale del Bargello, inv. Sculture 313 (*Dawn*), 314 (*Dusk*)

RESTORED. 2003, Daniele Angellotto

"Wherefore Tribolo, having regained a little courage, occupied himself … with copying in clay all the figures of marble in the Sacristy of S. Lorenzo which Michelagnolo had executed namely, Dawn, Twilight, Day, and Night. And he succeeded in doing them so well, that M. Giovan Battista Figiovanni, the Prior of S. Lorenzo, to whom he presented the Night in return for having the sacristy opened for him, judging it to be a rare work, presented it to Duke Alessandro, who afterwards gave it to Giorgio Vasari." It is with these words that in the life of Niccolò Tribolo Vasari (1568 – De Vere 1996, II, p. 230) recalls the four terracotta copies of Michelangelo's marble sculptures in the Sagrestia Nuova of San Lorenzo. Already dismembered from the outset as Vasari himself tells us, because without the portrayal of the now-lost *Night*, the series is preserved at the Museo Nazionale del Bargello (inv. Sculture, 313, 314, 315). In another passage, while describing the life of the painter Giuliano Bugiardini, the writer commented on the sculptor's method of working, informing him that he had "made some sketch-models in clay, which he executed excellently well, giving them that boldness of manner that Michelagnolo had put into the drawing, and working them over with the gradine, which is a toothed instrument of iron, to the end that they might be somewhat rough and might have greater force" (Vasari 1568 – De Vere 1996, II, p. 314). Vasari then states that Tribolo wished to imitate Michel-

angelo's method of "removal", making the masses rougher and stronger. The first reductions after Buonarroti's works, the two terracotta figures of *Dawn* and *Dusk* are examples of the great influence that Michelangelo's work had on later painting and sculpture (see Rosenberg 2000). Indeed, even in 1754, this important ancestry involved the Doccia manufactory: for the crowning of the porcelain *Fireplace* by Gaspero Bruschi and Domenico Stagi, the artists inserted copies of the statues from San Lorenzo (cat. 15), thus presenting the manufactory as the ideal continuation of the great tradition of Florentine sculpture. The *Inventario dei Modelli* mentions "2 Michelangelo terms. With moulds" (Lankheit 1982, 79:5), while in a letter sent by the Florentine sculptor Filippo della Valle from Rome to Carlo Ginori (16 February 1753), we learn that in his workshop the caster Francesco Lici "can take a cast of anything and make moulds since he has two of the figures copied from holdings of Michelangelo, which being the missing one he can cast it, but he cannot remember which you wish, but has said he will write to Sig. Bruschi to know more" (Balleri 2014[b], p. 444, doc 4). Balleri has argued that these were the three casts in Doccia, as opposed to what appears in the *Inventario*, since the casts of the 'two figures' referred to were already made and possessed by the manufactory, and assuming that Lici had made at least one more in this circumstance (Balleri 2014[a], p. 99). In fact, the caster sent to Rome

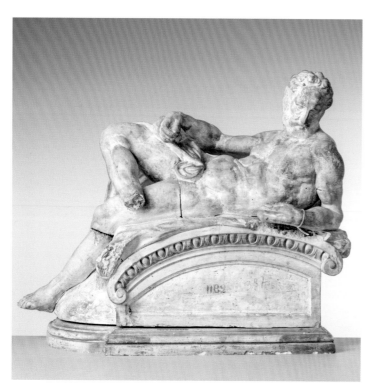

1. *Dusk* after Michelangelo, plaster, Sesto Fiorentino, Museo Richard Ginori of the Doccia manufactory

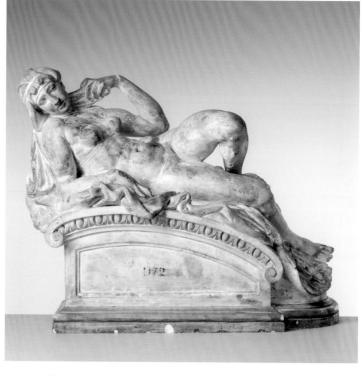

2. *Dawn* after Michelangelo, plaster, Sesto Fiorentino, Museo Richard Ginori of the Doccia manufactory

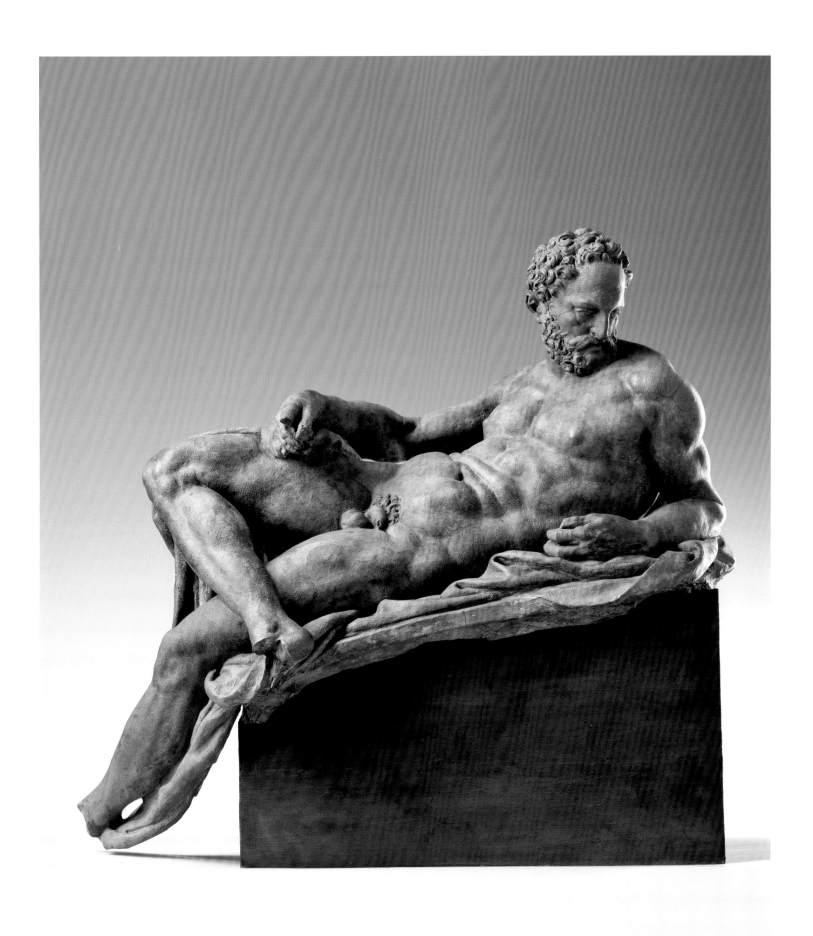

by Ginori should have asked Bruschi if the copy owned by the sculptor were one of the missing ones, but the letter does not inform us if this occurred. The caution required in these cases does not even allow us to link this information to the news of 24 February 1753, when Guido Bottari wrote to Ginori that Lici "had finished casting the third group, at Sig. Valle" (Balleri 2014ᵇ, p. 444, doc 6). The collectors' interest for Michelangelo's work had already involved Massimiliano Soldani Benzi in 1694–5, who had turned to Prince Johann Adam Andreas I of Liechtenstein to buy bronze castings of the allegories of the Sagrestia Nuova. However, because of the different postures, the Florentine sculptor declared that he opposed making them in the form of busts, and suggested instead producing whole statues (Lankheit 1962, pp. 326, 328, docs. 635, 640). And in 1725, Giovan Giacomo Zamboni wrote to Soldani, looking for terracotta models of the *Night* and the *Day* from the the Medici Chapels (Zikos 2005ᵃ, p. 159).

The two porcelain versions of the *Dusk* and *Dawn*, mounted at the top of the *Fireplace* (cat. 15), differ from both the Tribulo terracotta versions and the two plaster versions preserved at the Museo Richard Ginori of the Doccia manufactory (figs. 1–2). The direct derivations of the Bargello model appear more charged with that force which distinguishes the modelling in Michelangelo's work, while in the two models by Gaspero Bruschi we can note – in addition to the presence of the white-painted bronze 'loincloths' that Cosimo III commissioned from Giovan Foggini to cover the nudity (Middeldorf 1976, p. 33) – a different arrangement of the limbs, and also a greater definition in some details. The figures at Doccia appear designed to be viewed from below given their position, which is curved more outwardly and varied in finishes and posture. The two plaster versions of the same subject are also different to the smaller porcelain ones and without the drapes removed at the beginning of the 19th century (ibid., p. 33); mounted on a high shelf with volutes, they should be linked to the series of four allegories in biscuit produced by the Ginori manufactory between the end of the 19th and the beginning of the 20th century (2014ᵃ, p. 99), of which a complete group recently appeared on the art market (see Pandolfini, Florence, 19 November 2015, *Importanti mobili, arredi e oggetti d'arte, porcellane e maioliche*, lot 54, p. 68).

DANIELE LAURI

BIBLIOGRAFIA. Vasari 1568 – De Vere 1996, II, p. 230; Rossi 1893, p. 13; Supino 1898, p. 414, catt. 170–1; Rossi 1932, p. 18; Aschoff 1967, pp. 49–56; M. Bracco, R. Rossi Manaresi, in Florence 1967, pp. 20–1, cats. 23–4; Poeschke 1992/6, pp. 182–3; Rosenberg 2000, pp. 129–32; M. G. Vaccari, in Florence 2002, pp. 168–9, cat. 14; E. D. Schmidt, in Madrid 2007, pp. 399–401, cat. 54.

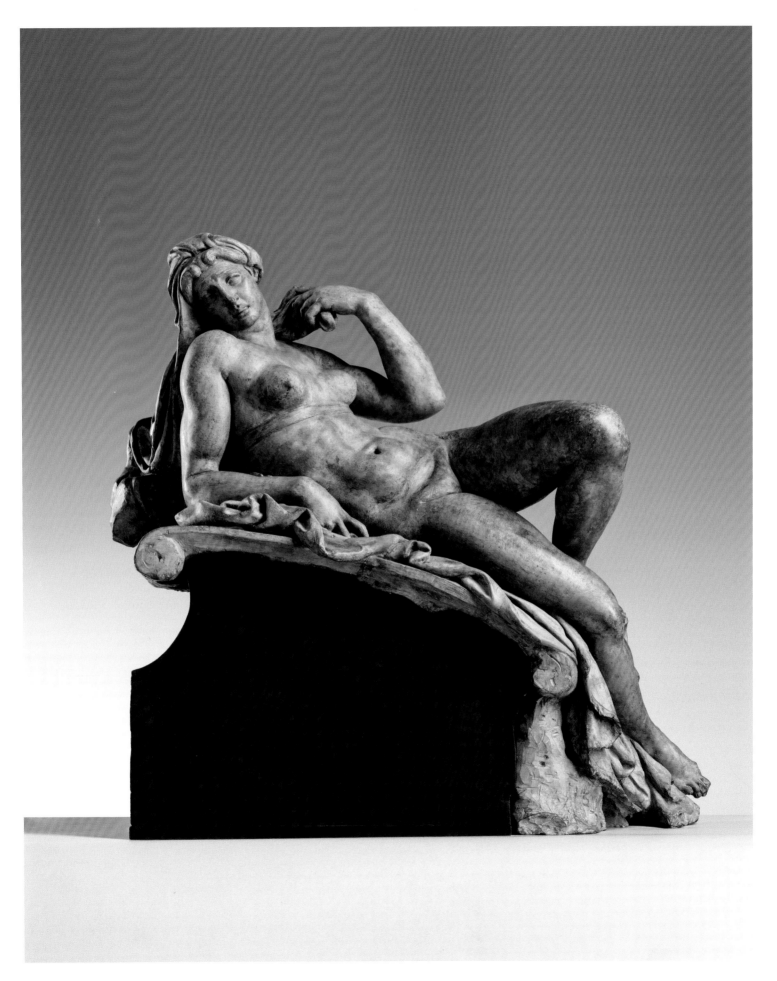

Abbreviations

AG – Archivio Guicciardini di Poppiano
AGF – Archivio Gallerie Fiorentine
AGL – Archivio Ginori Lisci
AOD – Archivio dell'Opera del Duomo
ASFi – Florence, Archivio di Stato di Firenze
ASM – Archivio delle Signore Montalve

BCAEC – Biblioteca del Comune e dell'Accademia Etrusca di Cortona
BGU – Florence, Biblioteca della Galleria degli Uffizi
BMF – Florence, Biblioteca Marucelliana
BNCF – Florence, Biblioteca Nazionale Centrale di Firenze
GDSU – Florence, Gabinetto Disegni e Stampe degli Uffizi

Bibliographical references

Acquisizioni e donazioni 2002
Acquisizioni e donazioni. Archeologia, Arte Orientale, Architettura, Arte. Acquisti e donazioni di opere d'arte dal Medioevo al Novecento dal Ministero dei Beni Culturali negli anni 1999-2000, edited by L. D'Agostino, L. Donelli, R. Mencarelli et al., Rome, 2002.

Addabbo [after 2008]
A.M. Addabbo, *L'Istituto Statale d'Arte di Sesto Fiorentino in Ceramica. 6000 anni di produzione a Sesto Fiorentino*, Sesto Fiorentino, n.d. [after 2008].

Aldrovandi ed. 1648
U. Aldrovandi, *Musaeum metallicum in libros 4 distributum...*, Bononiae, typis Io. Baptistae Ferronij, 1648.

Algarotti ed. 1823
F. Algarotti, *Opere scelte*, 3 vols., Milan, 1823.

Alinari 2009
A. Alinari, *La porcellana dei Medici. Bibliografia ragionata e catalogo essenziale*, Ferrara, 2009.

Antonini 2001
M. Antonini, 'Il museo di Doccia', in Tokyo 2001, pp. 61–3.

L'architettura 2011
L'architettura in Toscana dal 1945 ad oggi. Una guida alla selezione delle opere di rilevante interesse storico-artistico, edited by A. Aleardi and C. Marcetti, Florence, 2011.

Arfelli 1934
A. Arfelli, 'Lettere inedite dello scultore G. M. Mazza e dei suoi contemporanei', *L'Archiginnasio*, 29 (1934), pp. 416–34.

Aschoff 1967
W. Aschoff, *Studien zu Niccolò Tribolo*, Frankfurt am Main, 1967.

Avery 1982
C. Avery, 'Baroque Sculptors' Models for Porcelain', *Apollo*, new series, no. 116 (248), 1982, pp. 277–8.

Avery 1995ᵃ
C. Avery, 'The Pedestals, Frames, Mounts and Presentation of Massimiliano Soldani-Benzi's Bronze Statuettes and Reliefs', *Furniture History*, 31 (1995), pp. 7–22.

Avery 1995ᵇ
C. Avery, 'Who Was Antonio Selvi: New Documentary Data on Medal Production in Soldani's Workshop', *The Medal*, no. 25 (1995), pp. 27–41.

Avery 1998ᵃ
C. Avery, 'Lord Burlington and the Florentine Baroque Bronze Sculptor Soldani', in *Lord Burlington. The Man and His Politics. Questions of Loyalty*, edited by E. Corp, Lewiston/Quinston/Lampeter 1998 pp. 27–49.

Avery 1998ᵇ
C. Avery, 'Soldani's Bronze Reliefs of 'Summer' and 'Autumn': New Documentation on Their Date and Patronage', *Register / Spencer Museum of Art*, series 7, nos. 1–2, 1995–6 (1998), pp. 1–17.

Avery 2008
C. Avery, *The Triumph of Motion. Francesco Bertos (1678-1741) and the Art of Sculpture: Catalogue Raisonné*, Turin and elsewhere, 2008.

Bacchi 2010
A. Bacchi, *Agostino Cornacchini: "la Giuditta con la testa di Oloferne"*, n.p., 2010.

Balleri 2006
R. Balleri, 'L'invenzione giambolognesca nelle porcellane settecentesche di Doccia', in Florence 2006ᵃ, pp. 343–7.

Balleri 2007
R. Balleri, 'I Soldani del marchese Clemente Vitelli', *Paragone*, 3rd series, no. 74 (687), 2007, pp. 62–73.

Balleri 2009
R. Balleri, 'Il Tempietto Ginori dell'Accademia Etrusca di Cortona: una rilettura', in *Artisti per Doccia*, edited by L. Casprini Gentile and D. Liscia Bemporad, Florence, 2009, pp. 7–21.

Balleri 2012
R. Balleri, 'Una memoria ritrovata: ipotesi identificativa di sculture antiche della collezione Verospi fra i modelli della Manifattura di Doccia', *Quaderni. Amici di Doccia*, 5/2011 (2012), pp. 34–55.

Balleri 2014ᵃ
R. Balleri, 'Echi del genio di Michelangelo nella Manifattura di Doccia dal Settecento al Novecento', in Florence 2014, pp. 97–102.

Balleri 2014ᵇ
R. Balleri, *Modelli della manifattura Ginori di Doccia. Settecento e gusto antiquario*, Rome, 2014.

Balleri, Rucellai 2012
R. Balleri, O. Rucellai, 'Maioliche Ginori nella seconda metà dell'Ottocento. Vicende storiche e collaborazioni artistiche', in Florence 2012, pp. 77–120.

Barocchi, Gallo 1985
P. Barocchi, D. Gallo, *L'Accademia etrusca*, Milan, 1985.

Bellesi 1999
S. Bellesi, 'La scultura', in *Il Settecento a Prato*, edited by R. Fantappiè, Milan, 1999, pp. 273–91.

Bellesi 2003
S. Bellesi, 'La scultura tardo-barocca fiorentina e i modelli per la manifattura di Doccia: precisazioni e nuove considerazioni', in Florence 2003, pp. 9–17.

Bellesi 2008
S. Bellesi, 'I marmi di Giuseppe Piamontini', Florence, 2008.

Berlin 2010
Zauber der Zerbrechlichkeit. Meisterwerke europäischer Porzellankunst, exhibition catalogue (Berlin, Ephraim-Palais, 9 May–29 August 2010), edited by U. Pietsch and T. Witting, Leipzig, 2010.

Bertocci, Farneti 2002
S. Bertocci, F. Farneti, *L'architettura dell'inganno a Firenze. Spazi illusionistici nella decorazione pittorica delle chiese fra Sei e Settecento*, Florence, 2002.

Bettio, Rucellai 2007
Elisabetta Bettio, Oliva Rucellai, *L'archivio storico Richard-Ginori della manifattura di Doccia*, Florence, 2007.

Bettio, Rucellai 2015
E. Bettio, O. Rucellai, 'L'Archivio Storico e il Museo Richard-Ginori della Manifattura di Doccia', *Quaderni. Amici di Doccia*, 8/2014–15 (2015), pp. 118–29.

Bevilacqua 2017
P. Bevilacqua, *Felicità d'Italia. Paesaggio, arte, musica, cibo*, Rome–Bari, 2017.

Bewer 1996
F.G. Bewer, *A Study of the Technology of Renaissance Bronze Statuettes*, Ph.D. Diss., London, University of London, 1996

Biancalana 2005
A. Biancalana, 'La storia della manifattura Ginori 1737-1791. Il periodo di Carlo Ginori e quello di suo figlio Lorenzo', in *Quando la manifattura diventa arte. Le porcellane e le maioliche di Doccia*, proceedings of the symposium (Lucca, 7 May 2003), edited by A. Biancalana, Pisa, 2005, pp. 9–30.

Biancalana 2006
A. Biancalana, 'Terre, "massi, vernici" e colori della Manifattura Ginori dalla sua nascita agli albori del XIX secolo', *Faenza*, 92/4–6 (2006), pp. 48–92.

Biancalana 2009
A. Biancalana, *Porcellane e maioliche a Doccia. La fabbrica dei marchesi Ginori. I primi cento anni*, Florence, 2009.

Bianchini 1741
G. Bianchini, *Ragionamenti istorici dei gran duchi di Toscana della real casa de' Medici protettori delle lettere, e delle belle arti*, Venice, 1741.

Boccia 1965
L.G. Boccia, 'Il museo Richard Ginori a Sesto Fiorentino', *Antichità Viva*, 4/2 (1965), pp. 9–17.

Bologna 2000
I Bibiena. Una famiglia europea, exhibition catalogue (Bologna, Pinacoteca Nazionale, 23 September 2000–7 January 2001), edited by D. Lenzi and J. Bentini, Venice, 2000.

Bregenz 1967
Meisterwerke der Plastik aus Privatsammlungen im Bodenseegebiet, exhibition catalogue (Bregenz, Künstlerhaus, Palais Thurn und Taxis, 1 July–30 September 1967), Bregenz, 1967.

Brook 1986
A.M. Brook, *Sculptors in Florence During the Reign of Grand Duke Ferdinand II of Tuscany (1621-1670): Ferdinando Tacca and His Circle*, Ph.D. Diss., London, University of London (Courtauld Institute of Art), 1986.

Cagianelli 2009
C. Cagianelli, 'Le Conversazioni Letterarie Venutiane Liburnensi. Filippo Venuti, Anton Francesco Gori e la Colonia Colombaria nella Livorno della metà del Settecento', in *Livorno 1606-1806. Luogo di incontro tra popoli e culture*, proceedings of the symposium (Livorno, 22–4 October 2006), edited by A. Prosperi, Turin, 2009, pp. 211–24.

Cambiagi 1790
G. Cambiagi, *Guida al Forestiero per osservare con metodo le Rarità e Bellezze della città di Firenze*, Florence, 1790.

Campana 1966
G. Campana, 'Le fonti delle plastiche Ginori del Settecento', *Antichità viva*, 5/2 (1966), pp. 29–40.

Caròla-Perrotti 2008
A. Caròla-Perrotti, 'I marchi del giglio di Capodimonte e della N. Coronata ferdinandea nelle porcellane di Doccia', *Quaderni. Amici di Doccia*, 2 (2008), pp. 58–83.

Caròla-Perrotti, Melegati 1999
A. Caròla-Perrotti, L. Melegati, *Classico bianco barocco. Scultura italiana in porcellana bianca del Settecento*, Maroggia, 1999.

Casciu 1992
S. Casciu, 'Tempietto della gloria della dinastia dei Medici (Tempietto Ginori)', in *Il Museo dell'Accademia Etrusca di Cortona*, edited by P. Bocci Pacini and A.M. Maetzke, Florence, 1992, pp. 175–9.

Casciu 2006
S. Casciu, '«Principessa di gran saviezza». Dal fasto barocco delle corti al Patto di famiglia', in Florence 2006ᵇ, pp. 30–57.

Casprini 2006
L. Casprini, 'La fortuna di Carlo Ginori tra XVIII e XIX secolo', in Sesto Fiorentino 2006, pp. 47–54.

Chiarelli 1977
R. Chiarelli, 'Aggiunte a Ignazio Pellegrini: la sistemazione architettonica del Ponte Vecchio e il "Gabinetto Ovale" di Palazzo Pitti', in *Scritti di storia dell'arte in onore di Ugo Procacci*, edited by M.G. Ciardi Duprè Dal Poggetto and P. Dal Poggetto, Milan, 1977, pp. 598–613.

Ciechanowiecki 1973
A. Ciechanowiecki, 'Soldani's Blenheim Commission and Other Bronze Sculptures after the Antique', in *Festschrift Klaus Lankheit zum 20. Mai 1973*, edited by A. Ciechanowiecki, Cologne, 1973, pp. 180–4.

Colle 2009
E. Colle, *1765-1790: i cantieri decorativi di Palazzo Pitti*, in *Fasto di Corte. La decorazione murale nelle residenze dei Medici e dei Lorena*, IV: *L'età lorenese. La reggenza e Pietro Leopoldo*, edited by R. Roani, Florence, 2009, pp. 143–53.

Conti 1977
A. Conti, 'The Reliquary Chapel', *Apollo*, 106 (1977), pp. 198–200.

Contini 2002
A. Contini, *La reggenza lorenese tra Firenze e Vienna. Logiche dinastiche, uomini e governo (1737-1766)*, Florence, 2002.

Carradori 1802 – Sciolla 1979
F. Corradori, *Istruzione elementare per gli studiosi della scultura* (Florence 1802), [Italian/Deutsche], edited by Gianni Carlo Sciolla, Treviso, 1979.

Corsani 1997
G. Corsani, 'Le trasformazioni architettoniche del complesso della Quiete', in *Villa La Quiete* 1997, pp. 1–18.

Corti 1982
G. Corti, 'Two Picture Collections in Eighteenth-Century Florence', *The Burlington Magazine*, no. 953, 124 (1982), pp. 502–5.

Cortona 2011
Gli Etruschi dall'Arno al Tevere. Le collezioni del Louvre a Cortona, exhibition catalogue (Cortona, Museo dell'Accademia Etrusca e della Città di Cortona, 5 March–3 July 2011), edited by P. Bruschetti, F. Gaultier, P. Giulierini et al., Milan, 2011.

D'Agliano 2008
A. d'Agliano, 'Forme e sculture dall'antico nella porcellana europea', in *Ricordi dell'Antico: sculture, porcellane e arredi all'epoca del Grand Tour*, edited by A. d'Agliano and L. Melegati, Cinisello Balsamo, 2008, pp. 84–95.

D'Agliano 2010
A. d'Agliano, 'Gemme in porcellana: riproduzione dei cammei presso la manifattura Ginori a Doccia', in Florence 2010, pp. 76–9.

D'Albis 1999
A. d'Albis, 'Sèvres 1756-1783. La Conquête de la porcelaine dure', *Dossier de l'art Paris*, no. 54, 1999, monographic issue.

D'Albis, Biancalana 2008
A. d'Albis, A. Biancalana, 'Un voyage à Paris de Bartolomeo Ginori en 1771', *Sèvres*, 17 (2008), pp. 80–93.

Darr, Wilson 2013
A. Ph. Darr, Th. Wilson, 'Italian Renaissance and Later Ceramics', *Bulletin of the Detroit Institute of Arts*, 87 (2013), pp. 84–7.

De Milly 1772
Nicolas-Christiern de Thy, Comte de Milly, *L'Art de la porcelaine*, Paris, 1771 (1772).

De Vuono 2005
S. De Vuono, 'La raccolta d'arte della famiglia Gondi di Firenze: nascita, allestimento e dispersione', *Bollettino della Accademia degli Euteleti della città di San Miniato al Tedesco*, no. 72 (2005), pp. 111–44.

Detroit/Florence 1974
Gli Ultimi Medici: il tardo barocco a Firenze, 1670-1743, exhibition catalogue (Detroit, The Detroit Institute of Arts, 27 March–2 June 1974; Florence, Palazzo Pitti, 28 June–30 September 1974), edited by M. Chiarini and F.J. Cummings, Florence, 1974.

Digiugno 2011
E. Digiugno, 'La raccolta Ginori di impronte in zolfo di cammei e intagli', *Rivista dell'Osservatorio per le Arti Decorative in Italia*, 4 (2011), pp. 89–130.

Fagiolo dell'Arco 1997
M. Fagiolo dell'Arco, *Corpus delle feste barocche a Roma*, I: *La festa barocca*, Rome, 1997.

Florence 1935
Esposizione di porcellana antico-Ginori in occasione del bicentenario della fondazione della manifattura di Doccia oggi Società ceramica Richard-Ginori, exhibition catalogue (Florence, Palazzo Vecchio, April–May 1935), Florence, 1935.

Florence 1980
Palazzo Vecchio: committenza e collezionismo medicei 1537-1610, exhibition catalogue (Florence, Palazzo Vecchio, 1980), Florence, 1980.

Florence 2002
Venere e Amore. Michelangelo e la nuova bellezza ideale, exhibition catalogue (Florence, Galleria dell'Accademia, 26 June–3 November 2002), edited by F. Falletti and J. Katz Nelson, Prato, 2002.

Florence 2003
Le statue del marchese Ginori. Sculture in porcellana bianca di Doccia, exhibition catalogue (Florence, Palazzo Corsini, 26 September–5 October 2003), edited by J. Winter, Florence, 2003.

Florence 2006ᵃ
Arte e manifattura di corte a Firenze. Dal tramonto dei Medici all'impero (1732-1815), exhibition catalogue (Florence, Palazzo Pitti, 16 May–5 November 2006), edited by A.M. Giusti, Livorno, 2006.

Florence 2006ᵇ
Giambologna: gli dei, gli eroi. Genesi e fortuna di uno stile europeo nella scultura, exhibition catalogue (Florence, Museo Nazionale del Bargello, 2 March–15 June 2006), edited by B. Paolozzi Strozzi and D. Zikos, Florence, 2006.

Florence 2006ᶜ
La principessa saggia. L'eredità di Anna Maria Luisa de' Medici Elettrice Palatina, exhibition catalogue (Florence, Palazzo Pitti, Galleria Palatina, 23 December 2006–15 April 2007), edited by S. Casciu, Livorno, 2006.

Florence 2009
Il fasto e la ragione. Arte del Settecento a Firenze, exhibition catalogue (Florence, Galleria degli Uffizi, 30 May–30 September 2009), edited by C. Sisi and R. Spinelli, Florence, 2009.

Florence 2010
Pregio e bellezza. Cammei e intagli dei Medici, exhibition catalogue (Florence, Palazzo Pitti, Museo degli argenti, 25 March–27 June 2010), edited by R. Gennaioli, Livorno, 2010.

Florence 2012
The Revival of Italian Maiolica: Ginori e Cantagalli, exhibition catalogue (Florence, Museo Stibbert, 30 September 2011–15 April 2012), [English/Italian], edited by L. Frescobaldi Malenchini and O. Rucellai, Florence, 2012.

Florence 2014
L'immortalità di un mito. L'eredità di Michelangelo nelle arti e negli insegnamenti accademici a Firenze dal Cinquecento alla contemporaneità, exhibition catalogue (Florence, Accademia delle arti del disegno, 5–28 December 2014), edited by S. Bellesi and F. Petrucci, Florence, 2014.

Florence 2015
Nel segno dei Medici. Tesori sacri della devozione granducale, exhibition catalogue (Florence, Museo delle Cappelle Medicee, 21 April–3 November 2015), edited by M. Bietti, R. Gennaioli and E. Nardinocchi, Livorno, 2015.

Focillon 1934
H. Focillon, *Vie des formes*, Paris, 1934.

Frankfurt 1986
Die Bronzen der Fürstlichen Sammlung Liechtenstein, exhibition catalogue (Frankfurt am Main, Schirn Kunsthalle, 26 November 1986–15 February 1987), Frankfurt am Main, 1986.

Frescobaldi Malenchini 2013
L. Frescobaldi Malenchini, 'Intervista a Lorenzo Ginori Lisci', *Gazzetta Antiquaria*, no. 63 (2013), pp. 26–9.

Frescobaldi Malenchini, Giovannini, Rucellai 2015
L. Frescobaldi Malenchini, M.T. Giovannini, O. Rucellai, *Gio Ponti: the Collection of the Museo Richard-Ginori della manifattura di Doccia*, [English/Italian], Falciano, 2015.

Gaeta Bertelà 1997
G. Gaeta Bertelà, *La Tribuna di Ferdinando I de' Medici. Inventari 1589-1631*, Modena, 1997.

Garms 2003
J. Garms, 'Il 'Transito di San Giuseppe': considerazioni su modelli e sviluppi di un'iconografia ai tempi di Clemente XI', *Bollettino d'Arte*, 6th series, 87/2002–3 (2003), pp. 49–54.

Gasparotto 2005
D. Gasparotto, *Giambologna*, Rome, 2005.

Gasparotto 2015
D. Gasparotto, 'Il piacere del piccolo. Il fascino dell'antico nel Rinascimento italiano', in Milan/Venice 2015, pp. 288–92.

Genoa 2004
L'Età di Rubens. Dimore, committenti e collezionisti genovesi, exhibition catalogue (Genoa, Palazzo Ducale, 20 March–11 July 2004), edited by P. Boccardo, Genoa/Milano 2004.

Gentilini 1996
G. Gentilini, 'La scultura fiorentina in terracotta del Rinascimento. Tecniche e tipologie', in *La scultura in terracotta. Tecniche e conservazione*, edited by M.G. Vaccari, Florence 1996, pp. 64–103.

Gialluca 1993–4
B. Gialluca, 'Il mito etrusco a Cortona (1550-1740) tra archeologia e ideologia', *Annuario. Accademia Etrusca di Cortona*, 26 (1993–4), pp. 225–302.

Gialluca 2011
B. Gialluca, 'Filippo Venuti. Un ecclesiastico toscano illuminato tra Cortona, Bordeaux, Livorno', in Cortona 2011, pp. 37–71.

Ginori Lisci 1963
L. Ginori Lisci, *La porcellana di Doccia*, with an introduction by A. Lane, Milan, 1963.

Giovannini 2009
M.T. Giovannini, 'L'arte rivoluziona l'industria: Gio Ponti per Richard Ginori', in *Artisti per Doccia*, edited by L. Casprini Gentile and D. Liscia Bemporad, Florence, 2009, pp. 73–86.

González-Palacios 1996
A. González-Palacios, 'Le Virtù di Madrid', *Antologia di Belle Arti*, new series, nos. 52–5 (1996); repr. in González-Palcios 2010, pp. 23–6.

González-Palacios 2006
A. González-Palcios, 'La Manifattura Ginori di Pietre dure. 1745-1760', in Florence 2006ᵃ, pp. 28–35.

González-Palacios 2010
A. González-Palacios, *Nostalgia e invenzione. Arredi e arti decorative a Roma e Napoli nel Settecento*, Milan, 2010.

Gori 1734
A.F. Gori, *Museum florentinum exhibens insignioria vetustatis monumenta quae Florentiae sunt. Statuae antiquae deorum et virorum illustrium centum aeris tabulis incisae quae exstant in thesauro mediceo cum observationibus*, Florence, 1734.

Gori Pasta 2000
O. Gori Pasta, 'Ginori, Carlo', in *Dizionario biografico degli italiani*, Rome, 1960–, LV (2000), pp. 32–4.

Hallo 1927
R. Hallo, 'Bronzeabgüsse antiker Statuen', *Jahrbuch des Deutschen archäologischen Instituts*, 42 (1927), pp. 193–220.

Haskell 1963
F. Haskell, *Patrons and Painters: a Study in the Relations between Italian Art and Society in the Age of the Baroque*, London, 1963.

Haskell, Penny 1981
F. Haskell, N. Penny, *Taste and the Antique. The Lure of Classical Sculpture, 1500-1900*, New Haven–London, 1981.

Horace Walpole, *Correspondence*, ed. 1954–71
Horace Walpole's Correspondence with Sir Horace Mann, edited by W.S. Lewis, W. Hunting Smith and G.L. Lam, 11 vols., New Haven/London 1954–71.

Inventario 1589
Inventario della Tribuna, ms., 1589, Florence, BGU, 70.

Inventario 1784
Inventario Generale della Real Galleria di Firenze, edited by G. Pelli Bencivenni, ms., 1784, 3 vols., Florence, BGU, 113.

Jestaz 1979
B. Jestaz, 'À propos de Jean Bologne', *Revue de l'Art*, 46 (1979), pp. 75–82.

Keutner 1976
H. Keutner, 'Massimiliano Soldani und die Familie Salviati', in *Kunst des Barock* 1976, pp. 137–64.

Keutner 1984
H. Keutner, *Giambologna. Il mercurio volante e altre opere giovanili*, Florence, 1984.

Kunst des Barock 1976
Kunst des Barock in der Toskana. Studien zur Kunst unter den letzen Medici, edited by K. Lankheit, Munich, 1976.

La Condamine 1757
C.M. de la Condamine, 'Extrait d'un journal de voyage en Italie', *Histoire de l'Academie Royal des Sciences*, [59] (1757), pp. 336–410.

[Lambruschini] 1837
[R. Lambruschini], *Notizie biografiche intorno al marchese Leopoldo Carlo Ginori Lisci*, Florence, 1837.

Lankheit 1958ᵃ
K. Lankheit, 'Eine Serie barocker Antiken-Nachbildungen aus der Werkstatt des Massimiliano Soldani', *Mitteilungen des Deutschen Archäologischen Instituts*, 65 (1958), pp. 186–97.

Lankheit 1958ᵇ
K. Lankheit, 'Two Bronzes by Massimiliano Soldani Benzi', *The Journal of the Walters Art Gallery*, 29–30/1956–7 (1958), pp. 9–17.

Lankheit 1962
K. Lankheit, *Florentinische Barockplastik. Die Kunst am Hofe der letzten Medici. 1670-1743*, Munich, 1962.

Lankheit 1982
K. Lankheit, *Die Modellsammlung der Porzellanmanufaktur Doccia. Ein Dokument italienischer Barockplastik*, Munich, 1982.

Lanzi 1782
L. Lanzi, *La Real Galleria di Firenze accresciuta, e riordinata per comando di S.A.R. l'Arciduca Granduca di Toscana*, Florence, 1782.

Lauricella 2011
A. Lauricella, 'Le antiche forme a tasselli della Manifattura di Doccia: una risorsa per il restauro. Il caso esemplare della Pietà Corsini', *Quaderni. Amici di Doccia*, 4/2010 (2011), pp. 174–84.

Lenzi 2000
D. Lenzi, 'La dinastia dei Galli Bibiena', in Bologna 2000, pp. 19–35.

Lenzi Iacomelli 2014
C. Lenzi Iacomelli, *Vincenzo Meucci (1694-1766)*, Florence, 2014.

Lightbown 1969
R.W. Lightbown, 'Oriental Art and the Orient in Late Renaissance and Baroque Italy', *Journal of the Warburg and Courtauld Institutes*, 32 (1969), pp. 228–79.

Liverani 1967
G. Liverani, *Il Museo delle Porcellane di Doccia*, with an introduction by Bruno Molajoli, Sesto Fiorentino, 1967.

Lo Vullo Bianchi 1931
S. Lo Vullo Bianchi, 'Note e documenti su Pietro e Ferdinando Tacca', *Rivista d'Arte*, 13 (1931), pp. 133–213.

London 1978
The Baroque in Italy: Paintings and Sculptures 1600-1720, exhibition catalogue (London, Heim Gallery, 15 June–25 August 1978), London, 1978.

London 1983
The Adjectives of History. Furniture and Works of Art 1550-1870, exhibition catalogue (London, P & D Colnaghi & Co. Ltd., 14 June–30 July 1983), edited by A. González-Palacios, in collaboration with D. Garstang, London, 1983.

London 2012
Bronze, published to coincide with the exhibition "Bronze" (London, Royal Academy of Arts, 15 September–9 December 2012), edited by D. Ekserdjian, London, 2012.

Lorenzini 1861
C. Lorenzini, *La manifattura delle porcellane di Doccia. Cenni illustrativi*, Florence, 1861.

Madrid 2007
Tintoretto, exhibition catalogue (Madrid, Museo Nacional del Prado, 30 January–13 May 2007), edited by M. Falomir Faus, Madrid, 2007.

Mancini 1909
G. Mancini, *Cortona, Montecchio Vesponi e Castiglione Fiorentino*, Bergamo, 1909.

La manifattura 1867
La manifattura Ginori a Doccia, Florence, 1867.

La manifattura 1970
La manifattura di Doccia nel 1760. Secondo una relazione inedita di J. de St. Laurent, edited by G. Liverani, Florence, 1970.

La manifattura 1988
La manifattura Richard-Ginori di Doccia, edited by R. Monti, Milan/Rome, 1988.

Mansuelli 1958–61
G.A. Mansuelli, *Galleria degli Uffizi. Le sculture*, 2 vols., Rome, 1958–61.

Marchini 1982
G. Marchini, 'Per Massimiliano Soldani Benzi', *Antichità viva*, 21/2–3 (1982), pp. 71–4.

Marco Polo [14th century] – Rivalta 1960
Il libro di Marco Polo detto Milione, nella versione trecentesca dell'"ottimo", edited by P. Rivalta, with a preface by S. Solmi, Turin, 1960 (1st ed. Turin, 1954).

Maritano 2009
C. Maritano, 'Michelangelo sul camino: porcellane Ginori e bronzi Barbedienne in una pendola della collezione D'Azeglio', in *Per Giovanni Romano. Scritti di amici*, edited by G. Agosti and G. Dardanello, Savigliano, 2009, pp. 117–18.

Maritano 2012ᵃ
C. Maritano, 'Fortuna delle sculture in porcellana di Doccia in Inghilterra: la collezione di Emanuele d'Azeglio', *Quaderni. Amici di Doccia*, 5/2011 (2012), pp. 10–33.

Maritano 2012ᵇ
C. Maritano, 'Il Monte Calvario di Gaspero Bruschi ritrovato e un crocifisso fiorentino in argento', *Quaderni. Amici di Doccia*, 5/2011 (2012), pp. 102–6.

Mazzanti 2012
B. Mazzanti, "Carlo Ginori e Villa «Le Corti»: la fabbrica di porcellane di Doccia nella sua prima sede", *Annali di Storia di Firenze*, 7 (2012), pp. 123–63.

Medici 1880
Ulderigo Medici, *Catalogo della Galleria dei Principi Corsini in Firenze*, Florence, 1880.

Melegati 1999
L. Melegati, *Le porcellane europee al Castello Sforzesco. Civiche Raccolte d'Arte Applicata. Castello Sforzesco*, Milan, 1999.

Melegati 2000
L. Melegati, 'Alcune figure in porcellana dalla manifattura di Doccia', *Nuovi Studi*, 4/1999 (2000), 7, pp. 133–8.

Melegati 2005
L. Melegati, 'Gaspero Bruschi e la scultura a Doccia. Il ruolo di Gaspero Bruschi nello sviluppo della produzione plastica a Doccia durante i primi anni di attività della Manifattura', in *Quando la manifattura diventa arte. Le porcellane e le maioliche di Doccia*, proceedings of the symposium (Lucca, Accademia Lucchese di Scienze, Lettere e Arti, 7 May 2003), edited by A. Biancalana, Pisa 2005, pp. 53–63.

Meloni Trkulja 1983
S. Meloni Trkulja, 'Gli ultimi Medici attraverso i giornali di guardaroba', in *Gli Uffizi. Quattro secoli di una galleria*, proceedings of the symposium (Florence, Palazzo Vecchio–Palazzo Medici Riccardi, 20–4 September 1982), edited P. Barocchi and G. Ragionieri, 2 vols., Florence, 1983, I, pp. 331–8.

Middeldorf 1976
U. Middeldorf, '«Vestire gli ignudi». Un disegno del Soldani', in *Kunst des Barock* 1976, pp. 33–8.

Milan/Venice 2015
Serial/Portable Classic: The Greek Canon and its Mutations, exhibition catalogue (Milan, Fondazione Prada, 9 May–24 August; Venice, Fondazione Prada, 9 May–13 September 2015), [English/Italian], edited by S. Settis, with A. Anguissola and D. Gasparotto, Milan, 2015.

Montagu 1976
J. Montagu, 'The Bronze Groups Made for the Electress Palatine', in *Kunst des Barock* 1976, pp. 126–136.

Montagu 1983
J. Montagu, review of Lankheit 1982, *The Burlington Magazine*, no. 969, 125 (1983), pp. 757–9, 775.

Moore Valeri 2006
A. Moore Valeri, 'Le ambrogette della manifattura di Doccia: il pavimento in maiolica della Libreria Piccolomini a Siena: il rifacimento ottocentesco', *CeramicAntica*, 16/11 (2006), pp. 24–34.

Moore Valeri 2007[a]
A. Moore Valeri, 'La Loggia delle Benedizioni: a Tile Floor Made by the Richard-Ginori Factory for the Vatican', *Quaderni. Amici di Doccia*, 1 (2007), pp. 60–7.

Moore Valeri 2007[b]
A. Moore Valeri, 'Un'introduzione alla prima maiolica di Doccia 1740-1780', *Faenza*, 93/1–3 (2007), pp. 81–98.

Moore Valeri 2011
A. Moore Valeri, 'Early Nineteenth Century Maiolica from the Ginori Factory in Doccia', *American Ceramic Circle Journal*, 16 (2011), pp. 33–55.

Moore Valeri 2014
A. Moore Valeri, 'Mattonelle da rivestimento della manifattura Ginori. 1740-1840', in *Ceramica e architettura*, proceedings of the 46th annual international ceramics convention (Savona, 24–5 May 2013), Albisola, 2014, pp. 239–48.

Morazzoni 1935
G. Morazzoni, *Le porcellane italiane*, with an introduction by R. Papini, Milan/Rome, 1935.

Morazzoni, Levy 1960
G. Morazzoni, S. Levy, *Le porcellane italiane*, 2 vols., Milan, 1960.

Mottola Molfino 1976-7
A. Mottola Molfino, *L'arte della porcellana in Italia*, 2 vols., Busto Arsizio, 1976–7.

Munich 2015
Bella figura. Europäische Bronzekunst in Süddeutschland um 1600, exhibition catalogue (Munich, Bayerisches Nationalmuseum, 6 February–25 May 2015), edited by R. Eikelmann, Munich, 2015.

'Il museo di Doccia' 1965
'Il museo di Doccia a Sesto Fiorentino', *Richard Ginori*, 6/3–4 (1965), n.n.

Museo Richard Ginori 2003/2008
Museo Richard Ginori della manifattura di Doccia, edited by O. Rucellai (Florence, 2003), repr. Florence, 2008.

New York 2007
Richard-Ginori 1737-1937. Ceramics from the Manifattura di Doccia Museum, exhibition catalogue (New York, Istituto Italiano di Cultura, 20 February–18 March 2008), [English/Italian], edited by O. Rucellai, Palermo, 2007.

Pagliani 2003
M.L. Pagliani, *L'orma del bello. I calchi di statue antiche nell'Accademia di Belle Arti di Bologna*, Argelato, 2003.

Paolozzi Strozzi, Vaccari, Spallanzani 2003
B. Paolozzi Strozzi, M.G. Vaccari, M. Spallanzani, *Acquisti e donazioni del Museo Nazionale del Bargello 1998-2002*, Florence, 2003.

Paolucci 1978
A. Paolucci, 'Contributi per la scultura fiorentina del Settecento', *Paragone*, no. 339 (1978), pp. 67–71.

Paris 1999/2001
Les Bronzes de la Couronne (Paris, 1999), exhibition catalogue (Parigi, Musée du Louvre, 12 April–12 July 1999), 2nd. ed. Paris, 2001.

Paris 2007
Praxitele, exhibition catalogue (Paris, Musée du Louvre, 23 March–18 June 2007), edited by A. Pasquier, Paris, 2007.

Penny 1993
N. Penny, *The Materials of Sculpture*, London, 1993.

Poeschke 1992/1996
J. Poeschke, *Die skulptur der Renaissance in Italien, II: Michelangelo und seine Zeit*, Munich, 1962; English edition with the title *Michelangelo and His World. Sculpture of the Italian Renaissance*, New York, 1996.

Pope-Hennessy 1965
J. Pope-Hennessy, *Renaissance Bronzes from the Samuel H. Kress Collection. Reliefs, Plaquettes, Statuettes, Utensils, Mortars*, London, 1965.

Pratesi 1993
G. Pratesi, *Repertorio della scultura fiorentina del Seicento e Settecento*, 3 vols., Turin, 1993.

Radcliffe, Penny 2004
A. Radcliffe, N. Penny, *The Robert H. Smith Collection. Art of the Renaissance Bronze 1500-1650*, London, 2004.

Ravanelli Guidotti 2006
C.R. Guidotti, 'Il ritorno di Amore e Psiche', *Faenza*, 92/1–3 (2006), pp. 158–72.

Relazione 1758
Relazione de' Tricennali celebrati dall'Accademia Etrusca di Cortona, Lucca, 1758.

Roani 2006
R. Roani, *La scultura a Firenze in età lorenese*, in *Storia delle arti in Toscana. Il Settecento*, edited by M. Gregori and R.P. Ciardi, Florence, 2006, pp. 63–82.

Roani Villani 1986
R. Roani Villani, 'La decorazione plastica dell'arco di porta San Gallo a Firenze', *Paragone*, no. 437, 1986, pp. 53–67.

Roani Villani 1993
R. Roani Villani, 'Copie dall'Antico: F. Harwood e G. B. Piamontini', *Antologia di Belle Arti*, new series, nos. 43/47 (1993), pp. 108–115.

Romano 1959
E. Romano, *La porcellana di Capodimonte. Storia della manifattura borbonica*, Naples, 1959.

Rome 2008
Ricordi dell'antico. Sculture, porcellane e arredi all'epoca del Grand Tour, exhibition catalogue (Rome, Musei Capitolini, 7 March–8 June 2008), edited by A. d'Agliano and L. Melegati, Cinisello Balsamo, 2008.

Rosenberg 2000
R. Rosenberg, *Beschreibungen und Nachzeichnungen der Skulpturen Michelangelos: eine Geschichte der Kunstbetrachtung*, Munich, 2000.

Rossi 1893
U. Rossi, 'Il Museo Nazionale di Firenze nel triennio 1889-1891', *Archivio Storico dell'Arte*, 6 (1893), pp. 1–24.

Rossi 1932
F. Rossi, *Il Museo Nazionale di Firenze (Palazzo del Bargello)*, Rome, 1932.

Rossi 2016
F. Rossi, 'Intervento per la tutela della collezione di cere del Museo di Doccia', *Quaderni. Amici di Doccia*, 9 (2016), pp. 103–4.

Salmon 1757
T. Salmon, *Lo stato presente di tutti i paesi, e popoli del mondo naturale, politico e morale, con nuove osservazioni, e correzioni degli antichi, e moderni viaggiatori*, XXI: *Continuazione dell'Italia o sia Descrizione del Gran ducato di Toscana, della Repubblica di Lucca e di una parte del dominio ecclesiastico*, Venice, 1757.

Scaligero 1557
G.C. Scaligero, *Exotericarum exercitationum liber quintus decimus, de subtilitate, ad Hieronimum Cardanum*, Lutetiae, ex officina typographica Michaelis Vascosani, 1557.

Serafini 2008
F. Serafini, 'Le porcellane sperimentali di Carlo Andrea Ginori (1739-1757)', in *Il gusto esotico nella Manifattura di Doccia*, edited by L. Casprini Gentile and D. Liscia Bemporad, Florence, 2008, pp. 15–37.

Sesto Fiorentino 2001/2005
Il bello dell'utile. Ceramiche Ginori e Richard-Ginori dal 1750 al 1950 di una collezione privata, exhibition catalogue (Florence, Officina Profumo Farmaceutica di Santa Maria Novella, 22 September–14 October 2001), edited by Anna Chiostrini Mannini (Florence, 2001), ed. Florence, 2005.

Sesto Fiorentino 2006
Documenti e itinerari di un gentiluomo del secolo dei lumi. Album Ginori, exhibition catalogue (Sesto Fiorentino, Museo Richard Ginori, 2 December 2006–30 April 2007), edited by R. Balleri, L. Casprini, O. Pollastri et al., Florence, 2006.

Sesto Fiorentino 2010
Omaggio a Venere. Il culto della bellezza ideale nei modelli della Manifattura di Doccia, exhibition catalogue (Sesto Fiorentino, Museo Richard Ginori della Manifattura di Doccia, 17 June–14 November 2010), edited by R. Balleri e O. Rucellai, Florence, 2010.

Shearman 1967
J. Shearman, *Mannerism*, Harmondsworth, 1967.

Siena 2005
Siena e Roma. Raffaello, Caravaggio e i protagonisti di un legame antico, exhibition catalogue (Siena, Palazzo Squarcialupi, 25 November 2005–5 March 2006), edited by B. Santi and C. Strinati, Siena, 2005.

Smith 2013
D. Smith, 'Technical Characteristics of Bronze Statuettes from the Workshops of Antonio and Giovanni Francesco Susini', in *The Renaissance Workshop*, edited by D. Saunders, M. Springe and A. Meek, London, 2013, pp. 29–41.

Spallanzani 1978
M. Spallanzani, 'The Courtyard of Palazzo Tornabuoni-Ridolfi and Zanobi Lastricati's Bronze Mercury', *The Journal of the Walters Art Gallery*, 37 (1978), pp. 7–21.

Spallanzani 1978/1997
M. Spallanzani, *Ceramiche orientali a Firenze nel Rinascimento* (Florence, 1978), repr. Florence, 1997.

Suida, Fuller 1954
W.E. Suida, R.E. Fuller, *European Paintings and Sculpture from the Samuel H. Kress Collection*, Seattle, 1954.

Supino 1898
I.B. Supino, *Catalogo del R. Museo Nazionale di Firenze (Palazzo del Podestà)*, Rome, 1898.

Tietze-Conrat 1917
E. Tietze-Conrat, 'Die Bronzen der Fürstlich Liechtensteinschen Kunstkammer', *Jahrbuch des Kunsthistorischen Institutes*, 11 (1917), pp. 16–108.

Toderi, Vannel 1987
G. Toderi, F. Vannel, *La medaglia barocca in Toscana*, Florence, 1987.

Tokyo 2001
Porcellane italiane della Collezione del Museo di Doccia. L'antica Manifattura Richard-Ginori a Sesto Fiorentino, exhibition catalogue (Tokyo, The Museum of Contemporary Art, 18 March–20 May 2001), [Japanese/Italian], edited by M.M. Simari and M. Iseki, Tokyo, 2001.

Tosi 1997
A. Tosi, *Inventare la realtà. Giuseppe Zocchi e la Toscana del Settecento*, Florence, 1997.

Valeriani 2016
R. Valeriani, 'Le diverse maniere di acquistare un camino. Quando Roma divenne il centro di produzione di camini ambiti dall'aristocrazia europea', *Gazzetta Antiquaria*, 25-05-2016, <http://www.antiquariditalia.it/it/gazzetta/articolo/1/144/le-diverse-maniere-di-acquistare-un-camino>.

Vasari 1568 – De Vere 1996
Giorgio Vasari, *Le Vite de' più eccellenti pittori, scultori, et architettori, …* revised and enlarged, 3 vols., Florence, Giunti, 1568; Eng. trans. by Gaston du C. de Vere, 2 vols., New York, 1996 (1st edition New York, 1896).

Verga 1990
M. Verga, *Da "cittadini" a "nobili". Lotta politica e riforme delle istituzioni nella Toscana di Francesco Stefano*, Milan, 1990.

Verga 1999
M. Verga, 'La Reggenza Lorenese', in *Storia della civiltà toscana*, IV: *L'età dei lumi*, edited by F. Diaz, Florence, 1999, pp. 27–50.

Verga 2006
M. Verga, 'Strategie dinastiche e mito cittadino. L'Elettrice Palatina e Firenze', in Florence 2006', pp. 24–9.

Vienna 1978
Giambologna 1529-1608. Ein Wendepunkt der europäischen Plastik, exhibition catalogue (Edinburgh, Royal Scottish Museum, 19 August–10 September 1978; London, Victoria and Albert Museum, 5 October–16 November 1978; Vienna, Kunsthistorisches Museum, 2 December 1978–28 January 1979), edited by C. Avery, A. Radcliffe and M. Leithe-Jasper, Vienna, 1978.

Vienna 2005
Baroque Luxury Porcelain: The Manufactories of Du Paquier in Vienna and of Carlo Ginori in Florence, exhibition catalogue (Vienna, Liechtenstein Museum, 10 November 2005–29 January 2006), edited by J. Kräftner, Vienna, 2005.

Vienna 2006
Giambologna. Triumph des Körpers, exhibition catalogue (Vienna, Kunsthistorisches Museum, 27 June–17 September 2006), edited by W. Seipel, Vienna, 2006.

Vienna 2010
Der Fürst als Sammler. Neuerwerbungen unter Hans-Adam II. von und zu Liechtenstein, exhibition catalogue (Vienna, Liechtenstein Museum, 12 February–24 August 2010), edited by J. Kräftner, Vienna, 2010.

Villa La Quiete 1997
Villa La Quiete. Il patrimonio artistico del Conservatorio delle Montalve, edited by C. De Benedictis, Florence, 1997.

Visonà 2001
M. Visonà, 'Scultura in porcellana', in Tokyo 2001, pp. 55–60.

Voltaire 1751/1951
F.-M. Arouet known as Voltaire, *Le Siècle de Louis XIV*, 2 vols., Berlin, 1751.

Waquet 1990
J.-C. Waquet, *Le Grand-Duché de Toscane sous les derniers Médicis. Essai sur le système des finances et la stabilité des institutions dans les anciens États italiens*, Rome, 1990.

Watson 1978
K.J. Watson, 'Sugar Sculpture for Grand Ducal Weddings from the Giambologna Workshop', *The Connoisseur*, 199/9 (1978), pp. 20–6.

Watson, Avery 1973
K. Watson, C. Avery, 'Medici and Stuart: a Grand Ducal Gift of "Giovanni Bologna" Bronzes for Henry Prince of Wales (1612)', *The Burlington Magazine*, no. 845, 115 (1973), pp. 493–507.

Winckelmann 1764/1783
J.J. Winckelmann, *Geschichte der Kunst des Altertums*, Dresden, 1764.

Winter 2003
J. Winter, 'Le statue del marchese Ginori', in Florence 2003, pp. 19–28.

Winter 2005
J. Winter, 'Porcelain Sculpture at Doccia', in Vienna 2005, pp. 179–89.

Wittwer 2004
S. Wittwer, *The Gallery of Meissen Animals. Augustus the Strong's Menagerie for the Japanese Palace in Dresden*, Munich, 2004.

Zangheri 2000
L. Zangheri, *Gli Accademici del Disegno. Elenco alfabetico*, Florence, 2000.

Zikos 1996
D. Zikos, 'Antikenkopien in Bronze des Massimiliano Soldani Benzi', in *Von allen Seiten schön. Rückblicke auf Ausstellung und Kolloquium*, I: *Dokumentation zu Ausstellung und Kolloquium*, proceedings of the symposium (Berlin, Altes Museum, 27 January 1996), edited by V. Krahn, 2 vols., Köln 1996, I, pp. 125–38.

Zikos 2005ᵃ
D. Zikos, *Prince Johann Adam Andreas I of Liechtenstein and Massimiliano Soldani Benzi. The Late Baroque Florentine Bronze Sculpture*, in Vienna 2005, pp. 157–77.

Zikos 2005ᵇ
D. Zikos, *Giuseppe Piamontini. Il Sacrificio di Isacco di Anna Maria Luisa de' Medici, Elettrice Palatina*, Milan, 2005.

Zikos 2007
D. Zikos, '«Ars sine scientia nihil est». Il contributo di Pietro Tacca al bronzo italiano', in *Pietro Tacca: Carrara, la Toscana, le grandi corti europee*, exhibition catalogue (Carrara, Centro Arti Plastiche, 5 May–19 August 2007), edited by F. Falletti, Florence, 2007, pp. 55–73.

Zikos 2010
D. Zikos, *Giambolognas Kleinbronzen und ihre Rezeption in der florentinischen Bronzeplastik des 17. Jahrhunderts*, Freiburg im Breisgau, 2010.

Zikos 2011
D. Zikos, 'Sulla natura delle "forme" acquistate e commissionate da Carlo Ginori', *Quaderni. Amici di Doccia*, 4/2010 (2011), pp. 18–31.

Zikos 2013/2014
D. Zikos, 'Giovanni Bologna and Antonio Susini: an Old Problem in the Light of New Research', in *Carvings, Casts & Collectors. The Art of Renaissance Sculpture* (London, 2013), edited by P. Motture, E. Jones and D. Zikos, 2nd revised edition, London, 2014, pp. 194–209.

Zikos 2014ᵃ
D. Zikos, A "Kleinplastik" Collection in Regency Florence: Giovan Battista Borri's Bronzes and Terracottas', in *Renaissance and Baroque Bronzes from the Hill collection*, edited by P. Wengraf, London, 2014, pp. 37–67.

Zikos 2014ᵇ
D. Zikos, 'Soldani in Paris (1682)', in *Le arti a dialogo. Medaglie e medaglisti tra Quattro e Settecento*, proceedings of the symposium (Pisa, Scuola Normale Superiore, 2–3 December 2011), edited by L. Simonato, Pisa, 2014, pp. 269–82.

Table of contents

FSC
www.fsc.org

MISTO

Carta
da fonti gestite in
maniera responsabile

FSC® C103622

Printed in June 2017.